ABSENCE IN CINEMA

D1178488

FILM AND CULTURE

FILM AND CULTURE

A series of Columbia University Press

EDITED BY JOHN BELTON

For a complete list of titles, see page 243

ABSENCE
IN CINEMA

THE ART OF SHOWING NOTHING

JUSTIN REMES

Columbia University Press *New York*

Columbia University Press
Publishers Since 1893
New York Chichester, West Sussex
cup.columbia.edu

Copyright © 2020 Columbia University Press
All rights reserved

Library of Congress Cataloging-in-Publication Data
Names: Remes, Justin, author.
Title: Absence in cinema : the art of showing nothing / Justin Remes.
Description: New York : Columbia University Press, 2020. | Series: Film
and culture | Includes bibliographical references and index.
Identifiers: LCCN 2019052343 (print) | LCCN 2019052344 (ebook) |
ISBN 9780231189309 (cloth) | ISBN 9780231189316 (paperback) |
ISBN 9780231548281 (ebook)
Subjects: LCSH: Experimental films—History and criticism. |
Absence in motion pictures.
Classification: LCC PN1995.9.E96 R393 2020 (print) |
LCC PN1995.9.E96 (ebook) | DDC 791.43/611—dc23
LC record available at https://lccn.loc.gov/2019052343
LC ebook record available at https://lccn.loc.gov/2019052344

Columbia University Press books are printed on permanent
and durable acid-free paper.
Printed in the United States of America

Cover design: Milenda Nan Ok Lee

Cover photo: Hiroshi Sugimoto, *Teatro Communale di Ferrara*, Ferrara, 2015.
Gelatin silver print, 58 3/4 x 47 in. (149.2 x 119.4 cm). Courtesy of the artist and
Marian Goodman Gallery. Copyright © Hiroshi Sugimoto.

Cinema is the art of showing nothing.

—Robert Bresson

This page intentionally left blank.

CONTENTS

ACKNOWLEDGMENTS

The arguments in this book have been heavily informed by feedback provided by a number of filmmakers and film scholars, including Naomi Uman, Jennifer Proctor, Ross Lipman, Scott MacDonald, John Powers, Tanya Shilina-Conte, Glyn Davis, Elena Gorfinkel, Ofer Eliaz, Dijana Jelača, Daniel Gilfillan, Jeanpaul Goergen, Leo Enticknap, and Andy Birtwistle. I also appreciate the hard work of everyone at Columbia University Press, including Philip Leventhal, John Belton, Monique Briones, Milenda Nan Ok Lee, and my copy editor Anita O'Brien. CUP published my first book, *Motion(less) Pictures: The Cinema of Stasis*, and it was an honor to work with the press again. In both cases, the editors pushed me to improve my scholarship while also respecting my authorial autonomy. Additionally, the anonymous readers commissioned by the press (as well as the anonymous readers at *JCMS: The Journal of Cinema and Media Studies*) provided both words of encouragement and perceptive recommendations. I am also grateful to Hiroshi Sugimoto and Catherine Belloy at the Marian Goodman Gallery for allowing me to use Sugimoto's photograph *Teatro Comunale di Ferrara* (2015) on the cover of this book.

I received a great deal of support for this project from Iowa State University, including a valuable Center for Excellence in the Arts and Humanities (CEAH) Research Grant. I would like to thank Sandra Norvell for helping me prepare my application materials for this grant (and several others), as well as the English Department at ISU, which provided me with dedicated research assistants like Meredith Smith-Lane and Willis Patenaude. I appreciate the fact that my department gives me the freedom to select the subject matter of a number of my courses. Teaching courses like Absence in Cinema, Experimental Film, and Found Footage Films has enabled me to spend more time thinking about the films and writings that are most important to me and has given me the opportunity to hear insightful comments on these works from a number of smart students.

I would like to thank my friends Matthew Fisher and David Zimmerman, whose infectious enthusiasm for cinema and the arts continually energizes me. My gratitude extends to my mother, my brother, my sister, Nana, Ashley Ford, and my in-laws, Jim and Cynthia Rosiek, all of whom have been constant sources of love and encouragement. Finally, I would like to dedicate this book to my wife, Katrina, for the tireless support that she's given me over the past twenty years, and my son, James, who is the most perceptive eight-year-old film critic that I know.

ABSENCE IN CINEMA

INTRODUCTION

Voids

It's not what you see that is art, art is the gap.
—Marcel Duchamp

Boris—I feel a void at the center of my being.
Friend—What kind of void.
Boris—Well, an empty void.
Friend—An empty void?
Boris—Yes, I felt a full void about a month ago, but it was just
something I ate.
—Woody Allen, *Love and Death* (1975)

I n 1919, just a few months after revolutionizing art by draw-
ing a mustache and a beard on a postcard reproduction of the
Mona Lisa, Marcel Duchamp decided to purchase a French
souvenir for his American patrons, Walter and Louise Arens-
berg. But what kind of souvenir would be appropriate for a cou-
ple who, according to Duchamp, already had "everything that
money could buy?"[1] The artist decided to do something pro-
foundly weird. He entered a Paris pharmacy, purchased a
5¼-inch-tall glass ampoule of physiological serum, and asked the

pharmacist to drain the serum out of the ampoule and reseal it, leaving nothing inside it except for air. The pharmacist, no doubt bewildered by the unorthodox request, carried out the instructions. Duchamp christened the gift *50cc of Paris Air* (*50cc air de Paris*, 1919), even though the ampoule actually contained approximately 125 cubic centimeters of air.

What is *Paris Air*, exactly? Is it a souvenir? A practical joke? A work of art? If the latter, where *is* the art work? Has the ampoule itself become a readymade, an *objet trouvé* like Duchamp's bicycle wheel, bottle rack, and urinal? Perhaps. But it is significant that Duchamp's title directs our attention not to the ampoule but to the air itself, as if the ampoule is only a gift box with nothing inside. It is also significant that Duchamp does not title the work *Air* but *Paris Air*, raising the obvious question, "What makes Paris air different from any other air?"[2] If Duchamp had retained the title but covertly filled the ampoule with air from Lyon or New York City, would the art work be any different? (Perhaps it would only be different if the spectator somehow became aware of the deception?) If the ampoule became cracked, would the Paris air "escape," thus making the artwork disappear? Or would some trace or aura of the original air remain?[3]

If *Paris Air* is, in fact, an *objet trouvé*, it appears that the object that Duchamp has found and transmogrified into a work of art is not the ampoule but the air inside it. Or to put it another way, *Paris Air* may be the first invisible work of art. Since the work of art is the air itself (and not the ampoule, which is merely a package), Duchamp's art has become ethereal, insubstantial, ontologically unstable. As Dalia Judovitz puts it, "*Paris Air* functions as an olfactory trace rather than as a visual remembrance of the city."[4] Yet if this "olfactory trace" is an *objet trouvé*, it is also an *objet interdit*—a forbidden object. That is, not only has Duchamp

"discovered" the air of Paris, he has also had it hermetically sealed, thus denying the spectator phenomenological access to the substance in question. As Jerrold Seigel puts it, "Transported to New York, the Paris air could then work its attraction on anyone in its presence, but only so long as the beholder agreed to renounce the actual experience it seemed to promise; to open or break the glass so as to gain access to the desirable substance it contained was to lose it."[5] If the air could speak, it would sound like the alluring but elusive Alice (Patricia Arquette) from David Lynch's *Lost Highway* (1997): "You'll never have me."

Duchamp is just one of many artists who have exploited the power of absence. From the imageless cinema of Walter Ruttmann to the minimalist theater of Samuel Beckett, from the white paintings of Robert Rauschenberg to the silent music of John Cage, absence has played a crucial role in the history of avant-garde aesthetics. While considerable scholarly attention has been given to gestures of absence in art, music, and literature, little attention has been given to absence in cinema. This book will attempt to fill this gap (so to speak). Of course, studying absence may seem like a perverse enterprise. After all, in even the most extravagant and labyrinthine works of art, there are an infinite number of things that are absent. As the comedian Ricky Gervais is fond of pointing out, "Science doesn't concern itself with the non-existence of something. The periodic table of imaginary things would be too big for a classroom."[6] (It might be just the right size for a Borges story, however.) Still, when an expectation of presence is frustrated, absence becomes a useful theoretical concept. It is true, I suppose, that sound is "absent" from Hieronymus Bosch's painting *The Garden of Earthly Delights* (c. 1490–1510), but this would be a rather odd observation to make while strolling through the Prado Museum. After all, no one *expects* paintings to make a sound. But it is quite

reasonable to comment on the silence of Stan Brakhage's film *The Garden of Earthly Delights* (1981). The vast majority of films *do* feature sound (in the form of music, dialogue, and sound effects), so this suggests that Brakhage made a conscious decision to forgo this convention. Expectation is central to the phenomenology of absence. This is one of the fundamental insights of Jean-Paul Sartre's philosophical treatise *Being and Nothingness* (1943): "It is evident that non-being always appears within the limits of a human expectation. It is because I expect to find fifteen hundred francs that I find *only* thirteen hundred. It is because a physicist *expects* a certain verification of his hypothesis that nature can tell him no."[7] And this book is interested in precisely these moments—when one expects something from a film or artwork but is instead told no. What are the functions of such lacunae? How do they shape a spectator's encounter with an aesthetic work? Why might an artist encourage someone to look at (or listen to) something that is not there?

In other words, while this is a book about nothing, this term should be understood in all its radical relativity. The literary critic Vivian Mercier famously described Samuel Beckett's *Waiting for Godot* (1953) as a play in which "nothing happens, twice."[8] One could certainly argue with him by pointing out that a great deal happens in *Waiting for Godot*: Pozzo loses his sight, Lucky loses his speech, a boy arrives to tell Vladimir and Estragon that Godot will surely come tomorrow. But in a sense, this rebuttal misses the point of Mercier's terse synopsis. Mercier is arguing, justifiably, that "nothing happens" in *Godot* relative to what *usually* happens in plays. In most plays, waiting is rewarded (a rifle that appears in the first act will be fired in the second act). In most plays, the dialogue is detailed and revealing, not a succession of platitudes punctuated by silence. In most plays, there is narrative momentum and evolution, not an eternal recurrence,

in which the same banal events repeat again and again. Along similar lines, there are ways of pushing back against a discussion of the visual and auditory absences of cinema. After all, a "film without images" still gives spectators a blank screen to look at, and when one watches a film with no sound track, one does not literally hear *nothing*; one hears the hum of the film projector, the yawns of fellow spectators, and the sound of one's corduroy pant legs rubbing against each other. But the blank screen becomes visible only because we do not see Dorothy skipping on the yellow brick road, and the corduroy pants are audible only because their sound is not being drowned out by a euphonious rendition of "Over the Rainbow." In other words, nothingness is never absolute. As the theoretical physicist Lawrence Krauss has noted, even empty space is not nothing *senso stricto* but is, in fact, "a boiling brew of virtual particles that pop in and out of existence."[9] Every absence is a presence in disguise.

In this book I will interrogate the role that such absences have played in experimental works of the twentieth and twenty-first centuries. To focus on the avant-garde is not to diminish the importance of absence in more mainstream works, of course. It is perfectly reasonable—perhaps even essential—to ask of Leonardo da Vinci's *Mona Lisa* (c. 1503–1506), "What has been left out of the frame? Who is on the 'other side' of the canvas eliciting that enigmatic smile?" It is also reasonable to ask, "What notes is Thelonious Monk *not* playing in 'Round Midnight' and why?" In fact, I hope this book will inspire further research on the significance of absence in a wide variety of artworks. But I am primarily interested in the avant-garde of the twentieth and twenty-first centuries, since it has exploited absence in especially vital and provocative ways: paintings without imagery, music without sound, poems without words. In this introduction I will gesture toward some of these aesthetic

voids as a way of contextualizing the filmic absences that will be the focus of the remaining chapters.

INVISIBLE ART

I've been doing a lot of painting lately. Abstract painting. Extremely abstract. No brush. No canvas. I just think about it.

—Steven Wright, *I Have a Pony*

In 1915 the Suprematist artist Kazimir Malevich was working on an intricate and colorful abstract painting when he was struck by an idea: black. Not the black of representational art (a crow, an evening sky), nor the black of early abstract art, in which the hue might serve as one element in a variegated, polychromatic canvas. No, Malevich was interested in black *itself,* black *as* black. Unfortunately, at the moment of this idea's arrival, the Russian artist did not have a spare canvas. No matter. He painted a stark, monochromatic black square over another painting he had started and was immediately overwhelmed by the power of this minimalist gesture. He later claimed that he "could not sleep, eat, or drink for an entire week."[10] According to the philosopher Slavoj Žižek, Malevich's *Black Square* (1915) constituted an aesthetic "gap" in which "meaning is reduced to the minimal difference between the presence and absence of meaning itself."[11] A few years after *Black Square*, Malevich painted *Suprematist Composition: White on White* (1918), a tilted, off-center white square on a background colored a slightly different shade of white. Malevich had become the artist of "pure lack."[12] Still, he saw his aesthetic voids not as gestures of privation but as vehicles of liberation. He admonished spectators, "Swim in the white free abyss, infinity is before you."[13] And the austere artist

continued to drain paintings of their contents, producing progressively starker absences. By 1920 Malevich prepared his first solo show, *The Sixteenth State Exhibition*, in Moscow. The final room featured only blank canvases.

A number of avant-garde artists have followed the lead of Malevich (and Duchamp) by producing artworks that are seemingly devoid of content. One of the most infamous examples comes from the French painter Yves Klein, who often trafficked in "invisible art."[14] In 1958 the mystical artist staged an exhibition at the Galerie Iris Clert in Paris called *The Specialization of Sensibility in the Raw Material State Into Stabilized Pictorial Sensibility* (*La spécialisation de la sensibilité à l'état matière première en sensibilité picturale stabilisée*). (Those with an aversion to such grandiose appellations tend to simply call the exhibition *The Void*.) Klein sent out 3,500 invitations to spark interest in this new, mysterious exhibition, and on the evening of April 28, 1958, thousands of curious spectators made the pilgrimage to see what the innovative young artist was up to. When they arrived at the gallery, they saw nothing but the gallery's white walls; the exhibition was devoid of any paintings or sculptures. Apparently, a number of observers were enthralled by the event. According to Klein, some immersed themselves in the void "for hours without saying a word," while others were so moved by the experience that they began to "tremble" and "weep."[15] Among those who were inspired by Klein's empty gallery was the French existentialist Albert Camus, who remarked, "With the Void, full empowerment."[16] As for those who wanted a souvenir of the occasion, Klein graciously offered to give them nothing to take home with them. More precisely, Klein sold two "immaterial paintings" at the exhibition. While some might worry about the ethical implications of selling an invisible product, Klein offered the following reassurance: "Believe me, one is not robbed when

one purchases such paintings. I am the one who is always robbed because I accept money."[17] And in the summer of 1959, Klein continued "not robbing" patrons by selling empty spaces that he called *Zones of Immaterial Pictorial Sensibility* (*Zones de sensibilité picturale immatérielle*), although he accepted only gold (not money) for these "zones." Klein summarized the transactions this way: "Material for the immaterial. Gold for the void."[18]

Andy Warhol took cues from both Malevich and Klein in manufacturing aesthetic absences. For example, in *Untitled 12* (from the portfolio *For Meyer Schapiro*, 1974), Warhol obliterates a number of his iconic images (a Campbell's soup can, a cow's head, Brillo boxes) with a Malevichian black square, thus producing a complex palimpsest of appropriated images. And in 1985 Warhol channeled Klein by creating (if that is the right word) *Invisible Sculpture*. Warhol visited a New York nightclub called Area, stood on a pedestal, and walked away. After his disappearance, he left behind a photograph documenting the event and a plate that read, "Andy Warhol. USA. Invisible Sculpture. Mixed Media. 1985." Warhol would later describe the work as "just something or nothing on a pedestal."[19] In the words of Dörte Zbikowski, Warhol "brought about the disappearance of the last existing criterion of art: the criterion of presence."[20] In fact, Warhol was fascinated by nothingness. When he was asked why he painted Campbell's soup cans, he replied, "I wanted to paint nothing. I was looking for something that was the essence of nothing and that was it."[21] Warhol's love of absence is ubiquitous in his writings as well:

> I'm still obsessed with the idea of looking into the mirror and seeing no one, nothing.[22]
>
> My favorite piece of sculpture is a solid wall with a hole in it to frame the space on the other side.[23]

> I really believe in empty spaces . . . what I really want to do is
> help [people] *empty* their space.[24]

The Area nightclub was closed down in 1987. One wonders what became of Warhol's *Invisible Sculpture*. Perhaps one can still visit the area where Area once was and sense the presence of Warhol's absence.

It is worth reflecting on the diversity of these aesthetic voids. Malevich's black square is distinct from his white square, and there is a clear difference between an empty ampoule (Duchamp) and an empty room (Klein). But is there a difference between Klein's invisible paintings and Warhol's invisible sculpture? They certainly look the same. (One is reminded of Delos Banning McKown's maxim, a meme that is popular with atheists and secular humanists: "The invisible and the nonexistent look very much alike.")[25] But appearances can be deceptive. There are numerous important differences between the respective conceptual gestures of Klein and Warhol. To begin, Klein produced (and sold) *two* invisible paintings at his *Void* exhibition, and this duplicity (if you will) raises a number of questions: Were the paintings the same? Was one a copy of the other? Are both paintings equally valuable? Klein did, after all, sell ostensibly identical blue monochromes for different prices, since each one "presented a completely different essence and atmosphere."[26] Did each invisible painting have a different essence and atmosphere too? Posing such questions, one begins to feel like a medieval theologian trying to determine how many angels can dance on the head of a pin. (Is it any wonder that Thierry de Duve has called Klein "the theologian of the artistic commodity"?)[27]

But the differences between the voids of Klein and Warhol are not just quantitative—they are qualitative as well. Just as a painting is not a sculpture, an absent painting is not an absent

sculpture. This is because, in the words of philosopher Roy Sorensen, "Absences are relative. They draw their identity from their relata."[28] To illustrate this point, consider a joke told by Count Léon d'Algout (Melvyn Douglas) in Ernst Lubitsch's *Ninotchka* (1939): "A man comes into a restaurant. He sits down at the table. He says, 'Waiter, bring me a cup of coffee without cream.' Five minutes later, the waiter comes back and says, 'I'm sorry, sir. We have no cream. Can it be without milk?'" Slavoj Žižek's analysis of this joke is instructive: "In both cases, the customer gets coffee alone, but this One-coffee is each time accompanied by a different negation, first coffee-with-no-cream, then coffee-with-no-milk. What we encounter here is the logic of differentiality, in which the lack itself functions as a positive feature."[29] The author Ronald Green puts it this way: "A basket from which you take out all the apples and another basket from which you take out all the oranges will both be empty, but will be empty in a different way: one will have zero apples and one will have zero oranges."[30] Perhaps the most forceful articulation of this principle comes from Sartre's *Being and Nothingness*. Sartre asks his readers to imagine that he has an appointment to meet a friend named Pierre at a café at four o'clock. Sartre arrives fifteen minutes late, however, and discovers that Pierre has already left. Here is how Sartre conceptualizes this absence:

> There is an infinity of people who are without any relation with this café for want of a real expectation which establishes their absence. But, to be exact, I myself expected to see Pierre, and my expectation has caused the absence of Pierre *to happen* as a real event concerning this café. It is an objective fact at present that I have *discovered* this absence, and it presents itself as a synthetic relation between Pierre and the setting in which I am looking for him. Pierre absent haunts this café and is the condition of its

self-nihilating organization as ground. By contrast, judgments which I can make subsequently to amuse myself, such as, "[The Duke of] Wellington is not in this café, Paul Valéry is no longer here, *etc.*"—these have a purely abstract meaning; they are pure applications of the principle of negation without real or efficacious foundation, and they never succeed in establishing a *real* relation between the café and Wellington or Valéry.[31]

A café without Pierre is not the same as a café without the Duke of Wellington, a basket with no apples is not the same as a basket with no oranges, and coffee without cream is not the same as coffee without milk. Along similar lines, Klein's invisible paintings are not the same as Warhol's invisible sculpture. In each case, the phenomenology is shaped by what is negated.[32]

SILENT MUSIC

What is more eloquent than silence?
—Thereza, Charlie Chaplin's *Limelight* (1952)

The sound of silence begins not with Simon and Garfunkel but with Alphonse Allais, an impudent humorist (and friend of Erik Satie's) in *fin-de-siècle* France. Allais was a member of the Incoherents, a playful and subversive art movement that anticipated a number of the trends of the twentieth-century avant-garde. In the 1880s, for example, decades before Duchamp's *L.H.O.O.Q.* (1919), the Incoherent artist Sapeck (Eugène Bataille) created *Mona Lisa with a Pipe.* Around the same time, well before Kazimir Malevich's *White on White* (1918) and Robert Rauschenberg's *White Paintings* (1951), Allais himself created some of the first monochrome art works, such as a blank piece of paper stuck

to a wall entitled *First Communion of Young Anemic Girls in the Snow* (*Première communion de jeunes filles chlorotiques par un temps de neige*). Allais's fascination with absence extended to the realm of music as well. In 1897, as part of an *April Fool's Album* (*Album Primo-Avrilesque*), Allais published a noteless musical score entitled *Funeral March for the Obsequies of a Great Deaf Man* (*Marche Funèbre composée pour les funerailles d'un grand homme sourd*). Accompanying the silent composition was the following note: "Great sorrows being mute, the performers should occupy themselves with the sole task of counting the bars, instead of indulging in the kind of indecent row that destroys the august character of the best obsequies."[33] The tempo? *Lento rigolando* (slowly, jesting). One should never play nothing too fast.

A similarly playful spirit undergirds a number of works by the twentieth-century Czech composer Erwin Schulhoff. Performances of his Dadaist composition *Sonata Erotica for Solo Mother-Trumpet* (*Sonata erotica für Solo-Müttertrompete*, 1919), for example, require a soprano to spend "several minutes faking a carefully notated orgasm."[34] In the same year, Schulhoff composed *Five Picturesques* (*Fünf Pittoresken*), a piece for piano in five movements. The third movement, "In Futurum," is completely silent. A note admonishes the pianist to perform the silence "with as much expression and feeling as you like, always, right to the end!" (*tutto il canzone con espressione e sentimento ad libitum, sempre, sin al fine!*)[35] The score also includes what appear to be smiley faces, suggesting that Schulhoff, like Allais, had his tongue firmly in his cheek. Unlike Allais's blank measures, however, Schulhoff's score is absurdly complex. In addition to asking the pianist to use 3/5 time for one hand and 7/10 time for the other, Schulhoff mischievously litters his score with a bewildering range of symbols, including long rests, short rests, fermatas, exclamation marks, and question marks.

And then, of course, there is the American composer John Cage, whose *4′33″* (1952) has attracted far more noise than any other silence. For the premiere performance in Woodstock, New York, the musician David Tudor sat at a piano and closed the lid. He then sat in front of his piano with a Stoic expression and barely moved for approximately four and a half minutes. (A minor exception: Tudor opened and closed the lid twice to mark the beginnings of the second and third movements.) One of the central insights of Cage's *4′33″* is the fact that absolute silence is impossible. As Cage puts it, "There's no such thing as silence. What they thought was silence [in *4′33″*], because they didn't know how to listen, was full of accidental sounds. You could hear the wind stirring outside during the first movement [in the premiere]. During the second, raindrops began pattering the roof, and during the third the people themselves made all kinds of interesting sounds as they talked or walked out."[36] In other words, *4′33″* is a radically aleatory work, an experiment in indeterminacy in which the random sounds of the audience and their environment become a musical performance. For Cage, such compositions were "not an attempt to bring order out of chaos nor to suggest improvements in creation, but simply a way of waking up to the very life we're living."[37] And responses to this "waking up" vary wildly. As Craig Dworkin notes, "The audience attending a performance of John Cage's notorious *4′33″* . . . might feel cheated, or deprived of hearing a virtuoso musician play an instrument; but they might also feel liberated and promoted by the reversal that puts them effectively on stage, making them responsible for the sounds they would normally attempt to suppress and ignore in other concert settings."[38]

Was Cage simply copying the earlier silences of Allais and Schulhoff? No. To begin, there is no reason to believe that Cage was even *aware* of these arcane experiments. In a letter from

July 22, 1989, Cage explained that while he was familiar with Alphonse Allais, he did not know about Allais's *Funeral March for the Obsequies of a Great Deaf Man* when he composed *4'33"*.[39] I suspect that Cage was also unfamiliar with Schulhoff's "In Futurum" at this time. After all, "In Futurum" has always been obscure, and as far as I can tell, Cage never mentions Schulhoff in his interviews or writings. (Keep in mind that Cage was generally quite eager to discuss the artists and composers who influenced him, such as Satie, Duchamp, and Rauschenberg.) But even if Cage *had* been familiar with *Funeral March* and "In Futurum," his silence was still fundamentally different. Allais's *Funeral March* was essentially an April fool's prank. (This is not a criticism, of course. Like the best pranks, *Funeral March* is witty and thought-provoking.) Allais was a writer, not a composer, and it is not clear that he actually expected his composition to be performed. It seems more likely that he simply expected readers of his *April Fool's Album* to giggle at his playful provocation before turning the page and moving on to the next prank. This was far from the case with Cage, however. Not only did Cage insist that *4'33"* be *performed*, but he also viewed the work as a serious composition.[40] And *4'33"* is just as distinct from "In Futurum," which is a silent *movement* bookended by music. Schulhoff's two minutes of silence can be understood as an extended rest in the center of an intricate and noisy composition. *4'33"*, however, stands alone. Cage's silence is not *part* of a composition—it *is* the composition. Furthermore, while "In Futurum" is a Dadaist provocation, a scandalous subversion of audience expectations, *4'33"* is the expression of a carefully articulated philosophy of chance, indeterminacy, and Zen emptiness. There are an infinite number of silences. To the careful listener, silence is just as diverse and multifaceted as any other phenomenon—sonic or otherwise.[41]

LITERARY LACUNAE

What I would like to create is a book about nothing.

—Gustave Flaubert

In the domain of literature, the great purveyor of absence is Samuel Beckett. In his magnum opus, *Waiting for Godot*, five characters wander around a vacant landscape, complaining—with some justification—that "nothing happens, nobody comes, nobody goes."[42] Beckett's next play, *Act Without Words I* (1957), features only a single character (and, as the title indicates, no dialogue). The following decade, Beckett would write *Breath* (1969), a play with no characters at all—only a depopulated stage haunted by the sounds of breathing and crying. Throughout his career, the Irish avant-gardist kept condensing his theatrical works until they were barely there. He worked under the conviction that "the perfect play was one in which there were no actors."[43] In fact, Beckett's rigorously minimalist aesthetic was the inspiration for a 2006 parody in the *Onion* entitled "Scholars Discover 23 Blank Pages That May As Well Be Lost Samuel Beckett Play." The article quotes a (nonexistent) scholar of Irish literature named Fintan O'Donoghue on the "discovery": "In what was surely a conscious decision by Mr. Beckett, the white, uniform, non-ruled pages, which symbolize the starkness and emptiness of life, were left unbound, unmarked, and untouched. And, as if to further exemplify the anonymity and facelessness of twentieth-century man, they were found, of all places, between other sheets of paper."[44]

Though the *Onion* posits blank pages as the *reductio ad absurdum* of experimental literature, it is a gesture with a surprisingly rich and varied history. In 1913 the Russian Futurist Vasilisk Gnedov published a poem that is nothing more than a

title—"Poem of the End" (*Poema Kontsa*)—on a blank page. Gnedov would occasionally "read" this poem to audiences by walking on stage, making a gesture, and then sitting down. According to one spectator, Gnedov moved his hand from left to right and back again "so that one movement nullified the other and represented, symbolically, a self-erasure." These silent poetry readings were reportedly greeted with "stormy applause."[45] And Gnedov was hardly the only avant-gardist in early twentieth-century Russia with an investment in silence. At roughly the same time that Gnedov published "Poem of the End," a Russian Dada group called the Nothingists gave the following advice to authors: "Write nothing! Read nothing! Say nothing! Print nothing!"[46]

In Paris in 1924, the American expatriate Man Ray also decided to "write nothing." He composed a wordless poem for the magazine *391* that appeared on the same page as a drawing by Francis Picabia and a series of aphorisms by Erik Satie. Man Ray's untitled "dumb poem" features no language, only a series of thick lines—as if all the text of the poem (including its title) had been redacted. (An earlier dumb poem by Man Ray also makes a brief appearance in his film *Return to Reason* [*Le Retour à la raison*, 1923], where it functions as a useless intertitle.) The work of "degenerate" artists was often censored by totalitarian governments. Was Man Ray creating a poem that could not be censored by authorities, since it had already been censored by its own author? Or was he teasing readers with a poem that looks like it was written in Morse code? (Those with the patience to "translate" the poem's dots and dashes into language will discover only gibberish.)[47] Then again, perhaps attempts to "decode" the dumb poem are missing the point. When Man Ray's fellow Surrealists Luis Buñuel and Salvador Dalí made *Un Chien Andalou* (*An Andalusian Dog*, 1929), Buñuel adamantly asserted

that "NOTHING, in the film, SYMBOLIZES ANYTHING."[48] What if Man Ray had similarly produced a *poem* that had been drained of meaning and symbolism?

A number of additional literary voids have emerged from Oulipo (short for *Ouvroir de littérature potentielle*, or Workshop for Potential Literature), a group of authors who follow self-imposed restrictions when writing texts. (Oulipo was formed in Paris in 1960 by Raymond Queneau and François Le Lionnais; Marcel Duchamp joined the group two years later.) These restrictions often took the form of absences. For example, Georges Perec's *La Disparition* (*The Disappearance*) (1969) is a three-hundred-page novel about a missing person that is written without ever using the letter *e*, the most frequently used vowel in French (and English).[49] The Oulipo writer Paul Fournel goes further still in *Suburbia* (*Banlieue*, 1990) by banishing every other letter of the alphabet as well, thus creating a wordless novel. Even if *Suburbia* consists of blank pages, however, these voids are "framed" by paratextual elements, such as a table of contents, a foreword, footnotes, and an index. (Fournel even includes supplemental questions for educational purposes, such as "What can outskirts teach us about a centre?" and "Would you describe the text of this book as 'well written'?") The cover page boasts that this version of the novel is "UNCENSORED!" (although it is hard to imagine how a censored version of a wordless novel would look any different from the original). Still, the exclamation "UNCENSORED!" makes the reader suspect that the novel's invisible text is edgy and provocative, and this suspicion is confirmed by Fournel's footnotes, which are peppered with references to "obscene gesture[s]," "violent eroticism," "genital organs," and "drugs."[50] When one "reads" *Suburbia*, one inevitably projects a risqué narrative on Fournel's blank pages. A literary absence (like any other absence) can suggest just about

anything: the death of art and poetry (Gnedov), the rejection of "meaning" (Man Ray), existential anguish in a Godless cosmos (Beckett), or the absurdity of censorship (Fournel). Beckett is hardly the only writer who has sought to create a "literature of the unword."[51]

FILMIC ABSENCE

The most important thing to do in film now is to find a way for it to include invisibility, just as music already enjoys inaudibility (silence).

—John Cage, "On Film"

Before exploring the concept of cinematic absence, it is worth reflecting on the nature of cinematic presence. What does it mean for someone (or something) to be present in a film? André Bazin gives this question careful consideration in the second part of his essay "Theater and Cinema" (1951). For Bazin, while theater is unambiguously an art form of presence (that is, an actor is *here*, on the stage, "in flesh and blood"), art forms such as portraiture, photography, television, and cinema have a more complicated ontology.[52] This is because, as Bazin astutely notes, *presence* is a term that is fraught with ambiguity. To say, for example, that one is in the presence of Charlie Chaplin could mean that one is watching a young Charlie perform a live vaudeville routine on a London stage in 1907, but it could also mean that one is attending a screening of his film *Limelight* (1952). (In fact, Chaplin could be present in both senses. At the London premiere of *Limelight*, for instance, he was both on the screen and in the audience.)[53] For Bazin, cinematic presence is interstitial. Chaplin *is* present in his films, but these presences are "pseudopresences,"

"intermediaries between actual physical presence and absence." Bazin elaborates: "It is false to say that the screen is incapable of putting us 'in the presence of' the actor. It does so in the same way as a mirror . . . but it is a mirror with a delayed reflection, the tin foil which retains the image."[54] The image of Chaplin in a mirror or on a cinema screen is not the "flesh and blood" man himself, yet Chaplin remains provisionally present. In other words, in cinema even that which is present is absent. When I watch a Chaplin film, I do not really see Chaplin in the flesh: I see a reflection, an index, a representation. (As the artist René Magritte might have put it, "Ceci n'est pas Chaplin.")

The films that I will be investigating in this book often withhold even these "pseudopresences," however. Take, for example, *removed* (1999) (discussed in greater detail in chapter 3), in which filmmaker Naomi Uman erases the women from an old pornographic film using nail polish and bleach. While it is trivially true that these women are not present "in flesh and blood," what is most striking is the fact that they are not even present *on the screen.* They have been effaced from the film itself—and replaced by shimmering white voids. In other words, the central filmic texts that I analyze in this monograph all deprive spectators of images and sounds that seem like they *should* be there. Timothy Walsh calls such gaps "structured absences," ones to which a work "specifically calls attention."[55] And such structured absences have been remarkably common in the history of experimental film.

Consider, for instance, the French avant-garde movement Lettrism. (The appellation is etymologically derived from *letter*, suggesting the importance that the group's members placed on language and other symbolic systems.) While Lettrism was founded by Isidore Isou and Gabriel Pomerand in 1940s Paris as a poetry movement, by the early 1950s a number of the group's

adherents were experimenting with radically austere films, such as Isou's *Treatise on Drool and Eternity* (*Traité de bave et d'éternité*, 1951). *Treatise* was scheduled to be screened at the Cannes Film Festival on April 20, 1951, but a problem arose: when April 20 arrived, Isou had not yet completed the film's image track. This did not deter the young iconoclast, however. For most of the work's duration, Isou simply paired his completed sound track with an imageless screen. Unsurprisingly, many audience members became enraged at the prospect of watching a feature-length film in darkness, with nothing to actually *watch*. Jean Cocteau attempted to pacify the crowd by telling them that "an unusual ambience is always invigorating."[56] After this scandalous event, a number of other Lettrists began to create their own imageless films. On May 4, 1952, Cannes screened the premiere of François Dufrêne's *Drums of the First Judgment* (*Tambours du jugement premier*): a "live sound film with no visual images."[57] This "imaginary film" consisted of four Lettrists (François Dufrêne, Guy Debord, Gil J. Wolman, and Marc'O) standing in the four corners of a movie theater with flashlights and scripts, singing and reciting poetry.[58] The following month Guy Debord's first film, the seventy-five-minute film *Howls for Sade* (*Hurlements en faveur de Sade*), premiered at the Ciné-Club d'Avant-Gardes at the Musée de l'Homme in Paris. *Howls for Sade* alternates between white screens (which are accompanied by fragments of spoken language) and black screens (which are accompanied by silence). The language in *Howls for Sade* is often self-referential, commenting on the film's visual and auditory voids. At one point, a voice claims that Debord was supposed to make the following introductory remarks: "There is no film. Cinema is dead. No more films are possible."[59] (Notice how this assertion about the death of cinema mirrors the title of Vasilisk Gnedov's pamphlet

of poetry, *Death to Art*.) Another voice in *Howls for Sade* (that of Barbara Rosenthal) notes that, in spite of the title, "no one talks about Sade in this film." (Of course, by making this observation, Rosenthal paradoxically *does* talk about Sade, thus contradicting her own assertion.) In an uncompromising critique of what Debord would later call the "society of the spectacle," *Howls for Sade* concludes with twenty-four minutes of silence and blackness.[60]

In 1964 the Korean-American Fluxus artist Nam June Paik produced a more contemplative cinematic void. Unlike the noisy provocations of the Lettrists, Paik's *Zen for Film* (1962–1964) is both silent and imageless for its entire duration. (Depending on which version one sees, the film's running time can be a mere eight minutes or a full hour. It is also sometimes projected as an endless loop.) *Zen for Film* consists of nothing more than clear leader running through a projector, resulting in an imageless white screen, and the effects of this experiment in sensory deprivation are striking. For some spectators, the empty rectangle prompts them to redirect their attention to the projected beam of light, which becomes a light sculpture (not unlike Anthony McCall's *Line Describing a Cone* [1973]). For others, the white screen itself becomes the object of attention. These spectators often become absorbed in the aleatory "imperfections" of the filmstrip: scratches, splotches, dust motes. Consider, for example, John Cage's description of *Zen for Film*:

> It's an hour long and you see the dust on the film and on the camera and on the lens of the projector. That dust actually moves and creates different shapes. The specks of dust become, as you look at the film, extremely comic. They take on character and they take on a kind of plot—whether this speck of dust will meet that

speck. And if they do, what happens? I remember being greatly entertained and preferring it really to any film I've ever seen before or after. It's one of the great films, and it's not often available to see.[61]

And just as the blankness of *Zen for Film* permits one to notice elements that generally go undetected in other films (such as scratches and dust), the film's silence permits one to hear the environmental sounds that are normally drowned out by a film's soundtrack. Craig Dworkin gives the following advice for those preparing to watch *Zen for Film*: "If you get a chance, sit near the projectionist; even after only eight minutes you'll never forget the nervous clack and twitter of the shutter, blinking like a blinded Cyclops in the noonday sun."[62]

As a film with neither imagery nor sound, *Zen for Film* seems to push cinematic absence to its limits. But the Austrian experimental filmmaker Ernst Schmidt, Jr., arguably goes even further with his obscure but fascinating film *White* (*Weiß*, 1968). Like *Zen for Film*, *White* is a silent, imageless film that uses clear leader to project a white rectangle of light. There are some notable differences, however. *White* only lasts for about a minute and is thus briefer than *Zen for Film*. Additionally, unlike *Zen for Film*, *White*'s void is intermittently punctuated by circular shapes that appear and disappear with startling rapidity. To achieve this effect, Schmidt repeatedly punctured the filmstrip with an office hole-punch. When watching *White*, one is struck by the fact that the holes appear to be just as damaged and grungy as the rest of the film. This is an illusion, of course. When one views *White* on DVD and pauses at a relevant moment, it becomes clear that the holes are pristine in their whiteness. The fact that they *appear* dirty and scratched is the result of their instantaneity. As the filmstrip rushes through the projector at twenty-four frames per

second, the white holes and their surroundings begin to merge. The fact that Schmidt's filmic void is intermittently populated by circular forms might lead some to link *White* with abstract films like Hans Richter's *Rhythmus 21* (1921) and Oskar Fischinger's *Circles* (*Kreise*, 1933). But it is also worth emphasizing that Schmidt's forms are not presences (drawings, objects, computer-generated images) but absences. If we initially perceive an imageless white screen to be an absence (as we do in *Zen for Film*), Schmidt manufactures an absence within this absence. In other words, he reminds us that what we think is an absence (a blank white screen) is actually an index of a presence (a physical strip of celluloid).

The experiments of the Lettrists, Paik, and Schmidt are just a small sample of the filmic voids that have proliferated within the cinematic avant-garde. There are thousands of films that exploit blank screens, silences, holes, erasures, and other forms of absence. In this book I will attempt to direct attention to some potential functions of cinematic voids by giving close attention to four films that exploit absence in especially compelling ways: Walter Ruttmann's *Weekend* (1930) (a film without images), Stan Brakhage's *Window Water Baby Moving* (1959) (a film without sound), Naomi Uman's *removed* (1999) (a work that erases images from a preexisting film), and Martin Arnold's *Deanimated* (2002) (a work that erases both images *and* sounds from a preexisting film). My curation here may appear rather eclectic: a German city symphony from the 1930s, an American lyrical film from the 1950s, an American found footage film from the 1990s, and an Austrian found footage film from the 2000s. But this eclecticism is by design. The diversity of times and places discussed foregrounds the way that absence has repeatedly manifested itself throughout film history. And the specific films I have selected all exemplify the richness and power of cinematic absence more

broadly. In other words, this book is not simply an analysis of four rather obscure and idiosyncratic films (although it is that). It is also an attempt to think through the importance of the *unseen* and *unheard* in cinema more broadly. The vast majority of film critics and theorists have focused on analyzing what is *present* in a film: its images, its words, its sounds. This is unquestionably a valuable approach. But I argue that it can be equally illuminating to consider what is *absent* from a film: its omissions, erasures, and silences. By expanding our perspective on cinema to encompass both the visible *and* the invisible, the audible *and* the inaudible, we gain a richer sense of film's ontology and its aesthetic possibilities.

A NOTE ON METHODOLOGY

The invisible is there *without being an* object.
—Maurice Merleau-Ponty, "Working Notes"

In this book I try to not to approach cinematic voids with any kind of a priori methodological commitment. Rather, my goal is to use whatever conceptual tools seem most useful in thinking through each cinematic experiment, whether those tools come from film theory, philosophy, neuroscience, or some other field. That said, there are a number of specific analytic strategies that I have found especially valuable. In what follows, I will articulate a few of these strategies and explain why they are crucial for my project.

One of the central questions I want to answer is this: What effects do cinematic absences have on audiences? Of course, one way of answering this question involves introspection. In my research, I attempt to pay close attention to my own subjective

responses to films without imagery, films without sound, and so on. But I am also interested in the responses of others. Since many of the films I write about are relatively obscure, descriptions of how these works affected individual film critics can be difficult to come by (although when such descriptions *are* available, I generally include them and think through their implications). But this dearth of critical voices need not limit me to a sample size of one. I am fortunate enough to teach classes in experimental cinema, which means that I have screened the films I analyze in this book for hundreds of students, many of whom have shared their responses in class discussions and critical essays. I take these responses seriously. When, for example, a large number of students look around uncomfortably while watching an imageless film (and when this happens in class after class), it becomes clear that the black cinema screen has the power to disorient and disturb. When dozens of students tell me that, when watching a completely silent film by Stan Brakhage, they became more aware of the sounds they themselves were making (breathing, fidgeting, yawning), it becomes clear that cinematic silence can heighten an audience's awareness of their immediate surroundings. None of this is to posit a "universal spectator" or to suggest that these responses would be shared by *any* audience. Rather, such accounts suggest some of the many potential effects of cinematic absence. My autobiographical and anecdotal approach to film studies has been shaped, in part, by the work of the film phenomenologist Vivian Sobchack. While Sobchack is keenly aware that some dismiss autobiography and anecdote as "a fuzzy and subjective substitute for rigorous and objective analysis," she persuasively argues that giving attention to "particular (and sometimes personal)" experiences with specific films can "open up (rather than close down)" our understanding of the cinematic encounter.[63]

Along similar lines, this book uses autobiographical and anecdotal accounts to "open up" new ways of thinking about cinematic absence—and its potential effects on spectators.

Another methodology that is important to my analysis is the use of counterfactual thought experiments. Absence can only be understood in contrast to what *might have been present*. For instance, when thinking about the effects of a film's lack of sound, it is imperative to think about how the film would have been different if it did have sound. How might one's experience of that film's imagery change if one were hearing sound effects, or words, or music? Only by imagining how one might respond to the *presence* of these elements can one truly appreciate the effect of their *absence*. In fact, I would argue that a sophisticated appreciation of *any* film, art work, literary work, or piece of music involves paying attention not only to what is there but to what is *not* there. In the words of Thelonious Monk, "What you <u>don't</u> play can be more important than what you <u>do</u>."[64]

I should also note that my approach is both intertextual and interdisciplinary. In other words, while each chapter of this book focuses on a specific film, I trace out parallels between these films and related explorations of absence in other media. At times this approach foregrounds the influence that one artist has had on another. At other times it suggests that artists in different times and places often stumble on similar aesthetic strategies. In any case, I attempt to conceptualize the films in question not as isolated curios but as nodes in a vast intertextual network, a conversation that has been taking place in the avant-garde throughout the twentieth and twenty-first centuries.

Chapter 1 will unearth the aesthetic potential of films without images by giving careful consideration to *Weekend*. In this intermedia experiment, the German artist Walter Ruttmann pairs an imageless cinema screen with the sounds of Berlin:

voices, sirens, birds, buses. I argue that by privileging sound over vision, *Weekend* reorients the human sensorium and undermines ocularcentric conceptions of cinema. I also explore the aesthetic affinities that *Weekend* shares with twentieth-century musical compositions that traffic in quotidian sounds, such as Luigi Russolo's *Awakening of a City* (*Risveglio di una città*, 1913) and Pierre Schaeffer's *Railroad Study* (*Étude aux chemins de fer*, 1948).

Chapter 2 analyzes films without sound. The center of gravity here is not "silent cinema" (that is, films made between 1894 and 1929) but films made during the sound era that were designed to be purely visual experiences, without sound effects or musical accompaniment of any kind. The most visible and vocal proponent of this aesthetic was the American experimental filmmaker Stan Brakhage. To better understand Brakhage's use of silence, I explore his relationship with his mentor John Cage. I also engage in a close reading of his landmark film *Window Water Baby Moving*, an experimental documentary about the birth of his first child, as a way of outlining some of the effects of cinematic silence, such as aesthetic ambiguity and a heightened awareness of cinema's visual rhythms.

In chapter 3 I critically examine Naomi Uman's *removed*, a subversive experiment in which nail polish and bleach are used to erase the women from a German pornographic film of the 1970s. While spectators of *removed* still *hear* women moaning orgasmically and delivering histrionic lines of dialogue, these women are no longer visible, as they have been replaced by unstable and jittery white holes. I argue that *removed* foregrounds the centrality of both scopophilia (the pleasure derived from looking) and phonophilia (the pleasure derived from hearing) in the cinematic encounter. I also argue that *removed* exploits what the neuroscientist V. S. Ramachandran has called "the peekaboo principle," a quirk of human psychology that tends to make

content more alluring when it is less visible. In so doing, *removed* demonstrates the power of absence to intensify eroticism.

The fourth chapter also investigates found footage cinema, but in this case special consideration is given to digital manipulations, such as those carried out by the Austrian avant-gardist Martin Arnold in his film *Deanimated*. In this strange and witty work, characters, objects, lines of dialogue, and more are digitally erased from the Hollywood horror film *Invisible Ghost* (Joseph H. Lewis, 1941), starring Bela Lugosi. While the white splotches in Uman's *removed* make it obvious that elements of the source material had been erased, the smooth digital elisions of Arnold's practice make it difficult to discern how the original film was modified, thus producing an ambiguous and mysterious phenomenological encounter. I conceptualize *Deanimated* as a nexus of cinematic voids, including silence, emptiness, and blackness. Additionally, I argue that *Deanimated* demonstrates the aesthetic force of the Buddhist concept of *sunyata*, or emptiness, in which absence is understood not as a mere lack but as an experience of radical openness.

1

WALTER RUTTMANN AND THE BLIND FILM

Wherever we are, what we hear is mostly noise. When we ignore it, it disturbs us. When we listen to it, we find it fascinating.

—John Cage, *Silence*

The darkness that I like is the darkness of a movie theater.

—Anouk de Clercq, *Black* (2015)

L uis Buñuel and Salvador Dalí were no strangers to scandal. In their first film, *Un Chien Andalou* (*An Andalusian Dog*, 1929), the mischievous Surrealists assaulted spectators with a barrage of shocking and disturbing images: a razorblade slicing open an eyeball, a man fondling a woman's bare breasts as blood pours out of his mouth, two corpses buried in sand at the beach. Yet, somehow, Buñuel and Dalí's second film, *L'Age d'Or* (*The Golden Age*, 1930) (1930), was even more provocative. In it, a father shoots his son, a man's fingers are bitten off by his lover, a woman fellates the toes of a statue, and Jesus Christ makes a cameo appearance as a pedophile and

rapist. Critics denounced the film as "a criminal heresy" and "bolshevik excrement," and at a Paris screening on December 3, 1930, it provoked a riot.[1] Right-wing extremists began beating members of the audience with blackjacks, setting off smoke bombs, vandalizing priceless paintings by Dalí, Ernst, Man Ray, Miró, and Tanguy in the lobby, and crying out, "Death to the Jews!" (even though Buñuel and Dalí were not Jewish).[2] Shortly after this incident, the theater that screened the film was closed down and the film itself was banned for fifty years. (It was not shown again in Paris until 1981.) As for the rioters themselves, only a handful were arrested, and they were released shortly thereafter. Many Parisian authorities saw the violent reaction as defensible. As a December 10 column in *Le Figaro* put it, "The demonstrations and protests triggered by *L'Age d'Or* were not merely legitimate. They appear as the instinctive defense of honest men against an undertaking in which I do not hesitate to discern a Satanic influence."[3]

This scandal foregrounds a number of unsettling facts, from the rabid anti-Semitism that spread through Europe in the 1930s to the pervasiveness of film censorship throughout much of the twentieth century. I want to direct attention, however, to a less salient element of the *L'Age d'Or* riot: the tactics embraced by the Fascist mob. In addition to the aforementioned blackjacks and smoke bombs, at the sacrilegious moment when a monstrance is placed in a gutter, the rioters hurled purple ink at the screen. This is interesting for a number of reasons. To begin, if one were to splash purple ink on, say, Salvador Dalí's painting *The Great Masturbator* (1929), one would effectively destroy the artwork (and, of course, a number of Surrealist paintings *were* destroyed by the philistine mob that evening). But when ink is splashed on a movie screen, the film itself remains unharmed; it continues to circulate unmolested through the projector. Why hurl ink at

the screen on which the film is projected rather than destroying the film itself? The purple ink is interesting for another reason: *L'Age d'Or* is a talkie, one that exploits highly complex sound-image relationships. To erase the film's image does nothing to suppress its sound track: the music from Wagner's *Tristan und Isolde* (1859), the crackling of a fire, the sound of a horse-drawn cart that barrels through a bourgeois dinner party for no apparent reason.[4]

Just a few days before the Parisian mob attempted to turn *L'Age d'Or* into an imageless film, an *intentionally* imageless film was screened at the 2nd International Congress of Independent Film in Brussels, an event that took place from November 27 through December 1, 1930. The imageless film was Walter Ruttmann's eleven-minute intermedia experiment *Weekend* (*Wochenende*). To create this work, Ruttmann wandered through Berlin with a Tri-Ergon film camera and recorded his surroundings without ever removing the camera's lens cap.[5] Rather than using celluloid to record imagery, Ruttmann used it to record a multifarious assemblage of ambient city sounds, including industrial machines, marching bands, bells, voices, and sirens. He then synthesized these sounds with others produced at the Tri-Ergon Music Company's studio to produce a complex and textured sound collage with no visual accompaniment. *Weekend* was broadcast on the radio on June 13, 1930—in fact, it had originally been commissioned by Berlin Radio Hour—but the work was also subsequently screened in movie theaters. And *Weekend's* complicated categorical status persists to this day, when the work can be purchased on DVD (as a film with a black screen) and on CD (as a kind of musical composition).[6] Nevertheless, Ruttmann frequently described *Weekend* in distinctly cinematic terms: he called it "cinema for the ears" and "a blind film."[7] If a right-wing mob attended a screening of *Weekend* in 1930 and wanted

to protest the film, would they still throw ink at the imageless screen? And if they did so, would the other members of the audience miss anything?

In my previous book, *Motion(less) Pictures: The Cinema of Stasis*, I coined the term *monochrome films* to describe cinematic works that "exploit the affective intensity of the empty screen."[8] Giving especially close attention to Derek Jarman's *Blue* (1993), I explored the ways that monochrome films can heighten one's awareness of specific colors, sounds, and bodily processes. In this chapter I instead focus on the ways that these experiments can challenge our intuitions about the very nature of cinema, which has long been theorized as a multisensory medium, one predicated on the interaction of imagery and sound. By removing vision from the cinematic sensory regime, *Weekend* reorients the human sensorium, providing an opportunity to lose oneself in "a sea of sounds."[9] I also situate *Weekend* in the context of twentieth-century music history, arguing that Ruttmann has profound affinities with avant-garde composers like Luigi Russolo and Pierre Schaeffer since all three manipulate quotidian sounds in an attempt to create an art of noises.

SOUND AS AN END IN ITSELF

Listening makes the invisible present.

—Don Ihde, "The Auditory Dimension"

Walter Ruttmann is one of the most innovative and daring filmmakers in cinema history. His animated *Lichtspiel* (*Lightplay*) films—*Opus I* (1921), *Opus II* (1923), *Opus III* (1924), and *Opus IV* (1925)—are among the first abstract films ever made: colorful

and carefully choreographed dances between rigid geometric shapes and sensuous blobs.[10] (One might think that the lack of representational content in Ruttmann's early films would have helped him to avoid the kind of controversy courted by the salacious Surrealists, but one would be mistaken. *Lichtspiel: Opus II* was rated X by the Munich film censor owing to a concern that it "might induce hypnotic states"; it was also accused of arousing "lust" by exploiting "strong erotic associations.")[11] Ruttmann's *Berlin: Symphony of a Great City* (*Berlin: Die Sinfonie der Großstadt*, 1927), a key work in the city symphony genre, is a rhythmic and vibrant documentary that captures the vitality of urban life in the 1920s. And his *Melody of the World* (*Melodie der Welt*, 1929), Germany's first feature-length sound film, synthesizes footage of traditions and customs from all over the world in a hymn to both the unity and the diversity of the human race. Unfortunately, after making this ostensibly progressive and cosmopolitan film, Ruttmann would go on to contribute his talents to reactionary propaganda, such as the anti-Semitic, anti-miscegenation film *Blood and Soil* (*Blut und boden*, 1933), and the pro-Nazi *Triumph of the Will* (*Triumph des Willens*, 1935), on which Ruttmann collaborated with Leni Riefenstahl.[12]

As forward-thinking and experimental as his films of the 1920s are, *Weekend* is Ruttmann's most formally radical film. In fact, it is one of the most formally radical films ever made. Discussions of imageless films tend to begin with works from the 1950s or 1960s, such as Guy Debord's *Howls for Sade* (*Hurlements en faveur de Sade*) (1952), Peter Kubelka's *Arnulf Rainer* (1960), or Nam June Paik's *Zen for Film* (1962–1964).[13] Even though *Weekend* predates any of these works by decades, it has received relatively scant scholarly attention, and thus Ruttmann has gone unrecognized in most discussions of what Herman Asselberghs

has called "*cinéma du pauvre*."[14] As a result of *Weekend*'s marginalization, there is a great deal that is currently unknown about the film. For example, what would the audience at the 2nd International Congress of Independent Film in Brussels have seen? Presumably they would have seen an imageless screen. But would the screen have been blank or black? The question is a complex one since, in order to broadcast *Weekend* on the radio, it was necessary to copy the work to a gramophone record. It is possible that the 1930 "screening" of *Weekend* in Brussels (as well as subsequent screenings in movie theaters in Berlin in 1931) simply involved playing a record to an audience in a theatrical space. In this case, the screen would have been blank, with nothing (not even blackness) being projected onto it. But it is also possible that the filmstrip was used and that the film was *projected*, resulting in a solid black rectangle. If this were the case, the visual experience of the film would have been rather different. The audience may well have witnessed the imperfections of the celluloid—such as white specks and scratches—punctuating the blackness at random intervals. What is more, a black screen might have caused audience members to think that there would ultimately be a visual component of the film, one that simply had not started yet. Or the audience might have even supposed that something had broken down, and that they were experiencing only part of Ruttmann's film. Since there is so little data on the theatrical screenings of *Weekend*, much of the film's history remains shrouded in mystery.[15]

However *Weekend* might have been projected, the film has had a powerful effect on audiences. It has been called "stunning," "thrilling," and "alive with meaning."[16] Particularly noteworthy is the verdict of the German avant-gardist Hans Richter, who, along with Ruttmann, created some of the earliest abstract films. Richter proclaimed *Weekend* a "masterpiece" and asserted, "If I

had to choose between all of Ruttmann's works, I would give this one the prize as the most inspired."[17] Such accolades are normally reserved for Ruttmann's most famous film, *Berlin: Symphony of a Great City*, another work that attempts to capture the zeitgeist of Berlin in the early twentieth century. There is, of course, a crucial difference between the two films: *Berlin* foregrounds the *sights* of the great city, whereas *Weekend* foregrounds its *sounds*, from the pastoral soundscapes of the countryside to the industrial cacophony of cars, marching bands, and sirens. It is obvious why Ruttmann did not include sound in *Berlin*: synchronized sound was not yet available to filmmakers. (Alan Crosland's landmark talkie, *The Jazz Singer* [1927], would be released two weeks after the German premiere of *Berlin*.) But synchronized sound clearly *was* an option when Ruttmann created *Weekend*. What are we to make of Ruttmann's odd experiment with sensory deprivation? Why eliminate sight from the cinematic sensory regime?

To begin answering these questions, it is useful to consider an essay that Ruttmann wrote in 1928 entitled "Principles of the Sound Film." In this essay Ruttmann expresses concerns about how the new technology of cinematic sound might be used, but he also expresses excitement about its "great possibilities." In Ruttmann's view, cinematic sound should not be used as a mere supplement for moving imagery; rather, it should be used to develop a radically new art form: "It would be utterly wrong to see [sound film] as a simple augmentation of silent film. It is not sound film's task to give voice to silent film. It must be clear from the outset that its laws have almost nothing to do with those of soundless film. A completely new situation is evolving here."[18] *Weekend* represents Ruttmann's attempt to find a "completely new" use for cinematic sound. Rather than being a mere extension of a preexisting cinematic image, sound could instead prompt

spectators to imagine their own imagery on an empty screen in front of them.

Of course, Ruttmann was far from the only filmmaker to imagine novel approaches to cinematic sound. By the time *Weekend* was released in 1930, sound films had become ubiquitous, and the rise of synchronized sound had become a genuine cause of concern for many filmmakers, most notably Sergei Eisenstein. In his famous statement on sound films, written with Vsevolod Pudovkin and Grigori Aleksandrov less than a month before Ruttmann's own "Principles of the Sound Film," Eisenstein worries that cinematic sound "will proceed on a naturalistic level, exactly corresponding with the movement on the screen, and providing a certain 'illusion' of talking people, of audible objects, etc." He fears that this audiovisual complementarity will "destroy the culture of montage" and reduce cinema to a series of a filmed theatrical "performances." To counter this trend, Eisenstein instead advocates a "CONTRAPUNTAL USE of sound," one that would exploit the creative potential of "NONSYNCHRONIZATION."[19] The fact that Ruttmann shared Eisenstein's commitment to audiovisual counterpoint is made clear in another essay that he wrote in the late 1920s entitled "Sound Films?-!" In this essay Ruttmann writes, "The only possible way to make a sound film is by using counterpoint. This means that the picture on the screen cannot be intensified and augmented by sound which runs parallel to it. To do that would mean nothing less than an undermining of the work, in much the same way that repeated protestations of innocence do exactly the opposite of what they are intended to do."[20] Ruttmann goes on to give specific examples of the kind of counterpoint he is advocating:

You hear: an explosion. You see: a woman's horrified face.
You see: a boxing match. You hear: a frenzied crowd.

You hear: a plaintive violin. You see: one hand tenderly stroking another.

You hear: a word. You see: the effect of the word in the face of the other person.[21]

One wonders if Eisenstein would have approved of Ruttmann's examples—and if he would have also seen them as contrapuntal rather than complementary. After all, Eisenstein and his comrades argue that sound should be "divorced" from the image so as to produce an "attack," a sharp dialectic between sight and sound.[22] There is nothing particularly disjunctive about pairing the sound of an explosion with a woman's horrified face. It would surely be much more jarring for the sound of an explosion to be paired with, say, a woman dancing—or for a woman's horrified face to be paired with the sound of a young boy saying, "I love you, Mommy." This is why Michael Cowan has argued that "where Eisenstein saw counterpoint as a means of making palpable the dialectical conflict at the heart of film technology and film form, Ruttmann's counterpoint constructions . . . tend toward the analogical."[23] Nevertheless, it is clear that Eisenstein and Ruttmann both share a suspicion of sustained audiovisual convergences, ones that consistently and unthinkingly pair the image of an explosion with the sound of an explosion.

To work through the various ways that sound can relate to imagery in cinema, it will be useful to extend Eisenstein's "divorce" metaphor. I would argue that films can exploit at least three distinct audiovisual relationships: The first is *marriage*. When a sound and image are married, what you see is what you hear and vice versa. (You hear: an explosion. You see: an explosion.) The second is *divorce*. When a sound and an image are divorced from each other, the two seem to be radically dissociated. (You hear: an explosion. You see: a woman dancing.) And

the third is *separation*. This intermediate state is what Ruttmann calls "counterpoint" in his "Sound Films?-!" essay. Here there is a relationship between the sound and the image (they are not entirely dissociated), but this relationship is not a simple one-to-one correspondence. (To quote Ruttmann: "You hear: an explosion. You see: a woman's horrified face.") I should emphasize that these are not three discrete categories but points on a continuum—with marriage and divorce at opposite ends of the spectrum and separation somewhere in between.

What is so interesting about Ruttmann's experiment is the way it refuses to submit to even these broadly defined categorizations. In *Weekend*, the sound is not married to the image, nor is it separated or divorced from it. Rather, there simply *is* no image. This forces us to introduce a new category: *singlehood*. A sound is heard *without* any visual accompaniment. (You hear: an explosion. You see: nothing.) The inverse situation would also fit into this category: an image is seen without any auditory accompaniment. (You see: an explosion. You hear: nothing.) (This latter approach will be explored in greater detail in the next chapter.) And singlehood is precisely the condition that *Weekend* maintains throughout its eleven-minute duration. As Mary Ann Doane has noted, in everyday language, "one goes to 'see' a film and not to hear it."[24] If someone asks me what I did last night, I might answer, "I saw Walter Ruttmann's *Weekend*." But is *see* the right word here? Can one see an imageless film? I could instead say, "I heard Walter Ruttmann's *Weekend*." But this might lead someone to think that I merely listened to *Weekend* on CD rather than engaging with the film itself. I point out this linguistic predicament not to gesture toward a "correct" way of speaking about *Weekend* but to note the way that Ruttmann's imageless film confounds the very language we use to describe the cinematic encounter. As Ruttmann points out, in *Weekend*,

sound is not subservient or even complementary to filmic imagery; rather, sound is employed as "an end in itself."[25]

CINÉMA CONCRÈT

The noises must become music.

—Robert Bresson, *Notes on the Cinematograph*

On first listen, the autonomous sounds of *Weekend* may seem random and disjointed. On closer inspection, however, an organizing principle begins to surface. More precisely, Ruttmann compartmentalizes his soundscape into six movements:

I: "Jazz of Work" (*Jazz der Arbeit*). Workers in a factory. Saws. Cash registers. Voices.

II: "Closing Time" (*Feierabend*). The end of the workday. Clocks. Sirens.

III: "Journey into the Open" (*Fahrt ins Freie*). Automobile engines and horns. Whistling. Footsteps.

IV: "Pastorale." Roosters. Ducks. Cats. Fragments of song. Church bells.

V + VI: "Return to Work" (*Wiederbeginn der Arbeit*). Yawns. Sighs. Cash registers. A reprise of "Jazz of Work" and "Closing Time."[26]

When analyzing *Weekend's* sounds and structure, one is immediately struck by Ruttmann's interest in musicality. Fragments of music surface and subside throughout the film: a piano, a marching band, a choir. At several points, one hears the sound of someone softly whistling a pleasant melody. (Each time this happens, I imagine the source of the whistling as Hans Beckert,

the serial killer played by Peter Lorre in Fritz Lang's *M* [1931], who repeatedly whistles the melody of Edvard Grieg's "In the Hall of the Mountain King" [1875].)[27] But even nonmusical sounds become musical in Ruttmann's hands. For example, in the first movement of the film, "Jazz of Work," I hear what sounds like a drumbeat. But I am not hearing the pounding of a bass drum and the clashing of cymbals; I am hearing the banging of a hammer, the revving of an engine, and the slicing of a saw. A few seconds later, a car starts and the rhythmic pulsing of the car's engine is replaced by a fragment of music played by a violin. The melody played by the violin seems to echo the rhythm of the car engine, as if the two "instruments" are playing the same tune, one after the other. In fact, the very title of this segment, "Jazz of Work," attempts to undermine boundaries between noise and music, suggesting that the banal sounds of the work day can be apprehended as a spontaneous and exuberant musical performance. Furthermore, Ruttmann did not write a *script* for *Weekend*, but a *score* (complete with six movements). As Andy Birtwistle observes, Ruttmann's score "shows various sounds and fragments of speech plotted on a musical stave. The score is divided into bars, includes a time signature, and individual sounds and words from the programme are notated in simple musical form."[28]

In its use of sounds to create a quasi-musical composition, *Weekend* represents one of the earliest attempts to bring to fruition the fantasy articulated by the Italian Futurist Luigi Russolo in his seminal manifesto, "The Art of Noises" (1913), a text that would go on to influence composers like Pierre Schaeffer and John Cage. Russolo argues that traditional musical instruments (like violins, trumpets, and pianos) have overstayed their welcome. The time has come instead to discover the musicality of everyday objects: "We futurists have all deeply loved and

enjoyed the harmonies of the great masters. Beethoven and Wagner have stirred our nerves and hearts for many years. Now we have had enough of them, *and we delight much more in combining in our thoughts the noises of trams, of automobile engines, of carriages and brawling crowds, than in hearing again the 'Eroica' or the 'Pastorale.'*"[29] Russolo goes on to describe a hypothetical "art of noises," in language that could almost double as a proleptic description of Ruttmann's *Weekend*:

> Let us cross a large modern capital with our ears more sensitive than our eyes. We will delight in distinguishing the eddying of water, of air or gas in metal pipes, the muttering of motors that breathe and pulse with an indisputable animality, the throbbing of valves, the bustle of pistons, the shrieks of mechanical saws, the starting of trams on tracks, the cracking of whips, the flapping of awnings and flags. We will amuse ourselves by orchestrating together in our imagination the din of rolling shop shutters, the varied hubbub of train stations, iron works, thread mills, printing presses, electrical plants, and subways.[30]

While it is not clear whether or not Ruttmann was familiar with "The Art of Noises," the resemblance between Russolo and Ruttmann's respective projects is uncanny. Like Russolo, Ruttmann is deeply invested in the sounds of urban modernity: *Weekend* permits us to "cross a large modern capital [Berlin] with our ears more sensitive than our eyes." (Russolo's compositions, such as *Awakening of a City* [*Risveglio di una città*, 1913], also attempt to evoke urban spaces, although Russolo does so not by directly recording these noises but by replicating them through *intonarumori*, sound-generating devices that Russolo constructed himself.) Both Ruttmann and Russolo use their art to challenge "the old prejudice that noise cannot be musical."[31] And both

artists show little interest in strictly mimetic soundscapes (ones that would be perceptually indistinguishable from, say, simply walking through a city). Rather they each control, calibrate, and combine various sounds to produce specific predetermined effects. As Russolo puts it, "Although the characteristic of noise is that of reminding us brutally of life, the *Art of Noises should not limit itself to an imitative reproduction*. It will achieve its greatest emotional power in acoustical enjoyment itself, which the inspiration of the artist will know how to draw from the combining of noises."[32]

Ruttmann's careful control of *Weekend's* noises is made evident at the very beginning of the film. The first sound we hear, in a kind of prelude to the first movement ("Jazz of Work"), is a gong, followed by the sound of another gong at a higher pitch. These two gong sounds are repeated, and then repeated once more in reverse. The effect is reminiscent of one of the first films ever projected, Auguste and Louis Lumière's *Demolition of a Wall* (*Démolition d'un mur*, 1895), in which audiences see four workers demolish a wall, only to witness the wall magically reassemble itself when the film is projected in reverse. If the Lumière brothers craft the first *visual* reversal in cinema history, Ruttmann crafts what is likely cinema's first *auditory* reversal. The retrograde sound instantly makes it clear that Ruttmann is not merely presenting a straightforward linear recording of the sounds of Berlin. Rather, he is, in the prophetic words of Russolo, "selecting, coordinating, and controlling . . . noises" to engender "a new and unsuspected pleasure of the senses."[33]

But Ruttmann is not merely a successor of Russolo; he is also a predecessor of the French composer Pierre Schaeffer, the founder of *musique concrète* (concrete music). There are a significant number of parallels between Ruttmann's and Schaeffer's respective projects, but here, I will just focus on three: First, like

Weekend, musique concrète explores the musicality of quotidian sounds. For example, Pierre Schaeffer's influential composition *Railroad Study (Étude aux chemins de fer,* 1948) consists entirely of the sounds of trains. (Unlike Ruttmann, of course, Schaeffer's soundscapes are constructed not with celluloid but with magnetic tape.) Second, both Schaeffer and Ruttmann are interested in sounds themselves, rather than sounds as a means to an end. In creating *Railroad Study,* Schaeffer recalled, "I needed to tear noise away from its dramatic context. . . . If I succeeded, there would be concrete music. If not, there would be nothing but stage and radio sound effects."[34] Ruttmann and Schaeffer both succeed. Unlike the sound effects used in early twentieth-century radio plays, the sounds of Ruttmann's *Weekend* and Schaeffer's *musique concrète* are not merely tools in the construction of a narrative but "sound objects," "pieces of time wrested from the cosmos."[35] Third, both *Weekend* and *musique concrète* are manifestations of what Schaeffer has called the *acousmatic*: the hearing of sounds without seeing the *source* of those sounds.[36] Just as Ruttmann is interested in the "blind film," Schaeffer is interested in "blind listening."[37] As a result, when I am viewing *Weekend* or listening to *musique concrète*, I am often unable to identify the sources of the sounds I am hearing. At these moments, what I hear is no longer the sound *of* something (the sound of a train, the sound of a duck). What I hear is simply *sound.* The result is a deeply mysterious phenomenological encounter. I can either struggle to identify the sources of these ambiguous noises or simply enter a world of sounds *as* sounds.

In spite of these striking affinities, however, it seems clear that Schaeffer was not familiar with *Weekend.* In his writings, Schaeffer readily cites a number of precedents for his *musique concrète*, including "primitive black music," "Oriental music," and compositions by John Cage, Edgard Varèse, and Olivier Messiaen.[38]

But he never mentions Ruttmann. In fact, very few individuals would have known about *Weekend* in the mid-twentieth century since it was lost shortly after its premiere. As Dieter Daniels notes, *Weekend* "received no substantial literary references or presentations after 1932. The original sound-film vanished, as did the shellac record copies from the radio archives. In fact, *Weekend* survived only by chance as an audio tape recording belonging to the cutter Paul Falkenberg, who took the print with him when he emigrated to New York, where it was discovered in 1978."[39] It was broadcast for the first time in decades on the Bavarian Broadcast Station in April 1978, after which it gradually developed a small but devoted following. It is unfortunate that Schaeffer apparently never had a chance to experience Ruttmann's sound collage. It is equally unfortunate that Ruttmann, who died in 1941, never had a chance to hear Schaeffer's *musique concrète*. Still, as Falkenberg puts it, *Weekend* "received the supreme accolade, however silently and anonymously, when *musique concrète* presented itself before a public unaware of its ancestry."[40]

A VISUAL MEDIUM?

Whatever makes a work of art what it is need not necessarily be visible; it takes place in the artist's and beholder's minds.
—Dörte Zbikowski, "Dematerialized"

So *Weekend* can be understood as a musical composition in the style of Luigi Russolo's *Awakening of a City* and Pierre Schaeffer's *Railroad Study*. Given its renunciation of imagery, one could also place it in a tradition of monochrome art, like Kazimir Malevich's *Black Square* (1915) and Robert Rauschenberg's untitled

black paintings from 1951. This is because *Weekend* is promiscuously intermedial—as Andy Birtwistle notes, "In Ruttmann's *Weekend*, what we witness is . . . a folding of art forms, one into another."[41] Still, it is worth remembering that Ruttmann regularly called *Weekend* a film. Given this fact, why has so much of the research on *Weekend* been conducted, not by film scholars, but by scholars of music, radio, and sound art? Indeed, why do many scholars describe the work only as a work for radio, with no reference to cinema at all? The answer lies partly in the conservatism that has pervaded much of film theory. A number of film theorists have historically conceptualized cinema as an inescapably multisensory medium. A painting may address itself to the eye and a piece of music may address itself to the ear, but a film must necessarily synthesize the senses of sight and sound. As Noël Burch puts it, "The fundamental dialectic in film, the one that at least empirically seems to contain every other, is that contrasting and joining sound with image. The *necessary* interrelationship of sound and image today appears to be definitely established fact, as even the most doubting critic must concede once he has examined the history of film."[42] But *Weekend* challenges this view. The film is replete with sounds but devoid of images. Its audience has been blinded. Indeed, Ruttmann describes the film itself as "blind." This terminology is, at first, rather perplexing. After all, aren't all films blind? Surely the cinematic "gaze" is unidirectional: spectators look at films, but films do not look at spectators. (And this unidirectionality is precisely why cinema is often theorized as a voyeuristic medium.) Nevertheless, it might be useful to contextualize Ruttmann's counterintuitive statement by putting it in conversation with the Soviet filmmaker Dziga Vertov and his Council of Three, who forcefully argued in 1923 for the power of "kino-eye," the eye of the camera, which was "more perfect than the human eye."[43]

(This metaphor is memorably reified in Vertov's *Man with a Movie Camera* [1929], in which a human eye is superimposed over a camera, thus suggesting the possibility of a purely cinematic vision.) So if a standard film camera would have "seen" everything that Ruttmann recorded—including all the people, animals, and machines that populated Berlin in 1930—by leaving the lens cap on, Ruttmann "blinded" his camera (and, by extension, his audience). In Isidore Isou's experimental film *Treatise on Slobber and Eternity* (*Traité de bave et d'éternité*, 1951), the protagonist, Daniel, asserts, "I want to separate the ear from its cinematic master: the eye." Little did he know that Ruttmann had already accomplished this feat some two decades earlier.

Many film theorists have gone one step further by insisting that cinema must engage the eye and the ear *in that order*. In other words, film theory is littered with claims that film is primarily a *visual* medium. Consider, for example, a statement by René Clair, a contemporary of Ruttmann's who shared his interest in avant-garde cinema. (Clair directed the influential Dada film *Entr'acte* in 1924.) Clair's conception of cinema, like that of many film theorists who came before and after him, was unambiguously ocularcentric: "A blind man in a regular theater and a deaf mute in a movie theater should still get the essentials from the performance."[44] Siegfried Kracauer enthusiastically agreed with Clair's position, arguing passionately for "the supremacy of the [cinematic] image." For Kracauer, "Films with sound live up to the spirit of the medium only if the visuals take the lead in them."[45] And similar sentiments have been expressed by too many film theorists to mention, including Rudolf Arnheim, who calls film "a visual medium," and Stan Brakhage, who, when asked if film is "primarily a visual medium" responded, "Obviously."[46] As Rick Altman perceptively notes, "Early filmmakers' skepticism about the value of sound has been indirectly

perpetuated by generations of critics for whom the cinema is an essentially visual art, sound serving as little more than a super-fluous accompaniment."[47]

This ocularcentrism is also ubiquitous in popular conceptions of cinema. For example, I recently attended a screening of Stanley Kubrick's *2001: A Space Odyssey* (1968) at an independent movie theater in Des Moines. The screening was well attended, and the crowd burst into applause and began cheering when the Star Child appeared at the conclusion of the film's narrative. Dozens of committed Kubrickians stayed to watch the closing credits. But after the credits had run their course, the ethereal sounds of Johann Strauss's *The Blue Danube* (1867) continued on the sound track for four minutes and twenty-three seconds. Once there was no longer anything on the screen to *see*, the spectators promptly exited, and I was left alone in the theater. As pedantic as this may sound, I am tempted to argue that none of these spectators had actually experienced the film in its entirety that evening. After all, Kubrick's musical selections are a crucial part of the experience of *2001*. The film opens with several minutes of an imageless screen accompanied by music (in this case, György Ligeti's *Atmosphères*, 1961) and ends the same way. (Kubrick was always fond of symmetry.) Just imagine if, after the credits had ended, there was an additional four and a half minutes of *imagery* on the screen. It is hard to imagine that many cinephiles would have still thought of the film as being "over."

A similar kind of ocularcentrism manifests itself regularly in my cinema studies classes. When I show a film with imagery but no sound, like Stan Brakhage's *Window Water Baby Moving* (1959), it never occurs to students to ask whether the work in question is really a film. On the other hand, when I screen Rutt-mann's *Weekend*, a large number of students immediately and confidently assert that it is not a film at all. A film without images

seems to them to be a contradiction in terms. Many argue that
Weekend is nothing more than sound art or a work for radio.

Why, then, did Ruttmann call *Weekend* a film? Was it because
it was created with a camera and celluloid? If Ruttmann had used
some alternate, nonfilmic technology to construct the work,
would its categorical designation shift? Imagine, for example,
that Ruttmann had created *Weekend* not with celluloid but with
magnetic tape, a technology that had, in fact, been developed in
Germany in 1928 (even if it was not widely available until the
late 1940s). If Ruttmann had created *Weekend* with magnetic tape
but still displayed it at film festivals and movie theaters with an
imageless screen, would it remain a film? Would it at least qual-
ify as what Jonathan Walley has called "paracinema," a work
that finds "cinematic qualities or effects in nonfilmic materi-
als"?[48] After all, the cinema screen would still be an integral
part of the experience, and its emptiness would no doubt elicit
spectatorial projection, as audience members visualized the
invisible cats, marching bands, and machines that they heard
throughout the course of the work. On the other hand, imagine
that Ruttmann did indeed create *Weekend* with a camera and cel-
luloid but decided to broadcast it only via radio, not in a theatri-
cal setting. Would it then still be a film? One might argue that
this work would still have been cinematic in its *construction* since
it was made by a filmmaker who used a camera as a recording
device and who carefully edited celluloid to produce an effect on
an audience. But what is more important in determining an art
work's categorical status? Is it the work's *construction* or the *expe-
rience* that it provides?

It is possible that Ruttmann called *Weekend* a film primarily
because of its construction. According to this hypothesis, his cat-
egorical designation stemmed from his use of a camera and cel-
luloid in constructing the work, as well as his application of

cinematic principles of montage. If this is true, it suggests that even when the work was broadcast over the radio, Ruttmann would have still considered it to be a film. It is also possible, however, that he called *Weekend* a film principally because he planned to show the work in cinematic venues. According to this view, when *Weekend* was broadcast over the radio, it was a work of radiophonic art or avant-garde music. It became a film only when it was screened in a theatrical space.

While I do not know how Ruttmann himself would have addressed these issues, I will offer my own provisional intuition, one that has largely been shaped by reflecting on *Weekend*. I would argue that the experience a work provides for an audience is more crucial in determining its categorization than the technical means used to create or exhibit it. To illustrate this point, imagine that I plan on showing *Weekend* to two separate classes. In the first class, no screen is present. I introduce the piece as a work for radio, I leave the lights on, and I never turn on the classroom projector. I play the DVD version of *Weekend* from my laptop, but my students do not know I am using a DVD. Have my students just seen (or experienced) a film? I am inclined to say no. They have heard a piece of sound art, or a work for radio, or experimental music. But now I teach another class. A screen is present. I introduce the piece as a film, I turn out the lights, and I turn on the classroom projector. The students watch a black screen while listening to Ruttmann's sound collage. In this case, however, unbeknownst to my students, I am actually pairing the CD version of *Weekend* with a monochromatic black PowerPoint screen. Have *these* students just seen (or experienced) a film? I would argue that they have. As Michel Chion wrote, "Played through the speakers, *Weekend* is nothing other than a radio program, or perhaps a work of concrete music. It becomes a film only with reference to a frame, even if an empty one."[49]

I should emphasize that I am not attempting to draw sharp lines around what "counts" as a film. Cinema is amorphous and continually evolving, and this is partly what makes film theory so challenging and intellectually rewarding. What I am trying to foreground is the way that Ruttmann's experiment poses so many compelling questions about the nature of cinema. To put this another way, what is interesting about *Weekend* is not the exercise of trying to definitively determine whether it is a "true" film. What is interesting is how Ruttmann's decision to exhibit *Weekend* as a film destabilizes the very ontology of film. Just as Duchamp's *Fountain* (1917) prompts one to ask "What is art?" and Cage's *4'33"* (1952) prompts one to ask "What is music?," Ruttmann's *Weekend* prompts one to ask "What is cinema?"

BLACKNESS

Blackness is the definitive void, but also the ultimate space of creative possibility.

—Adam Lowe, "To See the World in a Square of Black"

While there are a number of unanswered questions about what early spectators of *Weekend* would have seen, it seems clear that blackness would have been a central part of the experience. If the celluloid version of *Weekend* was used, audiences would have stared at a solid black rectangle projected on a cinema screen. If the gramophone record was used, audiences would have likely found themselves in a pitch-black room with a barely visible empty cinema screen in front of them. (I should add that whenever I screen *Weekend* for an audience, I *project* blackness on a screen. I never cease to be excited by the black cinema screen: its minimalist rigor, its Zen emptiness, its eerie luminosity.)

Of course, black screens are not uncommon in cinema—the fade to black is especially ubiquitous. Nevertheless, *prolonged* black screens with no images are exceedingly rare, and their presence often seems to indicate that the film is over. Consider, for example, an experience that the filmmaker and film theorist Richard Misek had during a screening of his film *Rohmer in Paris* (2013):

> Immediately following a key revelation, there is a cut to black. The black lasts quite a long time, about seven seconds, so as to release viewers from the flow of images and allow them time to reflect on what has been said—too long, unfortunately, for one projectionist, who decided this signified the end of the film, and so raised the house lights. After a few moments of uncertainty, the nothingness of the black—for him—resolved to signify "no film."[50]

Or consider a similar incident at the 70th University of Film and Video Association (UFVA) conference of 2016, which screened a film by Jennifer Proctor entitled *So's Nephew by Remes (thanx to Michael Snow) by Jorrie Penn Croft* (2015).[51] According to Proctor, "Something kind of hilarious happened there—during the screening, in one of the long, dark, sound-only parts, the projector turned off. IT HAD FAILED TO RECOGNIZE THAT A FILM WAS STILL PLAYING! It was kind of a beautiful techno-meta moment, in which the projector itself had called into question what constituted a film."[52] In other words, any filmmaker who would like to use a black screen for more than a few seconds runs the risk of a confused projectionist (or projector!) terminating the screening before it is over.

Indeed, such confusion regularly accompanies screenings of *Weekend*. When I screen the film for my students, I never tell

them that it is an imageless film beforehand, and as a result, after about ten seconds of blackness, a number of students begin looking around the room, bewildered. They often have looks on their faces that seem to ask, "Is something wrong? Is the projector broken? Does someone need to call Classroom Services?" Some students scratch their heads while others smile, bemused by the oddness of the spectacle. Ara Osterweil's vivid description of her students' responses to the recurring black screens in Ken Jacobs' film *Blonde Cobra* (1963) could also apply to my own students' responses to *Weekend*: "What happens to a film audience when there is no longer anything on the screen to look at? . . . One student appears catatonic while another fidgets in discomfort. A few sit riveted, others stupefied, a couple ironically amused. Someone laughs uncontrollably while others glance nervously or curiously around the room."[53]

This spectatorial destabilization is a central element in *Weekend's* aesthetic. In many films, I know precisely what the filmmaker wants from me. Cuts, close-ups, and rack focuses tell me, "Look here. Now look there." Saturated colors direct my attention to the most important elements in the mise-en-scène. ("Ah, so the man wearing the *red hat* is the murderer!") But this clarity is withheld in Ruttmann's film. Am I supposed to look at the black screen—and nothing else—for all eleven minutes? What would happen if I closed my eyes? Would that transform the work back into a piece for radio? Or does the very fact that I know a screen is *present* make it a film, whether I see that screen or not? Should I look at the other members of the audience to see how they are engaging with the film? What would happen if we *all* looked at each other? What would happen if we all faced *away* from the screen? Is the room we are in dark enough? To experience *Weekend* properly, should it be

screened in a completely dark room? Or would this ultimately make the work much more sinister and unnerving than it was designed to be? Some spectators find this ambiguity maddening ("What does Ruttmann *want* from us?"), but I find it tantalizing. Watching *Weekend*, I feel a bit like John Cage looking at Marcel Duchamp's *The Bride Stripped Bare by Her Bachelors, Even* (1923) (often called *The Large Glass*): "Looking at the *Large Glass*, the thing that I like so much is that I can focus my attention wherever I wish. It helps me to blur the distinctions between art and life and produces a kind of silence in the work itself."[54] A similar blurring of distinctions takes place when viewing *Weekend*. The sounds of the film merge with the sounds of one's immediate environment, and the blackness of the screen merges with the blackness of the theatrical space. The result is an aesthetic encounter that is both enigmatic and engaging.

"LOST IN A SEA OF SOUNDS"

I was born lost and take no pleasure in being found.
—John Steinbeck, *Travels with Charley*

Every time I watch *Weekend* (if "watch" is indeed the right word), I seem to have a different experience. I will conclude this chapter by outlining just a few of these experiences to give a sense of the film's richness and malleability. On some occasions, I pay little attention to the sounds of Berlin and instead become intensely focused on the black screen itself. I begin to think of other works that make extensive use of the black screen, such as Kubrick's *2001: A Space Odyssey*, which begins with about three minutes of a black screen accompanied by György Ligeti's

haunting masterpiece of micropolyphony, *Atmosphères*. Kubrick's black screen seems to represent the nothingness before the Big Bang, the primordial chaos out of which everything (from apes to sentient computers) arises. As I stare at Ruttmann's black screen and reminisce about Kubrick's black screen, I begin to think of language from Anouk de Clercq's *Black* (2015), a film that, like *Weekend*, visually consists only of a black screen: "What is it exactly that we are looking at when we are looking at a black image? Can a black image depict (or be) a space at all, or is it always a two-dimensional plane?" How could I possibly tell if Ruttmann's blackness is two-dimensional or three-dimensional? What is the ontological status of filmic blackness? After all, when I look at a black screen, it is almost impossible to discern *what*, exactly, I am looking at. It could be Ruttmann's lens cap or a black monolith. It could be a starless night, a pitch-black room, or a close-up of Kazimir Malevich's *Black Square*. And this ambiguity is, in part, the source of *Weekend's* mystery and aesthetic power.

On other occasions, however, I think very little about the black screen per se. I instead become immersed in Ruttmann's soundscape. I begin to imagine what the *sources* of Ruttmann's sounds might have looked like, and I create my own movie on the empty screen in front of me. I *see* an invisible film. (Michael Cornelius describes a screening of *Weekend* this way: "Nothing was visible on the screen, but the pictures were streaming from the speakers.")[55] I see sweaty workers operating saws, a cranky stray cat meowing in pain as someone steps on its tail, and a chanteuse who looks suspiciously like Marlene Dietrich dancing provocatively at a musical soirée. I am reminded of a maxim by Robert Bresson: "The eye (in general) superficial, the ear profound and inventive. A locomotive's whistle imprints in us a whole

railway station."[56] *Weekend* becomes an intensely synesthetic experience: I see sounds. Of course, I do not feel free to create just *any* film. My imaginary film is circumscribed by Ruttmann's soundscape. I am engaged in a process that Julian Hanich calls "bounded imagination."[57] In a pair of perceptive essays on the role of imagination in cinema, Hanich asserts that film has the power to "invite—or even force—us to imagine something it does not show, but strongly suggests."[58] Consequently, film spectators do not generally "just imagine *anything*"; rather, a film will generally offer "a limited range of possibilities."[59] I may not know exactly what the cat I hear in *Weekend* looks like, but I know it does not look like a screwdriver. Of course, I may try to *refrain* from imagining a cat when I hear the pained meow in *Weekend*, but I find this almost impossible. As Fyodor Dostoevsky pointed out in 1863, we are not completely in control of our imaginative faculties: "Try to pose for yourself this task: not to think of a polar bear, and you will see that the cursed thing will come to mind every minute."[60] Or as Hanich puts it, "Often we cannot *not* imagine."[61]

But I do not always mentally visualize the sources of Ruttmann's sounds because I cannot always *identify* them. After all, not only are these sounds divorced from any imagery, but many of them are distorted through fragmentation or reversal. As I try to articulate the nature of the mysterious sounds I am hearing, I come up against "the limits of my language."[62] But perhaps I do not *need* to identify the source of Ruttmann's sounds. Instead, on some occasions, I engage in what Pierre Schaeffer calls *reduced listening* (*écoute réduite*): listening to sounds without attempting to identify their sources.[63] Following Schaeffer's lead, I try to experience "noise without text or context," abandoning any search for order or meaning and instead reveling in the

"in-itself-ness of the sound phenomenon."[64] I am no longer ana-
lyzing or interpreting *Weekend*; I am simply experiencing it. I
close my eyes and let the sounds wash over me. I *become* the
sounds.

There is yet another way of experiencing *Weekend*: through the
use of what the American composer and music theorist Pauline
Oliveros has called *deep listening*. Oliveros notes that we usually
"shut out sound that is extraneous to our current purposes."[65]
This is often necessary, of course. When I am at a party, I need
to "shut out" the sounds of loud music, glasses clinking, and gen-
eral chatter so that I can hear the words of my interlocutor. But
perhaps there are times when a more inclusive approach is pref-
erable, occasions for which, rather than singling out a solitary
source of sound (a friend speaking to me, a pianist in a concert
hall), we could attempt to open ourselves to every sound that
arises. Oliveros calls this approach deep listening, "a practice that
is intended to heighten and expand consciousness of sound in as
many dimensions of awareness and attentional dynamics as
humanly possible." It involves "expand[ing] the perception of
sounds to include the whole space/time continuum of sound—
encountering the vastness and complexities as much as possi-
ble."[66] When I approach *Weekend* this way, the sounds of the
film begin to fuse with those of the world around me. While
watching the film at home, I hear *two* car engines simultane-
ously: one from the film, the other from a car driving by out-
side. Rather than attempting to shut out the sound from out-
side, I welcome it as part of the aesthetic experience. The two
car engines are engaged in a duet. Ames, Iowa, becomes one
with Berlin, Germany; 1930 merges with 2020. *Weekend* becomes
the site of a spatiotemporal fusion.

To be sure, it would have been difficult to fully appreciate the
richness of *Weekend* in 1930. Those who were fortunate enough

to experience the work at all were generally able to do so only once (either in a movie theater or on the radio). But given its complexity, *Weekend* is a work that demands repeated viewings (and hearings). As Brían Hanrahan notes, when *Weekend* was first broadcast on the radio, "much of [its] formal complexity went unperceived."[67] In fact, Ruttmann himself was somewhat disappointed with the results, commenting, "The experiment was not quite a success. The film was difficult and incomprehensible, listeners got lost in a sea of sounds, grasped a few associations and connections, but essential aspects slid past unnoticed."[68] By contrast, I have been fortunate enough to visit the work again and again, repeatedly watching the version I own on DVD and listening to the version I own on CD. In recent years, thousands of others have had the opportunity to experience *Weekend* via YouTube, with the freedom to pause and repeat the work to better absorb its aural intricacies. Those who have given *Weekend* this kind of careful and sustained attention generally find it hard to share Ruttmann's assessment. *Weekend* may be "difficult," but it is hardly "incomprehensible"—and in any case, one need not "comprehend" the work to savor its innovative soundscape. One is free to conceptualize *Weekend* as an imageless film, an early work of *musique concrète*, or, in the words of Hans Richter, "a symphony of sound, speech fragments, and silence woven into a poem."[69] Regardless of the categorization, *Weekend* remains a work of startling power and originality. There are few activities more invigorating than getting "lost in a sea of sounds."

2

STAN BRAKHAGE AND THE BIRTH OF SILENCE

Why must one always talk? Often one shouldn't talk, but live in silence.

> —Nana, *Vivre sa vie* (Jean-Luc Godard, 1962)

That's when you know you've found somebody really special—when you can just shut the fuck up for a minute and comfortably share silence.

> —Mia, *Pulp Fiction* (Quentin Tarantino, 1993)

I n one of the most memorable scenes of Jean-Luc Godard's *Bande à part* (*Band of Outsiders*, 1964), Odile (Anna Karina), Franz (Sami Frey), and Arthur (Claude Brasseur) loiter and engage in idle chatter in a crowded café, as so often happens in films of the *nouvelle vague*. After an uncomfortable silence laced with ennui, Franz asserts, "Okay. If there's nothing left to say, let's have a minute of silence."[1] Unimpressed by the recommendation, Odile bluntly retorts, "You can really be dumb sometimes." But Franz persists: "A minute of silence can be a long time. A real minute of silence takes forever." Unable to think of a better way to pass the time, Odile concedes: "Okay. One, two, three."

What happens next is remarkable: *actual* silence. Godard does not simply revisit the awkward silence that the characters shared a few seconds ago. Instead, he completely eliminates *all* noises from the film's sound track. One retroactively realizes how noisy the previous silence was. While the film's central characters may not have spoken for several seconds, the café was still replete with the sounds of footsteps, chatter, and clanking silverware. During this new, purer silence, the characters exchange vacant glances. Arthur raises his eyebrows and purses his lips. Franz takes a couple of drags on his cigarette. Odile rests her chin on her right hand. After approximately thirty-four seconds, Franz breaks the silence: "That's enough. I'll put a record on." Why does Godard cut this "minute" of silence in half? Would a full minute prove too arduous for his characters? His audience? Both? Was the abruptness of the break simply an index of Godard's restlessness—most famously exemplified by the ubiquitous jump cuts of his first film, *À bout de souffle* (*Breathless*, 1960)? In any case, the moment that Franz speaks, the cacophony of the café returns and the silence is broken.

It is worth lingering on the precise species of silence that Godard has created here. It is not the silence of so-called silent cinema, since most silent films were projected with live or recorded music. (Some screenings even included additional aural elements, such as sound effects and live narration.) It is also not the silence that tends to intermittently punctuate sound films, a quasi-silence teeming with ambient sounds: creaking stairs, crickets, wind. The silence of *Bande à part* is a radical silence. By eliminating sound altogether, Godard momentarily transforms the cinematic encounter into an experience of pure visuality.

Godard, however, is not the first filmmaker to excise sound from cinema. There is a rich tradition of silence in experimental

cinema, one that reaches its apex in the films of Stan Brakhage. In this chapter I explore some of the functions of cinematic silence by giving especially close attention to Brakhage's landmark film *Window Water Baby Moving* (1959), a bold and uncompromising experiment that documents the birth of Stan and Jane Brakhage's first child, Myrrena. By removing the sound track from images that seem to demand an auditory supplement—such as a woman screaming in pain and a newborn child crying—Brakhage creates a disorienting and defamiliarizing cinematic experience. I argue that *Window Water Baby Moving*'s lack of a sound track reflects Brakhage's distrust of language and his antipathy toward the facile sound-image relationships of mainstream cinema. I also argue that his silence creates a musicality of vision by foregrounding the optical rhythms of the film's editing. Finally, I explore the ways that Brakhage's silent aesthetic is related to—but also distinct from—that of his mentor, John Cage.

A BRIEF HISTORY OF CINEMATIC SILENCE

Heard melodies are sweet, but those unheard
Are sweeter.

—John Keats, "Ode on a Grecian Urn"

To better understand what might have inspired Brakhage to make films without sound tracks, it will be helpful to briefly examine some precedents for his cinematic silences. What was the first truly silent film? This is a fiendishly difficult question to answer. After all, exhibition approaches varied greatly in the first several decades of cinema history, and the same film could

be projected in silence in one theater and with musical accompaniment in another. While many accounts of the silent era insist that "'silent' cinema was never silent" (that is, that music always supplemented cinematic imagery), Rick Altman has persuasively argued that "silence was in fact a regular practice of silent film exhibition" before 1910.[2] Furthermore, there were certain rare filmmakers of the silent era who insisted that their films should be projected in silence. The Swedish filmmaker Viking Eggeling, for example, "unequivocally instructed his friends never to add a musical score" to *Symphonie diagonale* (1924), since this abstract film was already a kind of "music for the eyes."[3]

But what if we limit our inquiry to the era of the talkie? To my knowledge, the first filmmaker to forgo the use of synchronized sound to construct a film that was designed to be viewed in complete silence was the German American abstract animator Oskar Fischinger. While Fischinger is best remembered for films that combine colorful abstract imagery with music, such as *Composition in Blue* (1935), *An Optical Poem* (1937), and *Motion Painting No. 1* (1947), he maintained that "a film can be even more beautiful without music."[4] To put this hypothesis to the test, in 1942 he created a little-known masterpiece called *Radio Dynamics*, in which sinuous and sensuous shapes appear and disappear at precisely timed intervals without any sonic accompaniment. Since Fischinger knew that many venues would see the film's lack of a sound track as an invitation to add their own, he added a title card to the beginning of the film that reads, "Please! No music. Experiment in Color-Rhythm." The exclamation mark and the underlined language reveal Fischinger's deep conviction that the film would lose its effect if it were given a musical score. Brakhage respected Fischinger's craft, and he called *Radio Dynamics* "the first truly silent film in the history of film."[5]

Shortly after the first screening of Fischinger's *Radio Dynamics*, the American avant-gardist Maya Deren (along with her second husband, Alexander Hammid) shot the seminal trance film *Meshes of the Afternoon* (1943).[6] Like *Radio Dynamics*, *Meshes of the Afternoon* was designed to be screened in silence (even if a musical score by Deren's third husband, Teiji Ito, was added in 1959). Unlike the abstract imagery of *Radio Dynamics*, however, *Meshes of the Afternoon* is populated with images that would normally demand a sonic supplement, such as a key clanging on the sidewalk, a record spinning on a phonograph, and a knife shattering glass. And Deren's later films were also silent, including *At Land* (1944), *A Study in Choreography for Camera* (1945), and *Ritual in Transfigured Time* (1946), although Ito also composed a score for *At Land* years after its release. Deren's decision to make silent films was initially the result of economic constraints, but she later came to see this "limitation" as serendipitous: "In creating a film experience which was silent in its very nature, I had used the muteness of my camera as a positive factor."[7] Brakhage admired Deren's cinema, and his own use of silence was almost certainly inspired by the silent aesthetic that Deren popularized in the 1940s.[8]

The silent aesthetic pioneered by Fischinger and Deren would go on to become remarkably prevalent in American experimental cinema, and films without sound tracks continued to be made by artists like Marie Menken, Sidney Peterson, Joseph Cornell, and Andy Warhol, among others. But the most prominent proponent of cinematic silence was Stan Brakhage. Not only did he create hundreds of films without sound tracks, he was also a vocal defender of silence in his writings and lectures. And no Brakhage film better demonstrates the power and complexity of cinematic silence than *Window Water Baby Moving*.[9]

SUBVERSIVE CINEMA

On the screen probably for the first time ever in film history: a
woman gives birth to a child. We see it all. The woman is
ecstatic. And so is the father. The audience is totally silent.

—Jonas Mekas, "Recollections of Stan Brakhage"

To better appreciate the significance of Brakhage's experiment, it is worth reflecting on the sheer number of taboos that are violated in *Window Water Baby Moving*. First, for a father to even be present during childbirth was heavily discouraged in 1950s America. As Brakhage recalls, "They did not want husbands watching the birth, for the reason that many husbands faint at that moment, or they interfere, and they come apart, and they faint and fall down and crack their head and then sue the hospital."[10] The filming of childbirth was also often verboten. Indeed, *Window Water Baby Moving* takes place in a home precisely because, after much discussion, Brakhage was forbidden from making his film in the hospital itself. There is no shortage of reasons why a film like *Window Water Baby Moving* could never have been made by a Hollywood studio, but chief among those are the film's explicit content. Not only did the Motion Picture Production Code forbid "nudity in fact or in silhouette," but it also stated, "Scenes of actual child birth, in fact or in silhouette, are never to be presented."[11]

Of course, as an experimental filmmaker working outside the bounds of the studio system, Brakhage was under no obligation to obey the dictates of the Production Code. Nevertheless, a number of obscenity laws with a far broader reach meant that the film was constantly in danger of being banned—and that Brakhage was in danger of being incarcerated. Here is how Brakhage remembers the conservative milieu of the 1950s:

I was certainly in danger of going to jail for having made *Window Water Baby Moving*. When I sent in the film to be processed, Kodak sent a page that said, more or less, "Sign this at the bottom, and we will destroy this film; otherwise, we will turn it over to the police." So then the doctor wrote a letter, and we got the footage back. But for years we lived under that threat.

Then, every time you showed the film in a public arena, there was a danger that someone would blow the whistle and you'd end up in jail. As you know, not too far down the line we were to have these big court cases with Jack Smith's *Flaming Creatures* (1963) and other films. Well, that could have happened with *Window Water Baby Moving* just as well. Nudity was forbidden, and only available in an underground way, in a gangster underground porn way. You could definitely go to jail for showing not only sexuality but nudity of any kind—though the idea of childbirth being somehow pornographic has always been offensive and disgusting to me.[12]

Beyond violating taboos about childbirth and nudity in film, *Window Water Baby Moving* also offended a number of audiences for its collapsing of the boundaries between the private and the public. For many, childbirth is an intensely personal experience, one that should be shared only with close friends and family members. Brakhage is quite content to "expose" this intimate experience to a broader public, however, and this provoked discomfort in many spectators, including Maya Deren. In spite of their strong aesthetic affinity, after the premiere of *Window Water Baby Moving* at the Living Theater in New York City in 1959, Maya Deren stood up before the audience and chastised Brakhage, asserting that birth is a "private matter." She added, "Even the animals, when they give birth, retreat into a secret place."[13]

But *Window Water Baby Moving* is iconoclastic not only in content but also in form. For example, the film embraces an uncompromising nonlinearity. This includes reverse motion (the water that covers Jane's belly retreats, leaving her body dry), as well as editing patterns that breezily shift between past, present, and future. (After breathing a sigh of relief when the baby is finally born, spectators are often horrified to see the film leap back in time to the painful delivery.) The film also violates the rules of continuity editing, instead favoring transitions that are abrupt and disorienting. Match cuts result in startling juxtapositions: Jane's right breast suddenly becomes her right knee; her closed left eye transforms into her bleeding vagina. Some images are shot out of focus; others appear upside down. Stan fragments Jane's body into a series of unrecognizable abstractions through the use of strange angles and extreme close-ups (see figures 2.1 and 2.2). (In its transformation of the body into an alien landscape, the film evokes Willard Maas and Marie Menken's

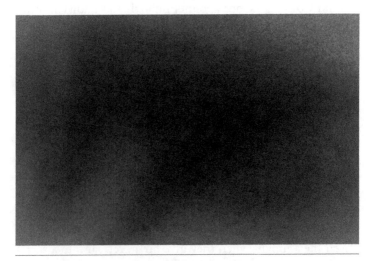

FIGURE 2.1 Stan Brakhage, *Window Water Baby Moving* (1959)

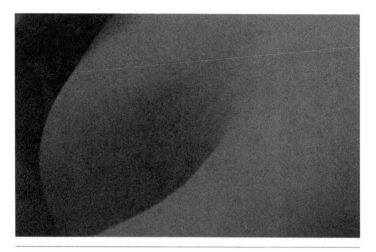

FIGURE 2.2 Stan Brakhage, *Window Water Baby Moving* (1959)

Geography of the Body [1943].) The shots do not suggest an objective world of cause and effect but a series of nebulous impressions and temporal dislocations reminiscent of Marcel Proust. In other words, *Window Water Baby Moving* does not attempt to realistically document childbirth; instead, it indexes the fragmentary and amorphous *memories* of childbirth.

"BEYOND WORDS": BRAKHAGE AND THE INEFFABLE

What we cannot speak about we must pass over in silence.
—Ludwig Wittgenstein, *Tractatus Logico-Philosophicus*

Of course, one of the most formally interesting elements of *Window Water Baby Moving* is its lack of a sound track. Brakhage has not always had reservations about sound in cinema, and his

earliest films do, in fact, have distinctive sound tracks. For example, his first film, *Interim* (1952), features music by James Tenney, and *In Between* (1955) features music by John Cage. In the same year that Brakhage released *In Between*, however, he also released *The Wonder Ring* (commissioned by Joseph Cornell), and according to Brakhage, this film represented a "turning point": it was the first time that he was "consciously against adding sound" since this would enable spectators to better "concentrate" on the film's visuals.[14] From this point on, the vast majority of Brakhage's films would have no sound track. This is not to say that Brakhage was now categorically against cinematic sound. He would go on to make a number of sound films—including *Blue Moses* (1962), *The Stars are Beautiful* (1974), *I . . . Dreaming* (1988), and *Passage Through: A Ritual* (1990)—and he would also praise a number of independent filmmakers for using sound in innovative ways, such as Peter Kubelka, James Broughton, and Kenneth Anger.[15] Nevertheless, Brakhage remained committed to the value of cinematic silence throughout his career, and he created hundreds of experimental films with no sound. Why?

One can imagine a number of alternate versions of *Window Water Baby Moving* that exist in parallel universes. All these films have the same imagery that exists in the film as we know it, but each one adds a sound track. One version, for example, would include the voice-over that was so typical of documentaries of the 1950s: perhaps the deep, authoritative voice of Charlton Heston waxing poetic about the miracle of birth. But this would strip the film of its complexity and make it either didactic or trite. Since Brakhage had a deep distrust of language, he was extremely reluctant to use it as a supplement to his visual experiences. And he was often disappointed when other filmmakers used language in such a supplementary role. For example, Brakhage criticized one of his favorite artists, Jean Cocteau,

for his reliance on language in cinema: "One of the weaknesses of Jean Cocteau was that he depended on words or poems within the film, whereas film has a poetry of its own."[16] Brakhage is interested precisely in that which cannot be reduced to language, the purely sensuous experience that effortlessly slips out of any linguistic straightjacket. He claims that one of his goals as an artist is to "drive the mind beyond words."[17] He admires the writer Osip Mandelstam because by lacing his poems with the "'blanks' of speechlessness" he remains true to "the ineffable."[18] And the famous opening of Brakhage's book *Metaphors on Vision* provocatively outlines his ambivalence about language: "How many colors are there in a field of grass to the crawling baby unaware of 'Green'? How many rainbows can light create for the untutored eye? How aware of variations in heat waves can that eye be? Imagine a world alive with incomprehensible objects and shimmering with an endless variety of movement and innumerable gradations of color. Imagine a world before the 'beginning was the word.'"[19] For Brakhage, the word *green* transforms an infinitely rich continuum of shades and hues into a prepackaged banality. He yearns instead for a prelinguistic, prelapsarian world of pure sensation. This is the world that he is attempting to create in his silent films: one that has been purged of the tyranny of language.

In fact, Brakhage was even hesitant to use language to *title* his films. In an interview in 2002, included as a supplementary audio track in *By Brakhage: An Anthology, Volume One*, Bruce Kawin points out that while Brakhage's films are silent, "the titles do give words to these images." Brakhage responds, in part, by saying, "There is a danger. I do recognize that the words can run away with—and dominate and distort even more than a sound track can—the vision. So I try to be cautious about that." But then Brakhage pivots to an illuminating discussion of sound:

"I also think when sounds are enigmatic enough, like *The Wold Shadow* (1972), it posits a mystery in itself, so it won't interfere that much with the appreciation of that film as a mystery." Brakhage's films are heavily invested in the mysterious (which is, according to Albert Einstein, "the fundamental emotion which stands at the cradle of true art and true science").[20] And Brakhage's titles also tend to be highly enigmatic: *Thigh Line Lyre Triangular* (1961), *Christ Mass Sex Dance* (1991), *The Lion and the Zebra Make God's Raw Jewels* (1999). Even the title *Window Water Baby Moving* exhibits an evocative ambiguity. Is the window of the title the literal window displayed at the beginning of the film? Is the film itself a "window" into the private and intimate space of childbirth? Is the window, perhaps, a metaphor for vision (in the spirit of the old cliché that claims that eyes are "windows to the soul")? One might even speculate about the grammatical function of the word "window" in this context. Followed as it is by an ostensibly unrelated noun ("water"), does the word become part of a compound noun ("window water")? Perhaps the juxtaposition of these two words suggests a metaphorical association insofar as both windows and water tend to offer transparent surfaces, ones that enable vision to penetrate through the surface to see what lies beyond. And this only scratches the surface of the title's polysemy. Along similar lines, in the rare Brakhage films that do traffic in spoken or written language—such as *The Stars Are Beautiful* (1974) and *For Marilyn* (1992)—the relationship between language and imagery tends to be highly elliptical. For example, *The Stars Are Beautiful* juxtaposes the image of a chicken with the voice of Brakhage saying, "The sky is the dead decaying body of God; the stars are glittering maggots." This linguistic instability is ubiquitous in Brakhage's essays as well. As he asserts in *Metaphors on Vision*, "I deck my prose with whatever puns come my way, aiming at

deliberate ambiguity, hoping thereby to create a disbelief in the rigidity of any linguistic statement, knowing only poetry immortal enough to escape the rigorous belief in any one word-world as sense-killing finality."[21]

"THE SOUND SENSE": HEARING IMAGES

If the eye is entirely won, give nothing or almost nothing to the ear. One cannot be at the same time all eye and all ear.

—Robert Bresson, *Notes on the Cinematograph*

Of course, directors are at liberty to deploy a wide variety of non-linguistic sounds in their films, so Brakhage's ambivalence toward language does not fully account for his silence. Another thought experiment will be useful. Now imagine a different version of *Window Water Baby Moving*, one that has no voice-over but retains all the diegetic sounds that Brakhage originally captured: Jane panting, Stan panicking, Myrrena crying. In fact, Brakhage did record the sounds of Myrrena's birth, even using one of them in a later film called *Fire of Waters* (1965).[22] And the event itself was rich with acoustic elements, as suggested by Jane's written description of it:

> Then I feel like a balloon full of water pops inside me, water shoots out of me. "Water! Water!" I shout. Stan rushes in with his camera and films while water pours out of me. So excited we are. "Here comes some more!" "Wait a minute!" "I can't!" Clickety-clackety-buzz goes the camera. Something tremendous is happening to me. I have entered into a world of beautiful agony—agony of great beauty, joyous agony, unbearable beauty. I roar like a lion. Stan films, clickety-clackety-buzz, his hands

are trembling with the camera, but clickety-clackety-buzz any-
way. I roar again and pant fast like I had run a mile and roar and
Stan films and we are so very happy because the baby is coming
at last![23]

Jane's onomatopoetic vignette exposes the general noisiness that
is hinted at, but never articulated, by the film itself. Why does
Brakhage withhold the splashing sounds of the amniotic fluid,
the leonine roars, the camera's "clickety-clackety-buzz"?

One answer to this question can be found in a *Film Culture*
essay that Brakhage wrote in 1960 (less than a year after the pre-
miere of *Window Water Baby Moving*) called "The Silent Sound
Sense." In this essay, Brakhage outlines a history of "silently
audible rhythm[s]" in cinema. He argues that filmmakers like
Georges Méliès, D. W. Griffith, and Sergei Eisenstein exploit
carefully calibrated editing, as well as movements within the
mise-en-scène, to unearth the possibility of a "musicality of
vision."[24] It is no accident that Brakhage's examples here are all
figures from the silent era. For Brakhage, the sound era resulted
in a series of misguided attempts to match an image with its
sound, rather than aiming for a more complex and creative rela-
tionship between sound and image. He writes:

> Creativity with sound has been lost in the superficial complacency
> of the mechanical adjustment of actual sound to visual occur-
> rence, as if a picture of a streak of lightning were real and there-
> fore must be followed by the sound of thunder, as if the moving
> images of leaves were fluttering from the screen and must be
> attended by their perhaps esthetically useless noise, as if the two-
> dimensional, cut-out actors on the screen were human beings in
> actual situations and the audience expected to attend their every
> statement whether or not they have anything to say, rather than

to comprehend them as simply in the act of talking, hearing only those dialogues whose spoken meaning is essential in what must predominantly be a visual work of art, if any art at all.[25]

While it may certainly seem "natural" for a lightning bolt to be paired with the sound of thunder (or for a crying newborn to be paired with vagitus), there is no a priori reason that a filmmaker needs to respect these traditional associations. One way of subverting such simplistic uses of synchronized sound is to strive for radically disjunctive sound-image pairings. Think, for example, of Michael Snow's *"Rameau's Nephew" by Diderot (Thanx to Dennis Young) by Wilma Schoen* (1974), in which the image of a chair is accompanied by the sound of hysterical laughter, and a shot of hands playing a keyboard is paired with the sounds of a woman having an orgasm. But another way of untying the audiovisual knot is to simply eliminate sound altogether. This is Brakhage's strategy. His films evoke sounds without making them. As Brakhage writes, "The sound sense which visual images always evoke and which can become integral with the esthetic experience of the film under creative control, often makes actual sound superfluous."[26] In the case of *Window Water Baby Moving*, the inclusion of diegetic sounds would have been not only superfluous but distracting. Because of the film's fragmented and nonlinear editing, diegetic sounds would have been chaotic and inchoate. Moans and cries would abruptly appear and disappear *in medias res*. Conversations would be cut short midsentence. The resulting cacophony would ultimately overpower the film's visual compositions. To be sure, the film *suggests* a wide variety of sounds. When Stan flirtatiously kisses Jane, she laughs. During childbirth, she screams in agony (see figure 2.3). When Myrrena makes her cinematic debut, the newborn cries (see figure 2.4). But we never actually *hear* any of

FIGURE 2.3 Stan Brakhage, *Window Water Baby Moving* (1959)

FIGURE 2.4 Stan Brakhage, *Window Water Baby Moving* (1959)

these sounds. We only imagine them. As a result, one cannot watch the film without attempting to mentally reconstruct the soundscape that must have accompanied the event, and the result is a highly participatory aesthetic encounter. The film is what Roland Barthes would have called "a readerly text," one for which the spectator is "no longer a consumer, but a producer."[27] In fact, when I recently screened *Window Water Baby Moving* in a class on experimental film, the first student response was revealing: "That. Was. So. *Loud*."

BRAKHAGE AND MUSIC

Most of Brakhage's films are silent? True, but their rhythms evoke music.

—Fred Camper, "Brakhage's Contradictions"

Permit me to traverse the multiverse once more. A still different version of the film would suppress all diegetic sounds but replace them with music, in the style of, say, Kenneth Anger. In fact, one does not need to travel to an alternate universe to experience the film this way. There are currently several versions of *Window Water Baby Moving* posted on sites like YouTube and Vimeo with added music tracks: electronic music, quirky psychedelia, jaunty French pop, and, of course, Pink Floyd. I must confess that I find a number of these modified versions of the film intriguing, although none of them retains the power of the original silent version. What is more, they are antithetical to Brakhage's aesthetic. Brakhage is not like Deren, who was quite content for sound tracks to be added to her works. When Brakhage created a silent film, he insisted that it *remain* silent.[28]

Given his distrust of language, Brakhage's resistance to voice-over tracks and spoken dialogue in his films is easy to understand; however, his resistance to music may, at first, seem more puzzling. After all, Brakhage had a love of music throughout his life and even studied informally under two of the greatest composers of the twentieth century, John Cage and Edgard Varèse. He also admits that his films are often inspired by the works of specific composers, including Bach, Webern, and Messiaen.[29] One might think that an artist with such an abiding passion for music would be eager to use it to complement his filmic imagery. But this was far from the case for Brakhage. As he wrote in 1966, "I now see/feel no more absolute necessity for a sound track than a painter feels the need to exhibit a painting with a recorded musical background. Ironically, the more silently-oriented my creative philosophies have become, the more inspired-by-music have my photographic aesthetics and my actual editing orders become."[30] This comment suggests that Brakhage's silent films are deeply musical. If he were to add music to *Window Water Baby Moving*, the film would paradoxically become *less* musical. Silence is necessary for the film's precisely calibrated editing rhythms to fully emerge. Here is how Brakhage's second wife, Marilyn, put it in an interview with Flicker Alley:

> The reason that Stan made mostly silent films is that he was concerned with the deep exploration of all forms of vision, and of making what he called a "visual music." Though his editing was often inspired by certain pieces of music, to then add actual music to the film would be like adding music to music. Any sound might tend to dominate over and influence how the images were seen, as his work did involve the intricate editing of multiple layers of micro visual rhythms. Several times, however, he did edit his film to music, but it was so precisely edited as to be a visual-aural

conversation in which one would respond to the other on an equality of terms. He did not want to use music as "background," nor for the images to be controlled by our experience of the sound.[31]

The lack of music in *Window Water Baby Moving* results in a deep ambiguity that makes it difficult to know how to engage with the film (and this difficulty is part of what makes the work so fascinating). Whenever I screen *Window Water Baby Moving* in class, I always ask students to share their impressions of the experience afterward, and I have never come across another film that elicits so many diverse and diametrically opposed responses. Some students react in a deeply visceral way. When I first screened the work, it was in an Introduction to Film class, and I decided that I wanted students to go in "cold," so I told them nothing about the film's content. I wanted them to encounter the imagery as an "adventure of perception,"[32] without a verbal introduction that might inadvertently engender biases or pre-conceptions. I came to regret this decision. After only a few minutes, two men ran out of the room screaming, and others told me that they wished I had warned them of what was about to happen so they could better "prepare" themselves. I took this to heart for subsequent screenings, warning students of the explicit content in advance and telling them that they were free to leave the room at any time (either before or during the screening). Even with this caveat, however, the film continued to constitute a visual assault for certain students. For example, during one screening, at the moment in the film when the placenta appears, one of my students passed out, and it was necessary to stop the film and call for emergency assistance. (Thankfully she recovered quickly and returned the next class period.) And such responses to *Window Water Baby Moving* are not uncommon.

Brakhage claims that at almost every early screening of the film, "someone would faint," and Carolee Schneemann recalls screenings in which "there were men who threw up" and others who "rushed out of the theater in revulsion and panic."[33] I suspect that these responses to the film are intensified by Brakhage's use of silence. In many films, unsettling music serves to prepare spectators for the shocking images that will soon appear on the screen. But Brakhage's silence—along with the film's nonlinear editing—makes it difficult for spectators to anticipate the sudden appearance of the film's most visceral images, such as the delivery of the placenta or the extreme close-ups of Jane's bleeding vagina.

So these intense responses capture how a certain segment of my students respond to *Window Water Baby Moving*. For some, the film is gruesome and horrific, an experience not unlike watching a body horror film. These students often demand a rationale for the screening, asking questions like "Why was it necessary to show us that?" For others, the film is tender and beautiful, a filmmaker's love letter to his family. For these students, the graphic images are beside the point. What really stands out is Brakhage's deep affection for his family: the way his hand gently caresses Jane's belly, or the way his face lights up with joy when Myrrena is born. Still others find the film to be exciting. The rapid editing and the out-of-focus shots all suggest an experience that is exhilarating. For these students, the film indexes the way a landmark event can overpower and overwhelm.

I have no desire to favor one of these readings over another. In a sense, they are all legitimate. *Window Water Baby Moving* is gruesome *and* beautiful, horrific *and* exhilarating. It explores the "joyous agony" of birth. Yet I suspect that this remarkable multiplicity of responses would not be possible if Brakhage's

images had a musical accompaniment. Music generally serves as a cue for the audience, alerting them to the emotional tenor of a specific scene. If the music of, say, Krzysztof Penderecki had been used, *Window Water Baby Moving* would have become a horror film, a disturbing concatenation of sweat, blood, and afterbirth. If it instead featured free jazz by Ornette Coleman, the film would have seemed more like a restless and improvisatory art film drenched in adrenaline and nervous energy. And if Brakhage had used inspirational music, à la *Chariots of Fire* (Hugh Hudson, 1981), the film would have become a drama about the beauty of birth and the triumph of the human spirit—or, perhaps, unbearably mawkish tripe. The silence of *Window Water Baby Moving* complicates its generic status and opens up a plethora of ways for spectators to engage with the film's content.

SILENCED CINEMA

We never see the same thing when we also hear.
—Michel Chion, *Audio-Vision: Sound on Screen*

To better appreciate the effect of silence in Brakhage's work and cinema more broadly, it will be useful to turn to the work of the sound theorist and *musique concrète* composer Michel Chion. In the opening chapter of his book *Audio-Vision: Sound on Screen*, Chion discusses the prologue of Ingmar Bergman's *Persona* (1966), a haunting sequence that is composed of cryptic and evocative images: an erect penis, an old cartoon of a woman washing her breasts, a spider, a bleeding sheep, nails being pounded into hands. These images are accompanied by an unsettling and discordant score by the Swedish composer Lars Johan

Werle, as well as a series of sounds that are often only obliquely related to the images on the screen: church bells, footsteps, dripping water. Chion recommends viewing this sequence (which is about five and a half minutes in length) *with* sound before cutting out the sound and watching it again in silence. This imposition of muteness produces a variety of revealing effects. To begin, Chion argues, one notices visual elements that had escaped one's attention previously. For example, he claims that silence changes one's perception of the sequence in which a hand is impaled by a nail: "Played silent, it turns out to have consisted of three separate shots where we had seen one, because they had been linked by sound." But beyond this, Chion argues that, without sound, "the entire sequence has lost its rhythm and unity." This prompts him to ask, "Could Bergman be an overrated director? Did the sound merely conceal the images' emptiness?"[34]

Since Chion is a perceptive theorist and a careful thinker, it is worth giving sustained attention to his audiovisual experiment and its implications. To begin, he is at his most Brakhagean when he suggests that silence enables him to detect visual elements in the film that he had initially been blinded to (that is, he sees that there are three shots of the impaled hand, not just one). During his 1973 interview with Robert Gardner on the television show *Screening Room*, Brakhage puts it this way: "If you're watching a TV program (like this one, for instance), and if you want to see how much sound distracts from your seeing something, go and turn the sound off. And when the sound's turned off, then my experience is . . . that seeing increases. Immediately. It's a physiological problem, really—or a psychological problem—that as we hear, vision diminishes."[35] For both Chion and Brakhage, filmic images are not discrete entities that maintain their autonomy regardless of their auditory

environment. Rather, they are inextricably imbricated in their soundscapes, even if those soundscapes are vacant ones. Like sound, silence does not merely *accompany* a visual experience; it *shapes* it.

Chion is keenly aware that silence is a double-edged sword, however. While he acknowledges that silence can enhance the visual field, Chion also suggests that silence can destroy the "rhythm and unity" of a sequence. What are we to make of this claim? And how are we to answer Chion's provocative questions: "Could Bergman be an overrated director? Did the sound merely conceal the images' emptiness?" There are a number of important points to make here. First, Bergman clearly *intended* for the images of his prologue to have a sonic supplement. In other words, Chion's version of *Persona* is not merely silent; it is *silenced*. To divest these images of their sound track and then denounce them for being empty would be a bit like attending a performance of *Hamlet*, putting in earplugs, and claiming that viewing the "To be, or not to be" soliloquy in silence exposed the poverty of Shakespeare's play. As Maurice Merleau-Ponty has argued, "Talking-films do not merely add a sonorous accompaniment to the spectacle, they modify the tenor of the spectacle itself."[36]

Furthermore, the perceived "emptiness" of Bergman's images is questionable. While I adore Lars Johan Werle's music and prefer the prologue with the sound track intact, I must confess that I still find Bergman's imagery to be remarkably powerful without the sound. I suspect that Chion's impression of "emptiness" is partly the product of his knowledge of what the film is "supposed" to sound like. When we get ready to project Bergman's prologue in silence, Chion encourages us to "try to forget what we've seen before, and watch the film afresh."[37] But, of course, we can't *really* forget what we've already seen. When watching

Persona in silence after watching it with sound, one cannot escape the feeling that something is missing. And even someone who had never seen *Persona* would still likely find the silenced prologue to be incomplete. Since the vast majority of films have a sound track, seeing a film without one is disconcerting—at least at first. When I first discovered Brakhage in my early twenties, I was uncomfortable with his silences, but after I watched several of his films, this discomfort disappeared. Once I became acclimated to Brakhage's aesthetic, his silences no longer seemed unnatural. They seemed essential.[38]

BRAKHAGE AND CAGE

It is all very well to keep silence, but one has also to consider the kind of silence one keeps.

—Samuel Beckett, *The Unnamable*

Any discussion of silence in Brakhage's cinema would be incomplete without an engagement with the work of John Cage, who famously argued that "there's no such thing as silence."[39] Since Brakhage was a student of Cage's—and since both artists made extensive use of silence in their works—it is worth reflecting on the relationship between their respective aesthetics. Is Brakhage's aesthetic, in some sense, Cagean? Is the silence of a film like *Window Water Baby Moving* analogous to the silence of Cage's *4'33"* (1952)?

To answer these questions, some historical context will be helpful. Cage was no stranger to experimental cinema. For example, he collaborated briefly with the German animator Oskar Fischinger in 1937 while the latter was working on *An Optical Poem* in Hollywood.[40] Cage was also a friend of Maya

Deren's and made a brief appearance in Deren's film *At Land* (1944), which, like *Meshes of the Afternoon*, was originally released with no sound track.[41] Furthermore, Cage collaborated with Marcel Duchamp on *Discs*, a segment in Hans Richter's portmanteau film *Dreams That Money Can Buy* (1947), which included contributions by Max Ernst, Fernand Léger, and Man Ray. *Discs* pairs hypnotic spinning rotoreliefs designed by Duchamp (familiar to anyone who has seen his film *Anémic cinéma* [1926]) with original music by Cage (a composition for prepared piano called *Music for Marcel Duchamp*).[42] Brakhage said that he sought out instruction from both Cage and Varèse because he was trying to discover "a new relationship between image and sound," one that might enrich his filmmaking practice.[43] Brakhage met Cage in 1954, just two years after the release of *4'33"*, through a mutual friend named James Tenney, the composer who collaborated with Brakhage on his first film, *Interim*. Brakhage called Cage and met up with him for a beer so he could ask permission to use a segment of Cage's *Sonatas and Interludes* (1946–1948) for the sound track of his film *In Between*. Cage responded without hesitation: "You know, I'm into something else now. I am no longer interested in the *Sonatas and Interludes* or any of my music from that period. You can do what you want with it."[44] Cage also spent hours drinking beer with Brakhage while articulating his musical philosophy, which Brakhage said "changed everything for [his] 21 year old self."[45]

Brakhage's admiration for Cage is clear. In addition to conversing with Cage and using his music for *In Between*, Brakhage was also inspired by Cagean aesthetics in his own cinematic practice. For example, in 1961 he used aleatory operations in the construction of the *Prelude* for his film *Dog Star Man* (1964), since, as he puts it, he was at that time "operating under some of Cage's ideas about chance."[46] And in a 1962 letter to Michael

McClure, Brakhage called Cage's book *Silence* "THE most completely perfect aesthetic structuralizing religious what-not statement yet made (to my knowledge) in our times. It IS the 'terrible machine' which will separate the men from the boys, as the saying goes, in all creative endeavors. Few will survive. It is a marvelous book! I have survived."[47]

In spite of all this, Brakhage was ambivalent about Cagean aesthetics. Later in the interview with Robert Gardner, Brakhage claims that he and Cage "agree about a lot of things" but then adds, "I'm not so agreeable about chance operations, which I think make a very rigid pattern ultimately, and I think mathematically that's provable." (Unfortunately, for no apparent reason, Gardner cuts Brakhage off at this point and changes the subject.) In fact, if Brakhage was open to Cagean chance operations in 1961 (during the filming of the *Prelude* to *Dog Star Man*), his views appear to have changed rather quickly. Just two years later, when *Metaphors on Vision* was published in *Film Culture*, Brakhage announced a break with his former mentor, articulating his desire to "avoid John's Cage, per chance, these last several years."[48] The clever severing of *perchance* into its constituent morphemes—*per chance*—evokes Cage's aleatory aesthetic, the very aesthetic that Brakhage had come to see as confining and restrictive (as suggested by the expression "John's Cage").[49] Similarly, in the introduction to *Metaphors on Vision*, Brakhage insisted that the "visual silences" of *Dog Star Man: Part I* were not Cagean but Feldmanesque: "I really love John Cage's music even though I only used his aesthetics to tie up my brain with. I do love the occasions in his music, but more particularly in the music of Morton Feldman, of sound occurring and there then being a silence that's just long enough to sustain that sound before the occurrence of the next sound."[50] Here and elsewhere, Brakhage expresses both an admiration for Cage and a desire to

move beyond him. Here is how he put it in a 1962 letter to P. Adams Sitney: "Cage has laid down the greatest aesthetic net of this century. Only those who honestly encounter it (understand it also to the point of being able, while chafing at its bits, to call it 'marvelous') and manage to survive (i.e., *go beyond it*) will be the artists of our contemporary present."[51]

So is the silence of *Window Water Baby Moving* a Cagean silence? Yes and no. On the one hand, the effect of the film's silence is strikingly similar to that of *4′33″*. For example, both works provide an aesthetic encounter with something that one expects to be audible, but which isn't: in one case, a woman in labor; in the other case, a pianist at a concert hall. And in both works the relative silence prompts one to experience a heightened awareness of the ambient sounds of one's immediate environment. For example, on one occasion, when I screened *Window Water Baby Moving* for an Introduction to Film class, I noticed something that I had never really noticed before, even though the class had been meeting regularly for about two months: the chairs in the classroom were incredibly noisy. The slightest movement forward or backward in my chair produced a high-pitched squeak for all in attendance to enjoy. It was clear that my students noticed the sounds of their own chairs as well, as a number of them became preternaturally still in an attempt to silence the cacophonous symphony of squeaks. Along similar lines, I always pay close attention to the aural environment of the room whenever the shot with the placenta appears. In my experience, classes are never uniformly silent at this point in the film. I always hear something: a shriek, a gasp, an "Oh, dear God!" (In this respect, the placenta's appearance in *Window Water Baby Moving* is not unlike the sliced eyeball sequence in Salvador Dalí and Luis Buñuel's *Un Chien Andalou* [1929], which also consistently elicits sounds of shock and incredulity.)

On the other hand, Cage is interested in opening up his composition to chance—the random sounds of the audience that happen to be present for a performance on any given day—and this is not one of Brakhage's preoccupations. While Cage was happy to assimilate any sounds emanating from the audience as simply part of the composition, Brakhage saw such sounds as undesirable. In fact, he even found the sound of the film *projector* to be an unfortunate distraction from his imagery.[52] If one is looking for Cagean aesthetics in experimental cinema, one should not turn to the films of Brakhage. One should turn, instead, to the films of Andy Warhol. For early screenings of his silent film *Sleep* (1963), Warhol turned on a radio set to a pop station and allowed it to accompany the film's images. Like Cage, Warhol relinquishes authorial control: whatever happens to be on the radio will become the film's sound track, and that sound track will change the next time the film is screened. And this is not to mention the way that *Sleep*'s aleatory radio accompaniment echoes Cage's own use of radios as instruments in compositions like *Imaginary Landscape No. 4 (March No. 2)* (1951) and *Radio Music* (1956). Beyond this, as Fred Camper has noted, Warhol had no desire to silence his films' spectators; rather, he "assumed that the audience would provide the sound track" by conversing about the film and other topics during the screening.[53] By contrast, Brakhage wants his audiences to be as quiet as possible, and he certainly doesn't want random pop music playing during his films. Cage does not believe in silence, and he wants to awaken his audience to the quotidian sounds that surround them. Brakhage's silences, however, are not Cagean nets designed to capture and aestheticize the sounds of the environment. Rather, Brakhage's silences are designed to heighten our awareness of the filmic image. Cage's silences open our ears; Brakhage's silences open our eyes.

BRAKHAGE'S LEGACY

Stan Brakhage taught a generation of experimental filmmakers how to see differently.

—Ara Osterweil, *Flesh Cinema*

I want to conclude with a brief examination of Brakhage's legacy, with an emphasis on how later filmmakers responded to his aesthetic of silence. In the wake of groundbreaking films like *Window Water Baby Moving, Mothlight* (1963), and *Dog Star Man*, almost every experimental filmmaker has felt compelled to respond to Brakhage's work in some way. As Annette Michelson puts it, in an essay that discusses Brakhage in tandem with Sergei Eisenstein, "You may, then, view Eisenstein and Brakhage negatively, postpone judgment, recommend rejection, but you cannot, I will claim, avoid situating yourself in relation to them."[54] For example, it is difficult to overstate how formative Brakhage's work was for the artist Carolee Schneemann, who wrote, "The conditions of affinity, mutual influence, and response are more consistent between Stan's and my work than is normally understood."[55] Nowhere is this clearer than in Schneemann's film *Fuses* (1964–1967), a direct cinematic response to *Window Water Baby Moving*. *Fuses* depicts Schneemann having a series of sexual encounters with James Tenney (the composer who introduced Brakhage to Cage), although the imagery is often deliberately indistinct, as the celluloid has been burned and stained. The film thus foregrounds both the materiality of the bodies displayed (Schneemann's and Tenney's) and the materiality of the filmstrip itself. Schneemann saw her film as a counterweight to *Window Water Baby Moving*. While Brakhage's film focused on childbirth, with little attention to the sexual energies that make such an event possible, Schneemann

claims, "I wanted to see 'the fuck,' lovemaking's erotic blinding core apart from maternity/paternity."[56] Nevertheless, there are a number of similarities between *Fuses* and *Window Water Baby Moving*. Both films give sustained attention to the human body (thus risking charges of obscenity). Both films collapse the boundaries between the public and the private. And both films are silent, relying on editing to produce what Schneemann has called "a music of frames."[57] Additionally, Schneemann's silence, like Brakhage's, results in a heightened level of ambiguity. Sex scenes in cinema usually have a musical supplement that allows the spectator to "read" the sexual encounter as romantic, erotic, or distressing. But the lack of sound in *Fuses* results in sexual encounters that are impenetrable.

Another experimental filmmaker who has situated herself in relation to Brakhage's work is Marjorie Keller. According to Keller, "I don't know that there could be an avant-garde film-maker in America that is not in some way indebted to Stan Brakhage, has not studied his films, has not thought about them and taken them seriously. And I certainly don't consider myself an exception."[58] Keller's film *Misconception* (1977) is often seen as a response to Brakhage's *Window Water Baby Moving* insofar as it is an impressionistic and nonlinear meditation on childbirth that records the actual birth of a baby girl. Of course, Keller's film provides a female perspective on childbirth that Brakhage could not provide.[59] Additionally, unlike Brakhage's film, *Misconception* uses a broad variety of sounds, including discussions of childbirth, heavy breathing, moaning, and vagitus. These sounds are often fragmentary and deliberately asynchronous. For example, at one point, when the placenta arrives, a man's voice is heard asking, "[Are you] sure I can't offer you one of these?" While the original conversation appears to be a simple slice of hospitality, as a man offers a beverage to a guest, its

recontextualization playfully gestures toward placentophagy, the practice of eating the placenta after birth. Additionally, in the spirit of the film's title, the sound track is filled with voices discussing a variety of "misconceptions" about conception, as when a woman's voice proclaims, "The way that the Virgin Mary and Jesus were conceived was by light coming from God entering the ear." (A man is then heard laughing incredulously and responding, "He stuck it in her ear!") Keller claims that she is "a student of [Brakhage's] filmmaking," but, she adds, "[Brakhage] is not interested in sound and I'm really interested in sound. I'm really interested in what sound does to an image, how many relationships there can be between an image and a sound."[60] In other words, Brakhage argues that sound changes the way we see an image, and because of this, he generally worked without sound, as this would allow his images to speak for themselves. Keller, on the other hand, works with sound precisely *because* it changes the way we see an image. She is interested in the dialectical relationship between image and sound, the way that, in the words of Merleau-Ponty, "visual and auditory experience . . . are pregnant with each other."[61]

It is worth giving sustained attention to one additional experimental filmmaker who has situated himself in relation to Brakhage's practice: James Benning. The prolific American filmmaker is a key figure in "structural cinema," a minimalist cinema "of the mind rather than the eye" that is often seen as the antithesis of the lyrical and mythopoeic works pioneered by Brakhage.[62] I would argue that no film better encapsulates Brakhage's complex relationship to the avant-gardists who followed him than Benning's *Grand Opera: An Historical Romance* (1978), a heterogeneous and sprawling structural film overflowing with allusions to the history of experimental cinema. The film features appearances by a number of canonical avant-garde filmmakers,

including Michael Snow, Yvonne Rainer, Hollis Frampton, and George Landow (aka Owen Land). While *Grand Opera* does not (quite) feature an appearance by Brakhage, at one point early in the film the screen goes black and a voice is heard rambling a bit before saying, "My ability to work with meaningful sound was left very far behind the abilities with vision." At this point, the source of the voice is made clear, as the words "By Brakhage" briefly appear on the black screen, apparently scratched onto the film by Benning himself in a delicious parody of the Brakhagean trademark. The black screen returns as Brakhage continues his speech:

> And then I began noticing sounds were holding films back. Then I began noticing how they're holding most films back—or, as it's used commercially, they are blinding the viewer to some extent so that films look very much better than they are. There is a distraction between the ears and the eyes—and the ears will always take it, actually. The eyes don't really have it in this case because in this society, at least, we're very, very oriented to hearing, and not very creative visually. So it was really that I began seeing how sound distracts from vision, and also, I was not able to keep the creativity of the sounds that I might use consonant with the development of vision. So sounds were gradually slipping into being illustrated. And at that point, it suddenly occurred to me that film did not *have* to have a sound track. The fact that we *have* the technical possibility doesn't mean you have to use it. And so I guess *most* of my work since then has been silent. And I'm not against sound film, though I rather think of it as grand opera.

These comments are followed by the appearance of a jazz trio playing music: a saxophonist, a bassist, and a bongoist. After a brief musical prelude, the bongo player introduces the band:

"Good evening. We're a group called Grand Opera. We'd like to play a little tune for you entitled 'Now Place the Number Fourteen on the Umbrella.'" They jam for approximately two minutes.[63]

There is much to unpack in this brief passage. To begin, what does Brakhage mean, exactly, when he dismisses much of sound film as "grand opera"? In part, Brakhage appears to be arguing that most sound films (like most operas) traffic in melodramatic spectacle and lavish production numbers, elements that are diametrically opposed to Brakhage's more subdued and contemplative aesthetic. But beyond this, opera as a genre is often predicated on straightforward audiovisual relationships (e.g., one watches Brünnhilde sing while listening to her voice), precisely the kind of relationship that Brakhage is attempting to reconfigure. Yet Benning embraces cinematic sound throughout his film and even titles the work *Grand Opera* in defiance of Brakhage. Here is how Benning puts it in an interview with Scott MacDonald: "I agree with what [Brakhage] says, basically that you can't see and hear at the same time. It made him decide to work visually, but I concluded the opposite. I wanted to use sound *because* it makes you look at things differently." He adds that *Grand Opera* is, in part, "about sound-image relationships."[64]

Benning's complicated relationship to Brakhage (he both "agrees" with him and moves in the "opposite" direction) is reflected in the aforementioned segment from *Grand Opera*. On the one hand, the segment can be read as an affirmation of Brakhage's assertion that simultaneously using sound and imagery can create a "distraction" for the viewer. In other words, one could argue that Benning's choice of a black screen (rather than, say, an image of Brakhage) is a respectful gesture, one that allows Brakhage's words to have their full effect, undiluted by any extraneous imagery. On the other hand, this segment can be

seen as a perversion of the Brakhagean aesthetic. If Brakhage normally affirms the primacy of sight by giving us imagery without sound, Benning takes us to a world in which imagery has been extinguished and *sound* is king. So Benning manages to pay homage to Brakhage while also distancing himself from Brakhage's aesthetic, embracing instead the new structuralist paradigm that Michael Snow and Hollis Frampton were then spearheading.[65] In fact, Benning's ambivalence about Brakhage is particularly salient in his discussion of the source of the Brakhage speech that he includes in *Grand Opera*. Here is how Benning remembers it:

> Brakhage was a visiting artist at the University of Oklahoma in the spring of 1977, invited there by John Knecht, who was the sole film faculty member at the time I was teaching photography. I asked Brakhage why he mainly made silent films. And I made it clear that my question wasn't "Why don't you make sound films?" I asked him earlier if I could tape record his talk with my Nagra for the art school archive and my own use and he had agreed. Then when I asked him the question, he gave the answer that's in *Grand Opera*, but before he gave that answer, he asked me in front of the audience if I was recording him, which of course he knew I was. And then he gave me a lecture in front of the audience about how I wouldn't really hear his answer because I was too busy recording him, and that since I'd never listen to the recording in the future, I'd never know what his answer was. Which made me think, "Why are you such a prick?" but I kept it to myself. I met Brakhage years later at CalArts where I now teach, and I must say he had mellowed out a lot and was quite nice, perhaps half of the prick I thought him to be. I do like some of his films though.[66]

In addition to being wildly entertaining (who can resist a bit of underground film gossip?), Benning's recollection further clarifies the significance of the Brakhage sequence in *Grand Opera*. If Brakhage is going to dismissively assure the audience that Benning will never listen to the recording he is making, Benning will call his bluff. He will not only listen to the recording, he will *prove* that he has listened to the recording by incorporating it into a film—one that simultaneously affirms and challenges Brakhage's assertions.

In spite of their occasionally antagonistic relationship, James Benning's own thinking about film continues to be informed by Brakhage's ideas. For example, in 2012 the AV Film Festival screened Benning's *Nightfall* (2011), a work that consists of a ninety-eight-minute shot of a sunset in the West Sierras. Benning was present for the screening, and after the film ended, one spectator commented on the rich auditory experience that the work provided. Benning's response was revealing: "I think if you watched it in the dark, you'd hear more. And maybe if you watched it silenced you'd see more. . . . It's hard to see and hear at the same time."[67] Benning's views on cinematic silence are remarkably similar to those of Brakhage. Both filmmakers recognize that sight and sound are deeply imbricated. And both filmmakers understand that silence enables one to see images that otherwise might escape one's attention. Silence is not merely a state of deprivation—it is a powerful aesthetic tool, one that has the potential to focus the mind and sharpen the eye. As Brakhage puts it, "I don't make my films silently out of caprice. I feel they need a silent attention."[68]

3

NAOMI UMAN AND THE
PEEKABOO PRINCIPLE

I hear underclothes tearing like some great leaf
Under the fingernails of absence and presence in collusion.
—André Breton, "Vigilance"

Accustom the public to divining the whole of which they are
given only a part. Make people diviners. Make them desire it.
—Robert Bresson, *Notes on the Cinematograph*

n 1951 Robert Rauschenberg rolled commercial white house
paint onto a series of canvases to create works that were osten-
sibly free of any content. His goal was to "see how much you
could pull away from an image and still have an image."[1] There
were several iterations of these austere, mysterious objects: some
with a single panel, others with two, three, four, or seven pan-
els. John Cage was deeply moved by Rauschenberg's white paint-
ings. He saw them not as mere voids but as "airports for the
lights, shadows, and particles."[2] Cage was astonished by just how
much Rauschenberg had managed to evacuate from the aesthetic
encounter:

No subject
No image
No taste
No object
No beauty
No message
No talent
No technique (no why)
No idea
No intention
No art
No feeling
No black
No white (no *and*)[3]

But where could Rauschenberg go from here? The white paint-
ings seemed to push aesthetic absence to its limits. If the rest-
less young artist had already created nothing, was the only
remaining option *something*? Or might he succeed in discover-
ing a new species of absence?

Rauschenberg had an idea. What if, instead of painting a can-
vas white, he *erased* a preexisting art work? He tried erasing
some of his own drawings, but he was dissatisfied with the
results. He would need to erase a work by another artist. In 1953
Rauschenberg visited the home of the celebrated abstract expres-
sionist Willem de Kooning: "I bought a bottle of Jack Daniel's
and hoped that he wouldn't be home when I knocked on the
door. And he was home. And we sat down with the Jack Dan-
iel's, and I told him what my project was. He understood it. And
he said, 'Okay. I don't like it, but I'm going to go along with it
because I understand the idea.'" De Kooning began to look
through his portfolios to find a drawing for Rauschenberg to

erase, but he did not want to sacrifice a subpar sketch. For the gesture to have meaning, de Kooning would have to sacrifice a work of considerable originality and inspiration, a work that he would "miss." De Kooning had another requirement. If his artistic creation had required time and effort, he wanted to ensure that its annihilation would require time and effort, as well: He told Rauschenberg, "I'm gonna make it so hard for you to erase this."[4] De Kooning finally gave Rauschenberg a drawing that he had made with charcoal, oil paint, pencil, and crayon. Rauschenberg gratefully accepted the gift and then proceeded to attack it with "about fifteen different types of erasers."[5] After scraping away at the canvas for a full month, Rauschenberg finally succeeded in effacing the image. Well, almost. *Erased de Kooning Drawing* (1953) is still teeming with the fragmentary and inchoate traces of the original drawing. As Craig Dworkin notes, a more accurate title for the work would be *Partially Erased de Kooning Drawing.*[6] Looking at the recalcitrant residue of de Kooning's art work, one is reminded of an aphorism by the Lettrist artist Gil Wolman: "An image cannot be deleted . . . something always remains."[7]

In 1919 Marcel Duchamp revealed that art could consist of simply *adding* an element to a preexisting work when he drew a mustache and a beard on a postcard reproduction of the *Mona Lisa*. Now Rauschenberg was moving in the opposite direction by *subtracting* elements from a preexisting work. John Cage provided a succinct synopsis of this aesthetic history: "Duchamp showed the usefulness of addition (mustache). Rauschenberg showed the function of subtraction (De Kooning). Well, we look forward to multiplication and division. It is safe to assume that someone will learn trigonometry. Johns."[8] Perhaps the time has come to fill in some of the blanks in Cage's schema: surely Andy Warhol is the great multiplier, with his endless

repetitions of soup cans, Coke bottles, and cow heads. My vote for the great divider goes to Agnes Martin, whose monochromatic canvases are partitioned into discrete tessellated units. But did Jasper Johns ever "learn trigonometry"? And did an artist ever manage to discover the aesthetic analogue of multivariable calculus?

How might we transfer Cage's mathematical metaphor to the domain of cinema? Sergei Eisenstein is the filmmaker who is most invested in addition, the way the montage of two distinct shots creates a whole greater than the sum of its parts ($1+1=3$). The apotheosis of cinematic multiplication comes from Bruce Conner. In his Warholian found footage film *MARILYN TIMES FIVE* (1968–1973), Conner loops erotic footage of the Marilyn Monroe doppelgänger Arline Hunter while the sound track repeats Monroe's rendition of "I'm Thru With Love" (from Billy Wilder's *Some Like It Hot* [1959]) five times. The great divider of cinema is Willard Maas, who in *Geography of the Body* (1943) uses extreme close-ups to subdivide the human form into its constituent parts: an eye, an ear, a breast, a mouth. And I would argue that one of the most forceful articulations of subtraction in cinema comes from Naomi Uman. In 1999 the American experimental filmmaker used nail polish and bleach to eliminate the women from a German pornographic film of the 1970s. The result, *removed*, is a fascinating and witty work of filmic erasure. While the spectator can still *hear* women reciting stereotypical lines of lubricious dialogue ("They say problems are best solved in bed"), the women can no longer be *seen*. In their place are amorphous, palpitating white holes that seem to be both immaterial traces of past presences and concrete ontological entities.[9] In this chapter I unearth precedents for Uman's experiment in the erasures of avant-garde artists like Tom Friedman and Tom Phillips. I also argue that *removed* exploits a dialectic between absence and presence to expose (and reconfigure)

the spectator's scopophilic and phonophilic desires. Finally, I claim that the film's potential for eroticism is largely derived from what the neuroscientist V. S. Ramachandran has called "the peekaboo principle," a psychological mechanism that causes humans to be drawn to that which is hidden, erased, or obscured. Before fleshing out these arguments, however, it will be useful to provide a brief summary of Uman's seven-minute found footage film.

"TELL ME WHAT YOU SEE": A SYNOPSIS OF *REMOVED*

Absence disembodies.

 —Emily Dickinson, "Absence disembodies—so does Death"

Prologue. *removed* begins with an erased woman staring at the camera in silence. Like Rauschenberg's *Erased de Kooning Drawing*, the effacement is only partial. Ghostly traces of the original image remain, permitting the viewer to glimpse a semblance of the woman's hair, eyes, nose, and mouth (see figure 3.1). The title of the film appears on the screen, and 1970s exploitation music begins to play.

Scene One. A white blob where a woman's body once was writhes and moans orgasmically on a bed as a young, handsome man with formidable sideburns watches. It appears that the woman—whose name is Yvonne—is masturbating, and the observant man strokes his chin, bemused by the spectacle. Yvonne seductively asks the man to join her, but he stays in place, saying, "I tried very hard that time too. But the good doctor's minions were more attractive. It's too bad, Yvonne. The train's pulled out of the station." It quickly becomes clear that we have

FIGURE 3.1 Naomi Uman, *removed* (1999)

entered this erotically charged film *in medias res*. Since its nar-
rative armature has been removed, we can only guess at the
meaning of the cryptic dialogue. (What did the man try so hard
to do? And who are the doctor and his minions?) When Yvonne
asks the man, "Will you stay on the platform and wave to me?"
he responds with a cocky "No." As she walks away, he stares at
her and says, "Have a good trip." After this, the screen becomes
black and the music abruptly stops.

Scene Two. After a few seconds of blackness and silence, the
music resumes and we are introduced to Walter, a short, middle-
aged man with a red bow tie and a cigarette dangling from his
mouth. Walter sits on a couch near an erased woman while using
a two-way mirror to voyeuristically spy on another woman in an
adjacent room as she undresses. Walter's female companion
removes her clothes and lies naked on a table in front of him,
in a position that prevents her from seeing the erotic spectacle

on the other side of the mirror. As Walter sensually caresses her body, she makes a request: "Tell me what you see." Throughout the following interchange, she breathes and moans heavily, clearly aroused by Walter's description of the woman on the other side of the mirror:

WALTER: She's standing near the mirror.

WOMAN: And?

WALTER: She's taking her make-up off.

WOMAN: And now?

WALTER: They're still arguing. He's taking his pants off.

WOMAN: Go on.

WALTER: She's almost finished removing her make-up. She's admiring herself. She's studying her body. She's rubbing her breasts.

WOMAN: How are her breasts? Hard? Small? Like mine?

WALTER: Bigger. Soft white skin. He's approaching her from behind.

WOMAN: What's he doing now, Walter?

WALTER: He's pulling her panties off. His hands are wandering over her body.

WOMAN: Oh yes!

WALTER: She's enjoying it.

WOMAN: Oh yes! Go on! Tell me! Everything! I want to know everything! Is she blonde? All over?

WALTER: As dark as you are.

WOMAN: Go on.

WALTER: She doesn't want to. Now he's turning her around. My God, she's got a fantastic ass!

WOMAN: Nicer than that lovely redhead's?

WALTER: Now he's pushing her down on the bed.

WOMAN: Oh yes!

WALTER: He's kissing her breasts.

WOMAN: Go on!

At this point, the music fades and a different mirror is shown. Unlike the two-way mirror that had previously displayed a man and his (absent) lover, this mirror is completely devoid of content. The shot of the mirror is initially bathed in blue before the color shifts to red. The woman asks, "What's the matter?" and the image of the mirror is abruptly replaced by film leader with upside-down numbers: 9, 8, 7, 6, 5, 4, 3. *Pornographia interruptus.*

Scene Three. We return to the attractive man from scene 1, who is on a bed with Yvonne. Since she had previously left him, it is unclear if the couple has reunited, or if we are simply witnessing events that took place *before* the ones presented at the beginning of the film. (After all, the placement of a countdown in the middle of the film—rather than at the beginning—suggests Uman's penchant for nonlinearity.) The man gets off the bed and walks away from Yvonne. Before leaving, he turns his head and gazes at her. Closing credits.

Epilogue. A black screen is displayed for almost a minute, accompanied by exploitation music and Yvonne's orgasmic moaning. Climax.

ERASURES

I composed the holes.

—Ronald Johnson, *Radi os*

Uman is not the only artist to remove the nude bodies from pornography. In the late 1990s and early 2000s, for example, a number of artists became interested in applying digital processes of erasure to pornographic images from the internet. In his *Buff*

series (1995–2005), Charles Cohen removes the actors from pornographic images, leaving in their place nothing more than evocative white silhouettes. In *Censored Porn (no flesh guaranteed)* (1997–2002), Mark Garrett replaces the flesh of nude bodies with computer desktop wallpaper. And in her *Stripped* series, Laura Carton erases the humans from pornographic photographs and digitally reconstructs the backgrounds, so that there is no longer any trace of the original lascivious content. (The only hint that there were once nude bodies in Carton's photographs comes from the titles, which are domain names like www.joyboys.com [2002], www.plumperhumpers.com [2004], and www.pussycakes .com [2004].)[10]

A noteworthy precursor to these experiments is *11 × 22 × 0.005* (1992) by the American conceptual artist Tom Friedman. The work is simply a blank sheet of creased paper suspended by a thumbtack that purports to be "an erased *Playboy* centerfold."[11] (The title is a straightforward articulation of the width, height, and depth of the blank page.) Craig Dworkin's analysis of *11 × 22 × 0.005* is perceptive: "The viewer's thoughts—whether of the no-longer-present *Playboy* image, or of Friedman's manipulation of that image—are all that is left to arouse interest in the work, which is otherwise an unexceptional sheet of minutely pierced and twice-folded paper. Like the magazine masturbator, the viewer of conceptual art (or at least of this work of conceptual art) falls back on the mental activity of imagination."[12] There are a variety of ways of engaging with the missing content of both *removed* and *11 × 22 × 0.005*: First, one could attempt to mentally reconstruct what the erased women look like. Second, one could "fill in the blanks" with one's own fantasies, in much the way that Laurence Sterne invites each reader of *Tristram Shandy* to imagine his own idealized woman on the novel's blank page: "Sit down, Sir, paint her to your own mind—as like your mistress as

you can—as unlike your wife as your conscience will let you—
'tis all one to me—please but your own fancy in it."[13] Third, one
could simply accept the absence *as* an absence, and stare into the
abyss. Fourth, one might reflect on the labor-intensive process
of each work's construction (or perhaps *de*struction). To create
removed, Uman had to first cover everything she wanted to pre-
serve with nail polish. She then covered the filmstrip in bleach,
which chemically reacted with the emulsion and effaced the
images that were not protected by the nail polish (that is, the
women in the film). In other words, before using bleach, Uman
had to meticulously apply nail polish to literally *thousands* of
individual frames on the filmstrip. When I asked Uman how
long it took her to create *removed*, she responded with exaspera-
tion: "A long time."[14] And one suspects a similar investment of
time would have been necessary to create *11 × 22 × 0.005*. If
Uman's methods involved working on her found footage one
frame at a time, Friedman's methods involved effacing the *Play-
boy* centerfold one eraser stroke at a time. Of course, one cannot
help but wonder if Friedman actually erased an image of a nude
woman (in much the way that Rauschenberg erased de Koon-
ing's drawing) or if he simply pretended to do so. But even if
Friedman's story about the construction of *11 × 22 × 0.005* is a fic-
tion, it is a functional fiction. The very fact that he *claims* that
this sheet of paper once featured a *Playboy* centerfold changes
the way a spectator "sees" the absence. Imagine how the aesthetic
experience would have changed if Friedman had instead claimed
to have erased a reproduction of the U.S. Constitution, or a page
from the Bible, or a photograph of Robert Rauschenberg's *Erased
de Kooning Drawing*. Absence never exists in isolation. An era-
sure can be understood only in relation to what has been erased.

I should add that precedents for Uman's experiment can be
found not only in the blank canvases of Rauschenberg and

Friedman but also in the literary erasures of the British artist Tom Phillips. In 1966 Phillips purchased a Victorian novel by W. H. Mallock entitled *A Human Document* (1892) and began covering most of its words with ink and paint. The result was an intermedia experiment that blurs the boundaries between literature and visual art. Phillips "erased" five letters of the original novel's title and christened his text *A Humument.* The first draft of the altered book was finished in 1970 and first published in 1980. The text has been in a state of constant evolution ever since.[15] *A Humument* features an astonishing array of aesthetic styles, from surreal squiggles (reminiscent of Miró) to parodic comic book appropriations (à la Lichtenstein). The (visible) text of the book is also replete with literary allusions, including nods to Beckett ("as years went on, / you began to / fail / better") and Joyce ("Oh, / Ah, / And / I said / yes / —yes, / I / will / yes).[16] In addition to Phillips's clear investment in postmodern pastiche, the artist is also interested in exposing the "unconscious" of the stuffy and humorless Victorian novel. In fact, the aesthetic underpinnings of Phillips's project are articulated on its very first page: "I / have / to hide / to reveal."[17]

This language provides a useful way of thinking about erasures in a broad variety of media. Let us return, for example, to *Erased de Kooning Drawing.* Not only did Rauschenberg (nearly) obliterate the titular de Kooning drawing, but when he had his erasure framed, he also "hid" another de Kooning drawing that was on the opposite side of the page. Yet by directing attention *away* from de Kooning's drawings, Rauschenberg simultaneously drew attention *to* details that one might normally overlook: the picture frame, the border, the inscription, the imperfections of the paper. Along similar lines, when viewing a pornographic movie, one's attention is normally monopolized by the eroticized body on the screen. But when this body is erased,

one instead notices other elements in the mise-en-scène: an empty bottle of Scotch, red flowers, Deutsche marks strewn across the bed. And one also experiences a heightened sensitivity to the film's sound track, including its lustful dialogue and orgiastic cries of pleasure. As Craig Dworkin puts it, "Erasures obliterate but they also reveal; omissions within a system permit other elements to appear all the more clearly."[18]

SCOPOPHILIA

There are circumstances in which looking itself is a source of pleasure.

—Laura Mulvey, "Visual Pleasure and Narrative Cinema"

One of the central themes of *removed* is scopophilia: the pleasure derived from looking.[19] As Laura Mulvey notes in her classic essay "Visual Pleasure and Narrative Cinema," scopophilia is a key component in cinematic spectatorship, since "the cinema satisfies a primordial wish for pleasurable looking."[20] This is particularly true of pornography, of course, a genre that is predicated on the gratification that comes from the gaze. In fact, in the original German pornographic film that Uman reworks, not only is the *viewer* meant to derive pleasure from looking at the eroticized bodies, but the film's *characters* derive pleasure from looking, as well. (Recall the scene in which Walter enjoys voyeuristically gazing on the sexual escapades of a young couple via a two-way mirror.) Mulvey further argues that women in film are often displayed in a way that foregrounds their "visual and erotic impact," their "*to-be-looked-at-ness.*" But by removing the female bodies from her film, Uman subverts women's "traditional exhibitionist role" in cinema while reconfiguring the spectator's scopophilic urges.[21]

Why does Uman do this? Why strip away porn's raison d'être: its nude bodies? I have shown *removed* to hundreds of students, and the answers they give to this question, while generally thoughtful, tend to be at odds with Uman's own stated intentions. For example, many students see *removed* as a critique of pornography, a way of destroying and defacing a pornographic film to fight back against the genre's misogyny and objectification of women. But Uman is not entirely comfortable with this reading of the film. She believes that "porn has an important role to play in society," adding, "[*removed*] is definitely not a critique of all pornography, since I'm not anti-porn. I think that porn made with the explicit consent of all adult participants is its own art form. It doesn't necessarily reduce women to simple recipients or vessels."[22] Other students see *removed* as a feminist deconstruction of what Laura Mulvey calls "the male gaze."[23] While *removed* may or may not be a feminist film (Uman deflected this question when I interviewed her), it was not intended to be a critique of the male gaze.[24] Uman rejects the assumption that "the gaze that desires to see the female body is entirely male." There are, after all, a number of gay men who have little desire to see sexualized female bodies, and a number of gay and bisexual women who *do* desire to see these bodies. And this is not to mention the scopophilic pleasure that even straight women and gay men can derive from gazing on the nude female form. For Uman, "the desire to see" is "without gender."[25]

So if, in Uman's view, *removed* is not a critique of pornography or a feminist treatise on the male gaze, what is it? Why did Uman laboriously erase the women from thousands of frames of pornographic film? In an interview with Soledad Santiago, Uman revealed that one of her motivations in making *removed* was thinking through what makes porn pornographic: "I wanted to see what would happen if you remove the women. Would it still be pornography?"[26] In her interview with me, Uman

concluded that the answer to this question is no: "I don't really think of [*removed*] as pornographic (and we have shown it in audiences with children). There is no nudity, and the point of the film is not to arouse."[27] There is much to unpack in this response. To begin, notice that Uman is not categorical in her categorization of the film. She does not say, "[*removed*] is not pornographic," but "I don't *really* think of [*removed*] as pornographic," a statement that suggests a certain level of ambivalence. Obviously, Uman has erased what many consider the *sine qua non* of heterosexual pornography: the nude women. But Uman is not entirely correct to assert that "there is no nudity" in *removed*. Early in the film a nude man's buttocks is visible for several seconds, and throughout the film there are very brief flashes of female nudity. Of course, nudity alone is hardly a sufficient condition for pornography, which is likely why Uman follows up this statement with another one: "The point of the film is not to arouse." I have no doubt that this is true. But even if arousal was not the point of *removed*, it is certainly one of the film's effects, at least for some spectators. In fact, Uman herself finds *removed* to be "far more erotic" than the original pornographic film it repurposes.[28]

It may be helpful to think of *removed* as a cinematic version of the sorites paradox. In this paradox, attributed to the ancient Greek philosopher Eubulides, the question is this: When is a heap of sand no longer a heap? (The word *sorites* comes from the Greek word *soros*, which means "heap.") Surely one cannot simply remove one grain of sand from a heap and then proclaim that it is no longer a heap. But how many grains of sand *would* one have to remove? A hundred? A thousand? There is no clear-cut boundary between a heap and a nonheap. Uman seems to be carrying out a similar procedure with pornography. The question now becomes this: When is a pornographic film no longer

pornographic? What if one erases the women? What if one erases all the imagery, leaving behind only orgasmic moans and music? Perhaps the best answer to the question "Is *removed* pornographic?" is "Kind of." Like a heap of sand, pornography is (in Wittgensteinian parlance) "a concept with blurred edges."[29]

But *removed* is more than a philosophical exploration of the ontology of pornography. Uman provides another motivation for her experiment: "I wanted to see what a porn film would *look like* if the women were removed and the absence remarked upon by the accentuating presence of an animated hole."[30] In other words, part of the impetus for the film's construction was sheer visual curiosity. If *removed* thematizes the scopophilia of its characters and its spectators, the film is also designed to satisfy Uman's *own* scopophilia, to reveal to Uman what she herself "wanted to see."

By both obscuring and revealing content that spectators might "want to see," *removed* has affinities with more traditional forms of erotic spectacle, such as stripteases. As Rachel Shteir has noted, striptease is not simply about exposed flesh but about the delicate tension between the seen and the unseen: "Striptease is more about the *relationship* of being dressed to being undressed than about mere nudity."[31] And Linda Williams persuasively argues that this dialectic between what is shown and what is hidden is present not only in striptease but in *many* forms of "sexual spectacle," including pornography.[32] After all, pornographic films rarely begin with completely exposed flesh. More often than not, there is a *build-up*, an attempt to tease (and entice) the audience as the nude body is gradually revealed. This tension is especially salient in softcore pornography, the genre that Uman appropriates in *removed*. In his monograph *Soft in the Middle: The Contemporary Softcore Feature in Its Contexts*, David Andrews perceptively conceptualizes softcore pornography as a "peekaboo

form emulating the mechanisms of striptease."[33] Uman is well aware of the game of "peekaboo" that is played in erotic spectacles such as striptease and pornography, and she playfully gestures toward this convention by playing her *own* game of peekaboo with the audience. As Danni Zuvela observes, *removed* exploits "the central erotic tension of the striptease, the play between exposure and concealment," and as a result, "the spectator strains to see what is denied, is inexorably drawn to what is withheld."[34]

Take the erased women, for example. At times they are completely invisible, replaced by jittery white holes (see figure 3.2). At other times the bleach does not entirely erase the nudity, resulting in barely legible traces of the original faces and bodies (see figure 3.3). On still other occasions Uman's bleach fails to completely cover the nude female form (see figure 3.4). Finally, there are moments in which a nude woman becomes completely visible, but only for a split second (see figure 3.5). The flashes of full frontal nudity are unintentional byproducts of the way the

FIGURE 3.2 Naomi Uman, *removed* (1999)

FIGURE 3.3 Naomi Uman, *removed* (1999)

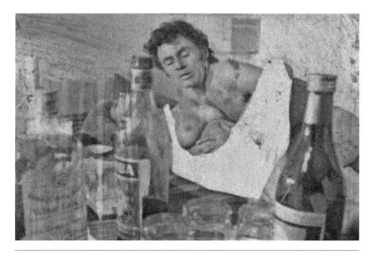

FIGURE 3.4 Naomi Uman, *removed* (1999)

source material was spliced. Uman recalls, "The original film print had been spliced in several places, and when I bathed the whole thing in bleach, the one frame on either side of the splice would not be erased." But even if these brief glimpses of nudity

FIGURE 3.5 Naomi Uman, *removed* (1999)

are unintentional, their inclusion is fortuitous. The sporadic "peeks" that the spectator is given result in a kind of cinematic striptease. And because the nudity that *is* seen can often only be seen for 1/24 of a second (blink and you'll miss it), Uman rightly suggests that "the viewer is compelled to look harder."[35]

But why would these momentary glimpses of nudity result in a film that is "far more erotic" than the original pornographic film that it reworks?[36] After all, many assume that the point of *removed* is precisely to drain the original film of its eroticism. They suspect that Uman is engaged in the Mulveyan project of using the "destruction of pleasure as a radical weapon."[37] Uman, however, claims that she had no interest in destroying pleasure.[38] Instead, by partially erasing the naked bodies, she intensifies the erotic charge of the bodies that intermittently "escape" from her bleach. As Ofer Eliaz correctly notes in his book *Cinematic Cryptonymies*, "The point . . . is not that *removed* is an antipornography film, but that it is a film that works to *rediscover* the

eroticism of the pornographic image." For Eliaz, Uman's era-sures do not de-eroticize the pornographic film; rather, they result in "a new eroticism of ruptured and collaged bodies."[39]

In fact, Uman's erasures expose what I call *the paradox of censorship*: while salacious content is often removed precisely to drain a work of its eroticism, in actuality such removals often result in an intensification of eroticism. This is the sentiment that undergirds André Bazin's conceptualization of Hollywood as "the world capital of cinematic eroticism." Given the severe restrictions placed on the sexual content of Hollywood films during the 1950s (when Bazin made this claim), this may seem like an odd assertion. But Bazin rightly argued that Hollywood cinema was supremely erotic precisely "*because* of the taboos that dominate it."[40] As Slavoj Žižek has noted, the prohibitions of the Hollywood Production Code, while designed to subdue sexual-ity, often had the paradoxical effect of generating "an excessive, all-pervasive sexualization."[41]

This is not to suggest that Uman created *removed* in order to make an explicit argument about censorship. (When I asked her if *removed* represented a "political statement" about "feminism or pornography or censorship," she simply responded, "I don't really think in those ways. I'm interested in cinema.")[42] Never-theless, as Ofer Eliaz notes, Uman's erasure of taboo images "ironically mimic[s] the work of censorship."[43] I find it difficult to watch *removed* without thinking about the long history of expurgating nudity from visual art: from the draperies that were painted over the genitalia in Michelangelo's *The Last Judgment* (1536–1541) to the black bars and pixelations that are used to cen-sor nudity in contemporary photographs, films, and TV programs.

But how might one explain this paradox of censorship? Why does leaving something to the imagination tend to increase

excitement? And why is a momentary glance of taboo content often more stimulating than a sustained gaze? The answer lies in a fundamental feature of human psychology, an "aesthetic law" that the neuroscientist V. S. Ramachandran has called "the peekaboo principle." Ramachandran persuasively argues that one can "sometimes make something more attractive by making it less visible": "A picture of a nude woman seen behind a shower curtain or wearing diaphanous, skimpy clothes—an image that men would say approvingly 'leaves something to the imagination'—can be much more alluring than a pinup of the same nude woman."[44] To illustrate this principle, consider a revealing passage in Pierre Louÿs's novel *La femme et le pantin* (*The Woman and the Puppet*, 1898), which served as the source material for both Josef von Sternberg's *The Devil Is a Woman* (1935) and Luis Buñuel's *That Obscure Object of Desire* (1977). The novel recounts Don Mateo's sexual longing for a beautiful young Andalusian woman named Conchita. At one point, he walks into "a room for dancing" and discovers Conchita dancing provocatively in front of several onlookers. Louÿs describes the encounter this way:

> Inside there was a second room for dancing, smaller but very well lit, with a platform and two men playing guitars. In the middle Conchita, naked, was dancing a frenzied *jota*, along with three other nude, nondescript girls in front of a couple of foreigners who were sitting at the back. In fact she was more than naked. She had on long black stockings that came right up to the top of her thighs, like the legs on a pair of tights, whilst on her feet she was wearing little shoes that made the wooden floor ring out as they struck it. I didn't dare interrupt. I was afraid I might kill her.[45]

What I find most interesting in this passage is Louÿs's formulation "more than naked." It implies that Conchita's "long black

stockings" and "little shoes" result in her becoming even more alluring than she would have been if she were literally naked. A number of thinkers have commented on the crucial role that concealment plays in stimulating sexual desire. In 1905, for example, Sigmund Freud asserted that "covering . . . the body," far from erasing eroticism, instead "arouses sexual curiosity."[46] In 1955 Roland Barthes argued that concealment is a crucial component in striptease, since at the "very moment" a woman becomes completely nude, she also becomes "desexualize[d]."[47] And in 1957 Andre Bazin pointed out that the quintessential erotic image of Marilyn Monroe is not one of her nude photographs but the iconic scene from Billy Wilder's *The Seven-Year Itch* (1955) in which "the air from the subway grating blows up her skirt"—a scene that stages an alluring interplay between concealment and exposure.[48] Is it any wonder that the Motion Picture Production Code warned in 1930 that "transparent or translucent materials and silhouette are frequently *more* suggestive than actual exposure?"[49]

Of course, in spite of the efforts of the censors, filmmakers have been exploiting Ramachandran's peekaboo principle since the birth of cinema. Consider just a few suggestive remarks from canonical directors:

FRITZ LANG: A half-dressed girl is much more sexy than a nude one.[50]

LUIS BUÑUEL: A woman in a black lace chemise with gartered stockings and high-heeled shoes is more erotic than a naked woman.[51]

ALFRED HITCHCOCK: Suspense is like a woman. The more left to the imagination, the more the excitement.[52]

While these examples focus on the erotic female form, Ramachandran is quick to note that the peekaboo principle transcends

gender: "Many women will find images of hot and sexy but partially clad men to be more attractive than fully naked men."[53] And even if Ramachandran's language posits a heterosexual subject, this desire for (partial) concealment extends to queer subjects as well. Regardless of gender or sexual orientation, eroticism is produced not only by what is seen but also by what is *unseen*. A central element in sexuality is fantasy, which suggests that seeing too much can impede our desire to imagine what is being withheld from us. This is why, in his influential text *Laocoön* (1767), the German aesthetician Gotthold Ephraim Lessing argues that "only that which gives free rein to the imagination is effective," adding, "To present the utmost to the eye is to bind the wings of fancy."[54]

This phenomenon may, at first, seem counterintuitive. After all, if *Homo sapiens* derives pleasure from seeing, one might conclude that seeing *more* would engender more pleasure. But this is not always the case. In his essay "The Science of Art" (published in 2000, eleven years before *The Tell-Tale Brain*), Ramachandran was already trying to resolve this ostensible paradox. Though he had not yet coined the term *peekaboo principle*, he was already well aware of its psychological force. In an attempt to explain "why a nude hidden by a diaphanous veil is more alluring than one seen directly in the flesh," Ramachandran speculates, "It is as though an object discovered after a struggle is more pleasing than one that is instantly obvious. The reason for this is obscure, but perhaps a mechanism of this kind ensures that the struggle *itself* is reinforcing—so that we don't give up too easily—whether looking for a leopard behind foliage or a mate hidden in the mist."[55] In *The Tell-Tale Brain*, Ramachandran elaborates on this evolutionary theorization of visual perception. He argues that we often prefer a level of "concealment" because "we are hardwired to love solving puzzles." After all, our

ancestors were those who were able to successfully solve "social puzzles" (such as persuading a member of the opposite sex to mate) and "sensorimotor puzzles" (such as chasing prey by skillfully navigating through "the underbrush in dense fog"). In the modern era, art and pornography can exploit this evolved feature of our minds by providing "a form of visual foreplay for the grand climax of object recognition."[56] This evolutionary framework helps to explain the appeal of a diverse range of phenomena, including hide-and-seek, peekaboo, jigsaw puzzles, murder mysteries, and, of course, stripteases. Uman is well aware of this quirk of human psychology. She believes that one of the questions posed by *removed* is this: "Can desire for narrative (or desire to complete an image or desire to see a naked woman) be similar to sexual desire?"[57] All these diverse desires involve a tension between absence and presence. Narratives must intentionally *withhold* certain information if they are to pique a spectator's curiosity. An image that is only partially exposed tends to be more intriguing than one that is fully exposed. And sexual desire is also predicated on absence. We fantasize about what we have not *yet* seen, and this yearning to uncover what has been hidden is one of the central engines of *eros*.[58]

PHONOPHILIA

It is accepted among true libertines that the sensations communicated by the organ of hearing excite more than any others and produce the most vivid impressions.

—The Marquis de Sade, *The 120 Days of Sodom*

This emphasis on the seen (and the unseen) tells only half the story, however. For cinema generally exploits not only the

pleasure derived from *looking*, but also the pleasure derived from *hearing*. While *scopophilia* has proven to be a useful and widely accepted term for the former, no analogous term has been established for the latter. Some terms that have been proposed include *acousticophilia* and *ecouteurism*.[59] It is easy to see why these two terms have never caught on: surely no one derives pleasure from hearing them. Additionally, the term *ecouteurism* is sometimes reserved for the enjoyment of *nonconsensual* listening (as when one listens in on the sexual liaisons of others without their knowledge). I am somewhat sympathetic to the colloquialism *eargasm*, although this term refers to an isolated incident of auditory gratification rather than a general tendency to take pleasure in sounds. In this chapter I use the term *phonophilia* to refer to the pleasure derived from sound, whether it be talking, whispering, breathing, moaning, music, or any other noise. While phonophilia would certainly include the arousal prompted by sexually stimulating sounds, I favor using the term in a broader way to encompass any kind of pleasure derived from sound, from the excitement produced by hearing Stravinsky's *The Rite of Spring* (1913) to the serenity that comes from the babbling of a brook.

Phonophilia plays a central role in scene 2 of *removed*. While Walter gazes at the attractive woman on the other side of the two-way mirror (the one who, for some reason, is "rubbing her breasts"), his female companion does not. She tells Walter that she wants to "know everything" that is happening on the other side of the mirror, but at no point does she simply get up and *look*. Instead, she asks Walter a series of questions about the woman ("How are her breasts? Is she blonde? All over?"). Her sexual stimulation comes from Walter's *descriptions* of the other woman's naked body. She apparently derives more pleasure from the experience when she cannot see the erotic spectacle, as absence of a visual stimulus allows her imagination to run wild.

In other words, if Walter embodies scopophilia, his sexual partner embodies phonophilia. In Hilary Bergen and Sandra Huber's view, the woman's reliance on Walter's descriptions of what is happening has the effect of "robbing her of her own vision."[60] But this description strikes me as problematic. She is not robbed of her vision; rather, she *chooses* to forgo visual pleasure in favor of phonophilia. It appears that Walter's lover is enthralled by the titillating narrative that he articulates—and, perhaps, by his deep, authoritative voice.

Then again, it is impossible to know what Walter's voice actually sounds like, as the American distributor of the original German pornographic film has dubbed each Germanophone voice with an Anglophone equivalent. (For obvious reasons, few spectators are eager to read subtitles while watching porn.) This means that, in *removed*, not only have the images of women been effaced, but their *voices* have been removed (and replaced) as well. When we hear a woman moaning, we are not hearing the sounds of the original actor, but the sounds of an American voice actor. By the time the epilogue arrives—in which orgasmic moaning is accompanied by a black screen—no trace of the original woman remains. We cannot see her (since the visuals of the film have been extinguished), nor can we hear her (since we only hear her voice actor counterpart). For its final minute, *removed* becomes a purely aural experience, a "blind film" akin to Walter Ruttmann's *Weekend*. (It is worth noting that Ruttmann's soundscape also briefly includes a woman's orgasmic moan.) Luis Buñuel once observed that pornography "finishes with everything . . . [and] leaves nothing to the imagination."[61] *removed*, on the other hand, finishes with nothing and leaves everything to the imagination.

Uman's black screen is especially interesting given that pornography is generally theorized in terms of the *visible*. In the

introduction to his edited volume *Earogenous Zones: Sound, Sexuality, and Cinema*, for example, Bruce Johnson laments the fact that scholarship on sex in cinema tends to have a "relentlessly visual focus." He recalls attending porn studies conferences that were "almost unanimous" in framing porn as a "visual form."[62] He is quick to point out, however, that the work of porn scholar Linda Williams is a welcome exception to this rule. It is true that in her most influential text, *Hard Core: Power, Pleasure, and the "Frenzy of the Visible,"* Williams argues that hardcore pornography tends to follow "principles of maximum visibility," particularly in the convention of the "money shot," which provides visual "proof of pleasure." But Williams is also quick to acknowledge that this evidence "extends only to the hydraulics of *male* ejaculation."[63] Perhaps, as John Corbett and Terri Kapsalis argue, "female sexual pleasure is better thought of in terms of a 'frenzy of the audible.' "[64] Since visible evidence of female climax is elusive, pornographic films generally indicate women's pleasure through orgasmic moaning. (As Corbett and Kapsalis succinctly put it, "You can *see* men orgasm; you can *hear* women orgasm.")[65]

Of course, money shots are absent from softcore pornographic films like the one that Uman appropriates in *removed*. But the sounds of female pleasure are prominent components of both hardcore and softcore pornography. Linda Williams's description of the sounds of women moaning in hardcore apply with equal force to softcore: "The articulate and inarticulate sounds of pleasure that dominate . . . are primarily the cries of women. Though male moans and cries are heard as well, they are never as loud or dramatic." And Williams draws attention to a variety of other potentially arousing sensual sounds that play an important role in pornography, such as "the smack of a kiss or a slap," "the sounds of bedsprings," and erotic expressions such as "fuck me harder."[66] Normally, of course, the sounds of porn are

synchronized with the images on the screen—even if the slight asynchronicity of dubbed films complicates this illusion. But at the end of *removed*, the sounds float free of any specific visual figure. The "ooohs" and "aaahs" become indexes of an unseen (and unseeable) sexual encounter. And the spectator (or should I say auditor?) is free to "complete" this sexual encounter in whatever way she sees fit. She can fantasize about *being* the woman in the throes of orgasmic ecstasy, or *pleasing* that woman, or both. By isolating these sounds of pleasure, Uman foregrounds the centrality of phonophilia to both eroticism and the cinematic encounter. The audience of *removed* becomes much like the woman in the film who gets excited simply by listening to her lover describe an erotically charged event on the other side of a two-way mirror. If, as Mulvey argues, "There are circumstances in which looking itself is a source of pleasure,"[67] there are also circumstances in which *hearing* itself is a source of pleasure.

I LOVE DICK

Absence often commands an attention that far surpasses the potential of anything present.

—Timothy Walsh, *The Dark Matter of Words*

Uman's erasures have proven to be contagious. The fifth episode of the Amazon TV series *I Love Dick* (2017) (created by Jill Soloway and Sarah Gubbins) opens with approximately thirty seconds from Uman's film. (In other words, this episode of *I Love Dick* is a televisual appropriation of an avant-garde reworking of an English-language dubbing of a German porno.) The episode—entitled "A Short History of Weird Girls"—also

features an excerpt from Uman's documentary short *Leche* (1998), about a Mexican family that lives on a dairy ranch. In fact, *I Love Dick* regularly pays tribute to the art of women in the avant-garde. "A Short History of Weird Girls" features allusions to Hannah Hoch's collage *Da-Dandy* (1919), Cauleen Smith's experimental film *Chronicles of a Lying Spirit (by Kelly Gabron)* (1992), Louise Bourgeois's sculpture *The Couple* (2003), and Petra Cortright's flash animation *Enchanted Foreststrippers-nopoloeeasy2girls[1]* (2012). But the key intertext in "A Short History of Weird Girls" is *removed*, which is referenced repeatedly throughout the course of the episode. In addition to the excerpt of the film that begins the episode, the motif of removal recurs throughout its duration, as female characters are periodically erased in an homage to Uman.

I Love Dick explores the fantasies of a woman named Chris (Kathryn Hahn) and her husband, Sylvère (Griffin Dunne), after they meet a handsome and rugged minimalist artist named Dick (Kevin Bacon). In "A Short History of Weird Girls," Chris recalls an early sexual encounter with Sylvère. The Chris of the present appears in her memory alongside the Chris of the past. As the older Chris circles around the bed watching her former self pose for Sylvère, the Chris of the past begins to be erased (see figure 3.6). As in *removed*, the erasure is not complete: traces of the original nude figure are still partially visible. In this case, the erasure of young Chris suggests her ontological instability: she exists not as a flesh-and-blood being but as Sylvère's fantasy—or perhaps as her future self's fading memory. As the episode continues, three other women recall sexual encounters from their pasts, and each woman is erased at an erotically charged moment. In part, these erasures suggest the ephemerality of memory and desire. But they also suggest the ways that female desire has historically been "erased" from film and

FIGURE 3.6 Jill Soloway, "A Short History of Weird Girls,"
episode 5 of *I Love Dick* (2017)

television, which have instead foregrounded the fantasies of
(straight) men.

There are important differences between Uman and Soloway,
of course. While Uman's erasures were achieved through the tac-
tile manipulation of celluloid, Soloway's erasures appear to be
digital effects. Additionally, as mentioned earlier, Uman is hes-
itant to conceptualize *removed* as an explicitly feminist work.
Soloway, by contrast, describes *I Love Dick* as a "feminist,
matriarchal revolution-inspiring comedy about love and sex."[68]
Nevertheless, both *removed* and "A Short History of Weird
Girls" display a commitment to the aesthetic force of absence, a
conviction that, in the words of Robert Bresson, "One does not
create by adding but by taking away."[69] From Robert Rauschen-
berg's *Erased de Kooning Drawing* to Tom Friedman's *11 × 22 ×
0.005*, from Naomi Uman's *removed* to Jill Soloway's "A Short
History of Weird Girls," the arts have long sought to satisfy
scopophilic (and phonophilic) urges, even if this has often

paradoxically involved *erasing* content to prompt a more active and participatory response. The peekaboo principle is a foundational part of human psychology, and art tends to exploit this evolved feature of the human brain. Seeing and hearing are often sources of pleasure, but so are *not* seeing and *not* hearing. By exploiting aesthetic absence, artists open up a space for a spectator to insert her own desires and fantasies. In the memorable words of Denis Diderot, "If you paint, must you paint everything? Have pity and leave a gap that my fantasy can fill."[70]

4

MARTIN ARNOLD'S
DISAPPEARING ACT

*I am going to close my eyes, stop my ears, extinguish one by one
the sensations that come to me from the outer world. Now it is
done; all my perceptions vanish, the material universe sinks into
silence and the night.*

　　　　　　　　　—Henri Bergson, *Creative Evolution*

Whoever must be a creator also annihilates.

　　　　　—Friedrich Nietzsche, *Thus Spake Zarathustra*

I n 2002 the American artist Cory Arcangel created the video
installation *Super Mario Clouds* by modifying a cartridge of
the Nintendo game *Super Mario Bros.* (1985) with a drill, wire
clippers, and a soldering iron. In the process, he stripped the
classic video game not only its music and sound effects but also
of its objects (coins, castles, flags) and characters (Mario, Prin-
cess Toadstool, the Goombas). All that remained of the origi-
nal video game were clouds slowly traveling across a blue sky,
which Arcangel projected as a continuous loop on a large screen
in a museum space (see figure 4.1). If the video game *Super Mario
Bros.* is interactive, complex, and exciting, *Super Mario Clouds* is

FIGURE 4.1 Cory Arcangel, Super Mario Clouds (2002)

autonomous, minimalist, and uneventful. And the experience
of watching 8-bit clouds slowly trace their way across a gallery
wall is evocative. As Robert Burgoyne notes, "Stripped of the
linear forward momentum of the game, the screen becomes
an image of transience, of fleeting impermanence, a loop cen-
tered on memory, duration, and loss."[1]

In the same year that Arcangel released *Super Mario Clouds*,
the Austrian avant-gardist Martin Arnold released another work
of aesthetic erasure: *Deanimated* (2002). To create this found
footage film, Arnold digitally removed characters, objects, and
lines of dialogue from Joseph H. Lewis's *Invisible Ghost* (1941), a
macabre horror film featuring an intricate (and barely compre-
hensible) plot involving homicide, hallucination, hypnosis, and
a long lost twin brother. Arnold's revision of *Invisible Ghost*
begins with no modifications at all. Soon, however, one begins

to notice subtle erasures: a missing line of dialogue, a character who has disappeared. Eventually, one sees nothing more than decontextualized objects in dark rooms: a painting, a window, a fireplace. Like Arcangel's *Super Mario Clouds*, Arnold's *Deanimated* erases elements from a pop culture artifact and transmogrifies a complex and exciting aesthetic experience into one that is quiet and meditative. Arnold does this not with a single monolithic void but with a series of interlocking voids, including silence, emptiness, and blackness.

In this chapter I link Arnold's film with explorations of disappearance in other media, such as the poetry of Vasilisk Gnedov and the paintings of Kazimir Malevich, thus pointing to a broader tendency in avant-garde aesthetics to move gradually from presence to absence. I further argue that Arnold's voids constitute instantiations of the Buddhist concept of sunyata, in which emptiness is understood not as deprivation or lack but as a state of radical openness. Before entering these voids, however, it will be helpful to situate *Deanimated* within Arnold's broader artistic oeuvre.

REPETITION AND REMOVAL

How do you interpret what you do not or cannot see?

—Martin Arnold, "Black Holes"

Ever since his first film, *pièce touchée*, in 1989, Arnold has obsessively deconstructed excerpts from classical Hollywood cinema. In *pièce touchée* Arnold stretches eighteen seconds of footage from *The Human Jungle* (Joseph M. Newman, 1954) into a sixteen-minute film. The original footage (of a man walking through a door and greeting a woman) becomes an absurd concatenation of Sisyphean repetitions: the door opens and closes repeatedly;

the woman gets out of her chair, sits down, and gets up once more. Arnold manipulates these two characters like chess pieces that are moved around a board aimlessly. (The title of the film, which means "touched piece," refers to a rule in chess that requires a player to move a piece after touching it.)

Arnold's second film, *passage à lacte* (1993), applies similar looping procedures to a scene from *To Kill a Mockingbird* (Robert Mulligan, 1962). In this case, not only are the images looped but the sounds are as well. The incessant repetition of phrases, words, and phonemes evokes both the poetry of Gertrude Stein ("a rose is a rose is a rose is a rose") and the tape pieces of the minimalist composer Steve Reich, such as *It's Gonna Rain* (1965) and *Come Out* (1966).[2] *passage à lacte* also reveals Arnold's deep interest in psychoanalysis, a subject that he studied intensively in Vienna. More specifically, in *To Kill a Mockingbird*, the young girl, Scout, gives her father, Atticus Finch, a brief kiss on the cheek before running outside. In *passage à lacte*, Arnold loops this kiss again and again, thus suggesting that Scout suffers from an Electra complex. (Arnold's investment in psychoanalysis is further underscored by the title, *passage à lacte*—or "transition into action"—a concept used by Freud and Lacan to describe a psychological shift into a state of disruption and aggression.)

Arnold's third major film, *Alone. Life Wastes Andy Hardy* (1998), is even more direct in its exploration of Freudian themes. The film begins with an excerpt of an old Mickey Rooney film in which Rooney approaches his mother from behind to give her a kiss on the cheek. Arnold loops this brief encounter so that Rooney kisses his mother slowly and repeatedly as her face contorts in orgasmic delight. And these Oedipal themes recur throughout the film. For example, at one point, Rooney has a violent confrontation with his father, who screams at his son and slaps him across the face three times.[3]

pièce touchée, *passage à lacte*, and *Alone*. *Life Wastes Andy Hardy* are often grouped together as a "trilogy of compulsive repetition."⁴ Building on this framework, I would suggest that Arnold's first three films of the twenty-first century—*Forsaken* (2002), *Dissociated* (2002), and *Deanimated*—constitute a *trilogy of erasure*. While Arnold's early found footage work uses radical repetition to unearth the cinematic "unconscious," his trilogy of erasure uses digital processes to remove elements from preexisting films, thus producing works that are preternaturally empty. In *Forsaken*, two projection screens face each other while playing nine-minute loops from the western *High Noon* (Fred Zinnemann, 1952). Arnold's decision to erase most of the film's characters from these loops results in an unsettling form of audiovisual counterpoint: while one *hears* suspenseful music, melodramatic breathing, and gunfire, one often *sees* little more than a door, a fence, or an abandoned barn. (At one point, one also sees a random dead body lying on the street, although it is never made clear who this man is or who killed him.)

Two screens facing each other are used once again in *Dissociated*. In this case, the appropriated content comes from *All About Eve* (Joseph L. Mankiewicz, 1950). One screen displays a close-up of Karen (played by Celeste Holm), while the other screen displays a close-up of Eve (played by Anne Baxter). Each appears in a perpetually repeating eight-minute loop. Neither Karen nor Eve says anything, although we do hear them breathe and swallow. Both characters look like they want to speak but simply cannot. Karen's mouth opens for a moment but nothing comes out; Eve leans forward as if to deliver important information to the spectator but simply stares into space.⁵

But Arnold pushes cinematic absence even further in the third film of his trilogy of erasure: *Deanimated*. The source material for this film is *Invisible Ghost*, a B-horror movie starring

Bela Lugosi as Mr. Kessler, a wealthy man whose wife has left him for his best friend. In *Invisible Ghost*, Kessler is so distraught over his wife's disappearance that each year on their wedding anniversary, he pretends she is present. He asks his butler, Evans (Clarence Muse), to bring dinner to her empty chair, and he proceeds to carry out a one-sided conversation with his absent wife. Arnold has indicated that one of his goals in making *Deanimated* was to "spread" Kessler's neurosis to the other characters in the film: "They get the same symptom and start talking to thin air, and in the end they all get lost."[6] To accomplish this, Arnold erased characters and lines of dialogue from *Invisible Ghost*. Unlike the erasures in Naomi Uman's *removed*, however, which are clearly indicated by a white, splotchy hole, the erasures in *Deanimated* are seamless. Arnold worked with a team of assistants to fill in the holes he created using digital compositing software.[7] As the philosopher Anna Farennikova has noted, there are circumstances in which an absence is *seen*, as when you suddenly discover that "the keys are missing from the drawer," but there are other circumstances in which an absence is only *sensed*, as when you intuit that "something is missing . . . from your desk," even though "you cannot, for the life of you, figure out *what* is missing."[8] In Uman's *removed*, absences are seen: it is clear *who* is missing (the women) and from *where* (the sites of the film's jittery holes). In Arnold's *Deanimated*, however, absences are generally only sensed. Spectators regularly get the distinct impression that *something* is missing, but who or what is missing (and from where) is often mysterious.

I should briefly note that Arnold's recent animated works, such as *Soft Palate* (2010), *Whistle Stop* (2014), and *Elsewhere* (2016), exploit both repetition and removal. In these works, Arnold digitally removes elements from classic Disney cartoons and loops what remains over and over again. When watching

these works, one is often confronted by an "amputated" body part (a hand, a foot, a tongue) moving back and forth on a black screen for no apparent reason. The result is uncanny. (Recall that one of Freud's examples of the uncanny is "a hand detached from the arm.")[9] And the sounds of these works are no less unsettling. When the cute noises and cheerful songs of Disney cartoons become fractured and looped ad infinitum, they become menacing. Like Arnold's trilogy of erasure, these works are constructed through a process of deconstruction. As Emmanuelle André argues—borrowing key concepts from Leonardo da Vinci—while most films are created *per via di porre* (through addition), Arnold's recent films have been created *per via di levare* (through subtraction).[10]

How have audiences responded to Arnold's repetitions and removals? Results have varied. After Arnold released his first two films—*pièce touchée* and *passage à l'acte*—film scholar Scott MacDonald marveled at Arnold's ability to fuse "theoretical and formal sophistication" with "widely accessible pleasure." Here are nonnarrative films that use complex mathematical patterns to explore ideas in Freudian psychoanalysis—and yet, they are also "laugh-out-loud funny."[11] And *Deanimated* also occupies this strange space between the esoteric and the accessible. As James Leo Cahill observes, *Deanimated* "is often funny, indeed hysterical, but this does little to alleviate the considerable demands the piece asks of us as viewers."[12] On the one hand, I have seen recalcitrant skeptics of the avant-garde break out in joyous laughter while viewing *Deanimated*. On the other hand, I have seen adventurous cinephiles driven to madness by the film's glacial pace. Arnold is well aware of how polarizing his cinema can be. When he was asked in 2016 how audiences generally respond to his films, he noted that most reactions are "pretty good," but he also acknowledged the violent antipathy that his work can

provoke: "The one bad reaction—although I wasn't there, I just read about this—was when they showed one of my films at Cannes before a feature film. And people didn't like it there. The French were shouting 'Arnold, go home!' which was very funny because I was home, I wasn't there!"[13] Like the characters of *Deanimated*, the audience at Cannes ended up having a one-sided conversation with someone who "wasn't there." Perhaps this audience expected Arnold to respond to their angry jeering, but all they got in response was silence. And it is to Arnold's silences that I now turn.

SILENCE

Always listen for what you can leave out.

—Miles Davis

While *Invisible Ghost* features a great deal of dialogue, *Deanimated* is dominated by silence. (By my count, there are only 258 words in Arnold's one-hour film.) Whenever Arnold removes a character from a shot, he also removes that character's dialogue. He does this, he claims, in order to avoid the "invisible man effect."[14] But these are not the only silences that Arnold exploits. Even when characters *are* present in *Deanimated*, he often erases their dialogue from the sound track and uses digital editing to suture their mouths shut. According to Akira Mizuta Lippit, the result of these mutations is a "deformed set of bodily gestures that seem like impulsive twitches and attempted restraint."[15] During these moments, characters often look as if they are exerting a great deal of effort to suppress statements that they cannot bear to say aloud. To better appreciate the effect of these dialogic erasures, consider the opening scenes of *Invisible Ghost* and

Deanimated. Both films begin with Kessler's imaginary dinner with his absent wife. Partway through this anniversary celebration, the doorbell rings. It is Ralph (John McGuire), the fiancé of Kessler's daughter, Virginia (Polly Ann Young). Here is an excerpt from Ralph and Virginia's conversation in *Invisible Ghost*:

RALPH: Hello, Virginia.

VIRGINIA: I told you not to come here this evening, Ralph.

RALPH: Why? Didn't you want to see me?

VIRGINIA: Well, it isn't that I didn't want to see you.

RALPH: You're certainly acting strange, darling. What's all the mystery about?

VIRGINIA: Let's go into the library.

[*Ralph hears something and walks away.*]

VIRGINIA: Ralph!

[*Ralph sees Kessler pretending to dine with his absent wife.*]

KESSLER: After dinner, we are taking a long walk.

VIRGINIA: I'd like to speak to you, Ralph.

RALPH: What's come over your father, Virginia? Is that why you didn't want me here tonight?

VIRGINIA: Yes.

RALPH: It stopped me cold. I'm sorry if I accidentally stumbled on something you didn't want me to know.

VIRGINIA: It must seem weird to someone who's never seen it before. It happens once a year.

RALPH: He always appeared perfectly rational to me.

VIRGINIA: There's something I must tell you. It's about my mother.

RALPH: I don't understand.

VIRGINIA: Well, it happened several years ago. My father and mother were apparently as happy as two people could be. He worshipped her.

RALPH: Another man.

VIRGINIA: The usual best friend. It almost broke my father's heart. He seems reconciled, but he never forgets their wedding anniversary and celebrates it that way.

RALPH: I guess he isn't the only one who resorts to make-believe, but it does give one an uncanny feeling.

This same conversation takes on a very different character in *Deanimated*, since Arnold has erased (and reconfigured) much of the dialogue:

RALPH: [*Silence.*]

VIRGINIA: I told you not to come here this evening.

RALPH: Why? Didn't you want to see me?

VIRGINIA: [*Silence.*]

RALPH: You're certainly acting strange, darling. [*Silence.*]

VIRGINIA: Let's go into the library.

[*Ralph hears something and walks away.*]

VIRGINIA: Ralph!

[*Ralph sees Kessler pretending to dine with his absent wife.*]

KESSLER: After dinner, we are taking a long walk.

VIRGINIA: [*Silence.*]

RALPH: [*Silence.*]

VIRGINIA: [*Silence.*]

RALPH: It stopped me cold. I'm sorry if I accidentally stumbled on something you didn't want me to know.

VIRGINIA: [*Silence.*]

RALPH: He always appeared perfectly rational to me.

VIRGINIA: There's something I must tell you. [*Silence.*]

RALPH: I don't understand.

VIRGINIA: Well, it happened several years ago. [*Silence.*] Father worshipped me.

RALPH: [*Silence.*]

VIRGINIA: [*Silence.*] It almost broke my father's heart. [*Silence.*]
RALPH: [*Silence.*]

There are a number of elements worth noting in this brief exchange. To begin, *Deanimated* is aesthetically quite distinct from Arnold's trilogy of compulsive repetition. The audience is no longer barraged with the clamor of characters performing the same actions over and over again. Instead, *Deanimated* is filled with aimless characters staring into space (à la Warhol) and long silences (à la Beckett). In spite of this aesthetic shift, Arnold's Freudian obsessions remain prominent. Notice that in *Invisible Ghost*, Virginia tells Ralph that Kessler worshipped *his wife*. Arnold remixes this dialogue so that Virginia instead says, "Father worshipped *me*." By introducing the suggestion of incest, Arnold is merely intensifying Freudian dynamics that are already present in the original film. At one point in *Invisible Ghost*, for example, Virginia plays with her father's suit jacket, and he flirtatiously slaps her face and kisses her forehead. After this, Virginia says, "Good night, my pet," and her father replies, "Good night, sweet." (Was it common for women to address their fathers as "my pet" in the 1940s?) At another point in *Invisible Ghost*, Kessler enters his daughter's bedroom while she is sleeping and removes his suit jacket. (In the context of the film, he is planning on murdering her, but the sexual subtext is inescapable.) Stranger still, Jules (Ernie Adams), the gardener in *Invisible Ghost*, repeatedly calls his wife "Mama," a habit that is never explained in the original film. Arnold amplifies these Freudian motifs through erasure and transferal. Like a cinematic psychoanalyst, Arnold seeks to uncover forbidden drives and impulses that are present but repressed in the original film.

It is also significant that Arnold retains the moment in which Ralph tells Virginia, "You're certainly acting strange, darling." The meaning of this line in *Invisible Ghost* is straightforward:

Virginia is acting strange because she does not want Ralph to find out about her father's delusions. In *Deanimated*, however, the line takes on a new meaning. Virginia is acting even stranger in this film, as she keeps darting her eyes about and gesticulating without saying anything. Indeed, *everyone* in *Deanimated* is "acting strange," as they are all repeatedly silenced by Arnold and are often reduced to staring at each other in helpless despair. In fact, since Arnold omits the scenes from *Invisible Ghost* that take place outside the mansion, one gets the sense that these characters are inexplicably confined. A number of works with similar premises haunt *Deanimated*: Sartre's *No Exit* (1944), Beckett's *Endgame* (1957), Buñuel's *The Exterminating Angel* (1962). And while Arnold erases a significant amount of dialogue from the opening scene, he erases far more as the film continues. In fact, in many of the scenes that follow, Arnold erases *all* dialogue, so that characters simply stare at each other dumbly for several minutes. The result is an epistemological vacuum: it becomes impossible to know who these characters are or what they are doing. Indeed, the characters *themselves* do not seem to know who they are or what they are doing. While *Invisible Ghost* presents a murder mystery that will eventually be solved, *Deanimated* presents an existential mystery that is insoluble.

EMPTINESS

There is no nothingness. Zero does not exist. Everything is something. Nothing is nothing.
—Victor Hugo, *Les Misèrables*

But Arnold does not simply erase dialogue from *Invisible Ghost*—he erases characters as well. The result is often a complex

dialectic between absence and presence. In one scene, for example, the doorbell rings, and when the butler, Evans, answers it, no one is there. But Evans seems to see *someone*, as he stares incredulously for several seconds at a vacant space, even moving his head to follow its invisible movements. In the next shot, Kessler and his daughter, Virginia, get up from the dinner table to look in amazement at nothing in particular. (Virginia even brings her hands up to her face in melodramatic alarm.) The character that Arnold has erased is Paul, the long-lost twin brother of Virginia's fiancé, Ralph. In *Invisible Ghost*, Evans, Kessler, and Virginia are all astonished when they see Paul because he looks exactly like Ralph, who has just been executed. In *Deanimated*, however, the object of the characters' gaze is no longer visible: he has become a disembodied ghost. And such ghosts are ubiquitous in Arnold's film: invisible presences open and close doors, move through hallways, and murder the residents of the mansion. Arnold's ghosts partake in an ambiguous and indefinable ontology. They are ostensibly invisible, yet characters see them. They seem to be incorporeal, yet characters touch them. In fact, this paradoxical ontology has always bedeviled accounts of ghosts, spirits, and gods. This is why Jacques Derrida, in his book *Specters of Marx*, conceptualizes ghosts as being "there without being there," as occupying "a space of invisible visibility."[16] Along similar lines (albeit working in a very different philosophical tradition), Daniel Dennett, in his book *Consciousness Explained*, begins a critique of the "incoherence" of Cartesian dualism by noting a revealing contradiction in a comic strip of Casper the Friendly Ghost:

> How can Casper *both* glide through walls and grab a falling towel? How can mind stuff *both* elude all physical measurement and control the body? A ghost in the machine is of no help in our

theories unless it is a ghost that can move things around—like a noisy poltergeist who can tip over a lamp or slam a door—but anything that can move a physical thing is itself a physical thing (although perhaps a strange and heretofore unstudied kind of physical thing).[17]

As Dennett notes, common conceptions of ghosts tend to be fraught with paradoxes: these slippery spirits are somehow both corporeal and incorporeal, visible and invisible. Tom Gunning draws attention to this vexed ontology in his essay on the phantasmatic, in which he attempts to answer the question, "What does a ghost look like?" His answer is instructive: "A ghost puts the nature of the human senses, vision especially, in crisis. A ghost, a spirit, or a phantom is something that is sensed without being seen."[18]

By the end of *Deanimated*, everyone has become a ghost: visible characters disappear from the film one by one, until all that is left is the house itself. (Incidentally, Arnold returns to the motif of haunting in a short animated film from 2012 entitled *Haunted House*.) As a result of Arnold's erasures, spectators must be content to stare at inanimate objects for a lengthy period of time: flickering candles in an empty kitchen (see figure 4.2), a phone that rings and rings with no one around to answer it (see figure 4.3), an empty chair (see figure 4.4). One is reminded of Yasujirō Ozu's pillow shots—or perhaps the depopulated environments at the end of Michelangelo Antonioni's *L'Eclisse* (1962). In Arnold's hands, however, these absences are not confined to a handful of shots or even an entire scene—rather, they become the currency of the film. As Thomas Miessgang points out, these empty spaces proliferate and produce a "shadowy silhouette of evanescence, an uncanny presence of the absent."[19]

FIGURE 4.2 Martin Arnold, *Deanimated* (2002)

FIGURE 4.3 Martin Arnold, *Deanimated* (2002)

This "uncanny presence of the absent" is not localized to the film's mise-en-scènes, however. It also permeates the theatrical space. *Deanimated* is designed to be screened in a makeshift movie theater nested within an art gallery, and Arnold has

FIGURE 4.4 Martin Arnold, *Deanimated* (2002)

specified that this theater should have far too many seats. The effect is that one does not merely experience the visual and auditory absences inscribed in the film; one also experiences absence via the vacant, ghostly theater in which the screening takes place. Here is how Arnold described his ambitions before completing *Deanimated*: "What I plan to do is construct a movie theatre—like an old theatre that smells bad, a rather fucked up place! What I want is to create the impression that the audience is also lost—not only the actors. So what I'll do is put in tons of rows of chairs, and usually there won't be more than 10 people in the whole theatre. It will be like a cheap, outdated, countryside movie space, showing an outdated film where the actors are getting lost."[20]

It is worth reflecting on Arnold's unorthodox screening conditions. To begin, it is significant that *Deanimated* is not simply screened in a movie theater or an art gallery—it is screened in a movie theater *within* an art gallery. Thus the reception conditions

reflect the work's own complex ontological status as a hybrid film/video installation. It is also highly unusual that Arnold installs far too many seats in the theatrical space. As James Leo Cahill notes, the "excess of seats" engenders "an exaggerated sense of emptiness, isolation, absence, and abandonment—suggesting the disappearance of the public rituals and social institutions associated with classical cinema-going."[21] Normally, of course, an abundance of empty chairs signals that a film screening has not been especially successful, that far fewer spectators have shown up than were anticipated. In the case of *Deanimated*, however, the empty chairs in the theater are essential to the atmosphere of absence that Arnold wants to create. In fact, it is one of many ways that Arnold constructs a situation in which what is happening in the film mirrors what is happening in the theatrical space. There are a number of empty chairs on the screen and a number of empty chairs in the theater. The characters in the film wander in and out of the mise-en-scène aimlessly, and the gallery visitors wander in and out of the theater aimlessly. (Indeed, it is quite likely that many of the film's spectators are just as confused by what is going around them as the characters in the film seem to be.) Additionally, as the characters in the film disappear, many of those in the audience disappear, as they begin to give up on trying to "get" the cryptic experiment on the screen. And a number of the lines of dialogue that Arnold retains in *Deanimated* could easily be spoken by bewildered spectators of the film: "I don't understand," "What?," and the last two words uttered in the film: "Now what?"

In spite of the confusion that *Deanimated* engenders, the film's title does help one to better understand its raison d'être. The *Oxford English Dictionary* provides a number of definitions of the transitive verb *animate*, including "to give (an image, character, film, etc.) the appearance of movement using animation

techniques" and "to breathe life into."[22] Regardless of which definition one prefers, Arnold subverts the telos of animation. If cinema has traditionally animated stills by putting them in motion, *Deanimated* begins with movement and transitions into stasis: shots of lively conversations give way to shots of isolated characters staring into space, and shots of empty rooms give way to a static black screen. If most filmmakers have attempted to "breathe life into" their characters, Arnold sucks the life out of his. They have less and less to say as the film progresses, and the last character we see is a woman who falls down dead for no apparent reason. Additionally, throughout the course of *Deanimated*, the shots get progressively darker, as if the light is fading and the film itself is experiencing a slow death. By the time the film reaches its (anti)climax, Arnold's void has swallowed up everything: characters, objects, settings, music, and sounds. The film ends with six minutes of a black screen accompanied by silence. (One wonders how many gallery visitors wandered into the theater shortly after the black screen appeared, waited several minutes for something to happen, and left in frustration.)

This gradual descent into nothingness mirrors artistic experiments of the early Russian avant-garde, such as those of the poet Vasilisk Gnedov and the painter Kazimir Malevich. In 1913 the Russian Futurist Gnedov published a series of proto-minimalist poems in an eight-page booklet called *Death to Art* (*Smert' Iskusstvu*). The first poem of the volume is sparse (one line in length), and as the volume progresses, the poems get sparser still. One poem consists of a single nonexistent word; another poem consists of a single letter. The fifteenth (and final) poem of the collection pushes this asceticism to its logical conclusion: "a poem without language."[23] It is nothing more than a title—"Poem of the End" (*Poema Kontsa*)—on a blank page:

VASILISK GNEDOV, "POEM OF THE END"

Among those who expressed interest in Gnedov's work was Kazimir Malevich.[24] One cannot help but wonder if Gnedov's *Death to Art* served as the inspiration for Malevich's Sixteenth State Exhibition in 1920. At this exhibition, Malevich did not simply present decontextualized blank canvases as works of art (as daring and provocative as such a gesture might have been). Instead, the first rooms that visitors entered were populated with dozens of abstract paintings. It was only once visitors reached the final room of the exhibition that they were confronted with empty canvases. In other words, Gnedov, Malevich, and Arnold are not merely interested in absence but in *disappearance*. They all present spectators with minimal content (words on a page, abstract forms, characters in a mansion) and proceed to efface that content until nothing remains.

But are a blank page, an empty canvas, and an imageless cinema screen really *nothing*? When looking at Gnedov's wordless "Poem of the End," one sees the imperfections of the paper on which it is printed (or perhaps the smudges on one's e-reader). When looking at an imageless painting by Malevich, one sees one's own shadow hovering over the canvas. And when one stares into Arnold's black screen at the end of *Deanimated*, one notices how the inky blackness is occasionally punctuated by the random specks and scratches on the filmstrip. One also notices that the conclusion of *Deanimated* is not completely silent. Rather, one hears the sounds that a record on a phonograph might make if it had no music on it.[25] In other words, Robert Rauschenberg is correct when he claims that "a canvas is never empty," and John Cage is correct when he asserts that "there is no such thing as silence."[26] As the Pre-Socratic philosopher Melissus of Samos argued, "nothing cannot exist."[27] Every absence is a presence in disguise.

While this theorization of absence strikes many in the West as deeply counterintuitive, it has a long history in the East.

Consider, for example, the Buddhist concept of sunyata (or *shunyata*). This Sanskrit word is often translated as *the Void*, but as Stephen Batchelor notes, this translation can be highly misleading:

> *Shunyata* (emptiness) is rendered into English as "the Void" by translators who overlook the fact that the term is neither prefixed by a definite article ("the") nor exalted with a capital letter, both of which are absent in classical Asian languages. From here it is only a hop, skip, and a jump to equating emptiness with such metaphysical notions as "the Absolute," "the Truth," or even "God." The notion of emptiness falls prey to the very habit of mind it was intended to undermine.[28]

While translating sunyata as *emptiness* (rather than *the Void*) helps one to avoid this metaphysical morass, it still risks obscuring the term's complexity and ambivalence. This is because, strictly speaking, sunyata is neither absence nor presence per se, but *both*. As Gay Watson has noted, the term is derived from the Sanskrit *svi* or *sva*, "which denotes hollowness and swelling, as of a seed as it expands. Thus Buddhist emptiness in its very etymology holds a hint of fullness that is lost in its English translation."[29] Or, in the words of the Japanese philosopher Masao Abe, sunyata posits a "dialectical and dynamic structure" in which "emptiness is fullness and fullness is emptiness."[30]

For many in the West, understanding the value of emptiness requires a shift in perspective. The term is often used as a pejorative, as indicated by a number of the definitions provided by the Oxford English Dictionary: "inanity," "poverty of artistic content," "futility," "pointlessness."[31] Western philosophers have long used the term *emptiness* to describe a state

of existential despair, as when Arthur Schopenhauer rails against "the emptiness of existence" or when Søren Kierkegaard argues that a Godless universe would be "empty and devoid of comfort."[32] But in the texts of Zen Buddhism, emptiness is often understood as "inclusive" and "sublime."[33] Consider the valorization of emptiness in the following Zen koan:

> Nan-in, a Japanese master during the Meiji era (1868–1912), received a university professor who came to inquire about Zen.
>
> Nan-in served tea. He poured his visitor's cup full and then kept on pouring.
>
> The professor watched the overflow until he no longer could restrain himself. "It is overfull. No more will go in!"
>
> "Like this cup," Nan-in said, "you are full of your own opinions and speculations. How can I show you Zen unless you first empty your cup?"[34]

Does this mean that Arnold's trilogy of erasure was informed by the Zen Buddhist tradition? Yes and no. On the one hand, it is unlikely that Arnold was directly influenced by Zen. When one searches through interviews with Arnold for a discussion of Buddhism, one only finds references to psychoanalysis, structural cinema, and hip-hop.[35] On the other hand, I would argue that Arnold's investment in sunyata was indirectly influenced by Zen Buddhism by way of John Cage and Andy Warhol.

Let's begin with Cage. In addition to his "silent" composition, *4'33"* (1952), Cage also repeatedly emphasized the value of absence and emptiness in his writings and lectures. Consider just a handful of relevant quotations from Cage's book *Silence*:

But now we are going from something towards nothing.
Listening is best in a state of mental emptiness.

In an utter emptiness anything can take place.
The thing to do is to keep the head alert but empty.[36]

This emphasis on emptiness was profoundly influenced by Zen Buddhism. As Cage writes in his foreword to *Silence*, "Without my engagement with Zen (attendance at lectures by Alan Watts and D. T. Suzuki, reading of the literature) I doubt whether I would have done what I have done."[37] Cage's Zen-inspired aesthetic of absence would prove to have a significant influence on Andy Warhol. In interviews, Warhol called Cage's work "marvelous" and "very influential."[38] What is more, when Warhol's long-term assistant Gerard Malanga was asked to list the pop artist's major influences, he mentioned Cage (along with Marcel Duchamp and Gertrude Stein).[39] Warhol's admiration for Cage helps to explain why he claimed that his early minimalist films, such as *Sleep* (1963) and *Empire* (1964), were designed precisely to help spectators become more empty: "The more you look at the same exact thing, the more the meaning goes away, and the better and emptier you feel."[40] And Warhol regularly articulated his fondness for absence and erasure:

The thing is to think of nothing . . . nothing is exciting, nothing is sexy.
You have to treat the nothing as if it were something. Make something out of nothing.
My mind is like a tape recorder with one button—Erase.[41]

It is no wonder, then, that Arnold explicitly cites Warhol's cinema as a reference point for *Deanimated*:

[The characters of *Deanimated*] look as if they are relaxing, dreaming, waiting for the part they can act out, but they're either

too early or too late. I think that's interesting, because it contradicts the usual expectations: actors are usually acting in feature films, they usually have something to do or to say, they don't hang around—hanging around in front of the camera is a Warhol-like approach that didn't exist in the 40s. Back then (times were better) actors were still actors and they had to act. That's what they were paid for. In *Deanimated* we're looking at actors in their spare time, Warholian actors that were born too early.[42]

Deanimated is Warholian not only in its emphasis on "waiting" and "hanging around" but also in its investment in emptiness. Arnold's film presents an aesthetic instantiation of sunyata, one that comes indirectly from Zen Buddhism by way of Cage and Warhol.

THE BLACK SCREEN

Look upon some object, then slowly withdraw your sight from it, then slowly withdraw your thought from it. Then.

—Shiva

While sunyata plays a prominent role throughout *Deanimated*, it reaches its apotheosis in the film's concluding six minutes of blackness and silence. I must confess that when I first saw *Deanimated* in 2015, I did not experience this ascetic conclusion. I had read about the film in various essays and books and decided to purchase a research copy on DVD for $60 from Amour Fou, an Austrian film production company. I found the film to be both unsettling and hysterical, and I was immediately haunted by its silenced characters and vacant spaces. But about two years

later, it dawned on me that something was wrong. The DVD I had purchased indicated that the running time of the film was sixty minutes, but it was actually only fifty-four minutes in length. Was this just a typo? Had the version I received been projected at the wrong speed? Then I read an essay that indicated that *Deanimated* concluded with "six minutes of complete blackness" punctuated by the "scratchy ambient sounds from the original tail leader of the film."[43] My version included only about thirty-six seconds of complete blackness. Arnold's final absence was . ., . absent. I had been robbed! I contacted Amour Fou to inform them of the mistake, but I was told that since so much time had passed, I would have to pay an additional $60 to purchase another version with the full six minutes of blackness. Never had I spent so much money on nothing.

When I screen *Deanimated* for my classes, I am never quite sure how to handle its concluding six minutes. Should I "warn" my students that the film will end with silence and blackness? After all, without such advance knowledge, these absences can be quite disorienting. Students look around and wonder why I have not yet turned on the lights and started discussing the work. A number of them give me looks that seem to say, "The film is over, right?" My students already get annoyed that I ask them to sit through the closing credits of films. Am I really going to push my luck and ask them to stare at a black screen? A number of students fidget and begin to wonder what kind of responses might be appropriate. Is it okay if they check their text messages on their phones? They aren't really going to "miss anything" at this point, are they? Can they whisper to their friends about the weirdness of what they just experienced? Would this be an acceptable time to leave the class for a minute to get a drink of water? In fact, maybe we should all disappear, one by one, just

like the characters in *Deanimated*. We have just stared at dozens of shots of empty rooms. Perhaps the time has come to make this room empty as well.

Then again, what if I were to inform students about the film's conclusion beforehand and even tell them what kinds of responses might be "appropriate"? I could ask them to meditate on an apposite aphorism during the blackout, such as Heraclitus's "Fullness and emptiness are the same thing" or Heidegger's "The absent is also present."[44] Or I might encourage them to clear their minds of conscious thought, to make their minds as empty as the black screen in front of them. Perhaps I should pacify them by chatting with them about *Deanimated* while the black screen runs its course. But to fill Arnold's silence with chatter seems to betray its spirit. I want my students to lose themselves in the darkness, to absorb the quiescence of the aleatory pops and hisses on the sound track. (After a while, these sounds seem to create their own rhythm. Are we listening to the same auditory "void" again and again? Is it possible to repeat silence?) I do not simply want my students to think about absence or to discuss absence; I want them to *experience* absence. I must admit that some of my students become annoyed at the prospect of sitting in a dark, silent room for six minutes without doing or saying anything. I am sometimes tempted to tell them, "I paid $60 for this six minutes of blackness so you're going to watch it and you're going to enjoy it!"

It is hard for me to describe to my students (or to anyone else, for that matter) why I relish the opportunity to stare at Arnold's black screen. Perhaps it is partly because I am fond of looking at screens. (Why shouldn't one occasionally look *at* a screen rather than *through* it?) As Tanya Shilina-Conte notes, "Blank space draws attention to the *pageness* of the page and the *screenness* of the screen, both as material substrates (made of paper or vinyl)

and as their respective conceptual constructs."[45] In contemporary Western culture, of course, screens are ubiquitous. I encounter numerous screens every day in the form of computers, smartphones, tablets, televisions, and cinema screens. But these screens tend to be teeming with images: explosions, consumer products, attractive models. I have no problem with any of this content per se, but I do sometimes find it exhausting. I need a breath, a moment without a barrage of images vying for my attention, an opportunity to look at (and perhaps feel) nothing. *Deanimated* gives us a respite from what Guy Debord has called a "society of images."[46] In the world of *Deanimated*, images do not endlessly proliferate as they do in our contemporary consumer culture; rather, images disappear, one by one, until they have all been consumed by the void. Sitting in a darkened theatrical space while listening to a (relative) silence, one can lose oneself in Arnold's "infinite emptiness."[47] Why do we so often prefer imagery to its absence, sound to silence? Or, to rephrase the classic philosophical question, "Why must there always be something rather than nothing?"

CONCLUSION

Nothing Is Important

One day when I was studying with Schoenberg, he pointed out the eraser on his pencil and said, "This end is more important than the other."

—John Cage, *Silence*

My work consists of two parts: the one presented here plus all that I have not *written. And* it is precisely this second part that is the most important one.

—Ludwig Wittgenstein

I n 1976 the Japanese photographer Hiroshi Sugimoto paid a dollar to see a movie at St. Marks Cinema in Manhattan's East Village. He sat down and discreetly took out a large-format camera that he had smuggled into the theater. When the movie began, Sugimoto released the shutter. When the movie ended, he closed it. Rather than photographing a specific frame of the film, Sugimoto had, in a sense, photographed *every* frame of the film. He developed the photograph that evening and saw that this approach to photography had emptied the screen of its contents. By photographing everything, he had photographed

nothing. Instead of displaying characters or objects, the screen simply became a luminous white rectangle, one that lit up the surrounding theatrical space. This would be the first work of Sugimoto's *Theaters* (1976–present), a series of photographs of movie theaters from around the world. In the center of each photograph is a glowing white screen that is simultaneously full and empty.

What was the impetus for *Theaters*? In part, Sugimoto wanted to use photography to capture the mystery and aura of the movie theater itself. When he was a young child in Japan, Sugimoto's mother had taken him to see a film for the first time, and he was immediately struck by the theater's "mysterious atmosphere."[1] Consequently, Sugimoto wanted his *Theaters* photographs to be infused with a sacred aura, to be both "mysterious" and "religious."[2] But Sugimoto is also interested in subverting photographic indexicality, the sense that photographs only reflect what is present in the real world. After all, one who did not know the context of a *Theaters* photograph might assume that Sugimoto had actually photographed an empty white screen—perhaps while attending a screening of Nam June Paik's *Zen for Film* (1962–1964). But the films that Sugimoto photographs are far from empty; they each contain thousands of individual stills. Sugimoto would later reflect on one of his *Theaters* photographs and muse, "The image was something that neither existed in the real world nor was it anything that I had seen. So who had seen it, then? My answer: it was what the camera saw."[3]

But if Sugimoto's camera saw the blinding whiteness of every image and no image, what do human spectators see? When looking at a photograph of a film, one's attention is normally monopolized by the film's images. But by effacing these images, Sugimoto instead foregrounds other elements of the cinematic encounter: the size and shape of the screen, the arrangement of

the seats, the architecture of the theater. Consider, for example, his *Teatro Comunale di Ferrara* (2015), which depicts the interiors of a lavish opera house (and occasional movie theater) in Ferrara, Italy (see figure 5.1). When looking at this photograph, one notices the elements circumscribing the imageless white screen: empty seats, dark boxes, a curved ceiling with a chandelier in

FIGURE 5.1 Hiroshi Sugimoto, *Teatro Comunale di Ferrara* (2015)

its center. The ceiling is covered with painted figures, but only those figures nearest to the glowing screen are visible—the others are cloaked in darkness. The theatrical space is depopulated, but it is also teeming with lively architecture and art. (The art on the ceiling, by a Milanese painter named Francesco Migliari, depicts scenes from the life of Julius Caesar.) *Teatro Comunale* is not simply a photograph. It is an aesthetic experience that fuses elements from various art forms: photography, cinema, architecture, painting.

Teatro Comunale also has striking affinities with many of the films discussed in this book. Sugimoto's imageless white screen reminds one of Walter Ruttmann's imageless black screen in *Weekend* (1930). Like Stan Brakhage's *Window Water Baby Moving* (1959), *Teatro Comunale* provides an atmosphere of intense silence.[4] *Teatro Comunale* also reminds one of Naomi Uman's *removed*, since both Sugimoto and Uman erase cinematic images. And, of course, *Teatro Comunale* has much in common with Martin Arnold's *Deanimated*. Both works evoke absence through empty chairs, and both works are heavily invested in the *disappearance* of cinematic imagery. Additionally, both *Teatro Comunale* and *Deanimated* embody the Buddhist concept of sunyata: emptiness as fullness.

As I argued in chapter 4, Buddhist ideas seeped into Arnold's film indirectly via the influence of John Cage and Andy Warhol. In Sugimoto's case, however, the influence of Buddhism was direct. When he took his first *Theaters* photograph at the age of twenty-eight, Sugimoto was "pondering the similarities between Zen Buddhism and the phenomenology of Edmund Husserl." He was also writing Zen koans, such as "When I stare at a stone, the stone looks back at me as if to say, 'I have no tricks up my sleeve.'"[5] And Sugimoto would later cite the Buddhist tea master Sen Rikyū as one of the most important influences on his

work.[6] In fact, Sugimoto claimed that the only other figure whose influence on his work rivaled that of Rikyū was Marcel Duchamp, the artist who embraced absence in works like *50cc of Paris Air (50cc air de Paris)* (1919). A number of art critics and scholars have noted the parallels between Duchamp's art and Buddhist philosophy. Kay Larson, for example, argues, "Either Duchamp absorbed Buddhist teachings from books, or he got the point all by himself."[7] Along similar lines, Tosi Lee sees Zen undercurrents in a number of Duchampian aphorisms, such as "My position is the lack of position."[8] While Duchamp did not invoke Zen Buddhism as an inspiration for his work in the way that his disciple John Cage did, Sugimoto is convinced that Duchamp's aesthetic was nevertheless shaped by Zen: "To me, it sounds like he was heavily influenced by Zen Buddhism. But many times, he's been asked, 'Are you influenced by Zen?' and he's said, 'Never. I never heard of Zen.' But he's lying, I think. . . . It's very clear to me that Duchamp is influenced by Zen."[9]

Whether or not Duchamp is "lying," his philosophy of absence clearly echoes the Buddhist concept of *sunyata*. In the Zen tradition, there are two answers to the question "What is Zen?" One involves a myth in which a fish asks the queen fish, "What is the sea?" The queen responds, "You live, move, and have your being in the sea. The sea is within you and without you, and you are made of sea, and you will end in sea. The sea surrounds you as your own being."[10] The other answer to the question "What is Zen?" is this:

In other words, Zen is both everything (the sea that surrounds the fish) and nothing (the silent reply). And Duchamp defines Dada in much the same way. When the subversive artist was asked in 1921, "What is Dada?," he responded by saying, "Dada is nothing," before adding, "Everything is nothing."[12] Both Duchamp and the Zen tradition complicate the boundaries between *is* and *is not*.

This tension between absence and presence can also be found in the vacant photographs of Hiroshi Sugimoto, the blank canvases of Kazimir Malevich, the wordless poetry of Vasilisk Gnedov, and the silent music of John Cage. A number of avant-gardists have extended this investment in absence to the domain of film. Like absence in visual art, literature, and music, absence in cinema has proven to be malleable and multifarious. In *Weekend*, Walter Ruttmann uses a filmic void to reorient the human sensorium, reminding us that, in the absence of images, hearing can become a profoundly visual experience. In *Window Water Baby Moving*, Stan Brakhage uses silence to create an intensely ambiguous aesthetic encounter. In *removed*, Naomi Uman demonstrates the power of absence to amplify eroticism. And in *Deanimated*, Martin Arnold's erasures enable spectators to experience sunyata, a state of radical openness.

The minimalist filmmaker Robert Bresson once proclaimed that "cinema is the art of showing nothing." He was excited by the medium's capacity to create rich aesthetic experiences using a "minimum of means."[13] As filmmakers continue to use blackness, silence, and erasure in new and challenging ways, it is worth remembering just how significant nothing can be. For many, the word *nothing* evokes existential anxiety and nihilistic dread. But it can also evoke freedom, openness, and multiplicity. As Duchamp reminds us, there is nothing wrong with nothing: "Nothing is good, nothing is interesting, nothing is important."[14]

FILMOGRAPHY

n the following filmography I provide brief descriptions of a number of key films that exploit cinematic absence. I have favored a tripartite taxonomy (Films Without Images, Films Without Sound, Cinematic Erasures), although there are obviously films that fall into more than one category, such as Nam June Paik's *Zen for Film* (1962–1964), which features neither sound nor imagery. I should emphasize that I have selected dozens of films from a list of thousands (particularly in the case of films without sound, which are quite common within the cinematic avant-garde). In other words, this filmography is not intended to be exhaustive but rather to give the reader an overview of some of the diverse ways that absence has been exploited within experimental cinema.

.

FILMS WITHOUT IMAGES

Weekend. Dir. Walter Ruttmann.
Germany, 1930.

Nothing to see here.

Weekend appears to be the first imageless film ever made: an intricate sound collage of words, songs, cash registers, and

industrial machines. By assembling some 240 sound samples on a black filmstrip, Ruttmann created a rich and challenging work that dissolves the boundaries between cinema, radio art, sound art, and music. As K. J. Donnelly notes, films like *Weekend* suggest that "just as it is possible for silent film to be meaningful without sonic accompaniment, film can lose the image and survive as an object."[1]

Howls for Sade (*Hurlements en faveur de Sade*). Dir. Guy Debord. France, 1952.

For seventy-five minutes Debord presents his audience with nothing more than white screens (accompanied by voices) and black screens (accompanied by silence). The voices are those of Gil J Wolman, Serge Berna, Barbara Rosenthal, and Debord himself, and the language is a disconcerting mélange of aphorisms ("Order reigns but does not govern"), anti-Semitic outbursts ("But he's a Jew!"), and banalities ("Would you like an orange?").[2] While the titular reference to Sade is by no means straightforward, one wonders if the film itself is an exercise in sadism. As Dieter Daniels notes, *Hurlements* assaults spectators with a "violent silence" and an "aggressive emptiness."[3] Furthermore, like Sade's notorious *120 Days of Sodom*, the language of *Howls for Sade* is often graphic and distressing: the voices discuss war, murder, rape, and suicide.

Arnulf Rainer. Dir. Peter Kubelka. Austria, 1960.

There are four elements in *Arnulf Rainer* (a film named after an iconoclastic Austrian painter): white screens, black screens, white

noise, and silence. Kubelka's radical experiment interweaves these primordial elements in mathematically complex patterns over the course of five and a half minutes. When the film premiered in Vienna in May 1960, the vast majority of those present walked out. For many, Kubelka had simply gone too far. The filmmaker would later recall, "I lost most of my friends because of *Arnulf Rainer*."[4]

The Flicker Film. Dir. Norman McLaren. Canada, 1961.

Black frames and white frames alternate with dizzying rapidity for approximately four minutes, as an unnerving clicking sound dominates the sound track. Though the film was made years before the more widely known flicker films of Tony Conrad and Paul Sharits, it has received little scholarly attention, in part because McLaren never finished it. He simply said, "Too esoteric, even for me."[5]

Zen for Film. Dir. Nam June Paik. United States, 1962–1964.

Saint Augustine: "What then is time? Provided that no one asks me, I know. If I want to explain it to an inquirer, I do not know."[6] Hanna B. Hölling: "What, then, is *Zen for Film*? If no one asks me, I know what it is. If I wish to explain it to someone else . . . I do not know."[7]

In *Zen for Film*, Paik projects clear leader, resulting in a luminous white rectangle that is occasionally punctuated by hairs,

scratches, and specks of dust. I have long wanted to project *Zen for Film* on top of one of Robert Rauschenberg's *White Paintings*. The soundtrack for this multimedia event, of course, would have to be John Cage's *4′33″* (although if the rights to Cage's composition could not be secured, Alphonse Allais's *Funeral March for the Obsequies of a Great Deaf Man* or Erwin Schulhoff's "In Futurum" could be performed instead).

The Flicker. Dir. Tony Conrad.
United States, 1965.

Like *Arnulf Rainer*, the filmstrip for *The Flicker* is composed entirely of black frames and clear frames. Unlike *Arnulf Rainer*, however, *The Flicker*'s aggressively pulsating rhythms tend to produce vivid hallucinations in spectators: shapes, colors, patterns, faces, demons. The film's otherworldly atmosphere is also a byproduct of its mesmeric sound track, a score that Conrad created with an electronic instrument that he built himself. Conrad had been inspired, in no small part, by the electronic music of Karlheinz Stockhausen, especially compositions like *Gesang der Jünglinge* (*Song of the Youths*) (1956) and *Kontakte* (1960).[8]

Although Jonas Mekas has hailed *The Flicker* as "one of the few original works of cinema,"[9] the film is not for everyone. In fact, it begins with the following title card: "WARNING: The producer, distributor, & exhibitors waive all liability for physical or mental injury possibly caused by the motion picture *The Flicker*. Since this film may induce epileptic seizures or produce mild symptoms of shock treatment in certain persons, you are cautioned to remain in the theater only at your own risk. A physician should be in attendance." I have screened *The Flicker* in numerous classes, and thankfully, it has not yet induced any

epileptic seizures (although one young man did run out of the classroom in the middle of a screening to vomit).

White (Weiß). Dir. Ernst Schmidt, Jr. Austria, 1968.

To create *White*, Schmidt punched small holes in a clear film-strip. But if the white screen is the ultimate filmic void, what happens when a filmmaker tears through its very fabric, thus destabilizing the boundaries between absence and presence? For Schmidt, the mise-en-scène is simultaneously a *mise en abyme*: an absence within an absence.

The Song of Rio Jim. Dir. Maurice Lemaître. France, 1978.

While the screen remains black for all six minutes of this film's duration, the sounds that are heard in the darkened theatrical space leave little doubt as to the work's generic status. Country music, birds chirping, horses running, and gunshots all suggest that we are in the mythic realm of the American western. As Yann Beauvais notes, Lemaître does not create these sounds for his film but appropriates them from preexisting westerns: "In *The Song of Rio Jim* (1978) Lemaître creates a western using only found sound."[10]

A Movie Will Be Shown Without the Picture. Dir. Louise Lawler. United States, 1979.

For the premiere performance of this work at the Aero Theatre in Santa Monica, California, the audience stared at a blank

screen while listening to all the sounds of *The Misfits* (John Huston, 1961), a film that features Marilyn Monroe's final cinematic performance. Much of the film's dialogue takes on new meaning in Lawler's darkened theatrical space. (For example, Monroe's final line in the film is "How do you find your way back in the dark?") For later permutations of *A Movie Will Be Shown Without the Picture*, Lawler stripped the imagery from *A Face in the Crowd* (Elia Kazan, 1957), *The Hustler* (Robert Rossen, 1961), and *Saturday Night Fever* (John Badham, 1977).

I am especially fond of Lawler's imageless screenings of *What's Opera, Doc?* (Chuck Jones, 1957) at the Bleecker Street Cinema in New York in 1983 and at the Museum of Modern Art in 2017. *What's Opera, Doc?* is an animated parody of Richard Wagner's operas featuring Bugs Bunny and Elmer Fudd. There is something both unsettling and hilarious about sitting in a dark room with strangers while listening to a disembodied voice intone, "Kill the wabbit! Kill the wabbit! Kill the wabbit!" The result is a sly deconstruction of the Wagnerian *Gesamtkunstwerk*. In the words of Thomas Beard, *A Movie Will Be Shown Without the Picture* prompts spectators to learn "how to watch a literally unwatchable film."[11]

Passage Through: A Ritual. Dir. Stan Brakhage. United States, 1990.

A black screen predominates throughout almost all fifty minutes of *Passage Through: A Ritual* (1990). Unlike most Brakhage films, *Passage Through* features a musical sound track: Philip Corner's composition *Through the Mysterious Barricade, Lumen 1 (after F. Couperin)*. While Brakhage's black screen is occasionally punctuated by flashes of imagery—such as grass, weeds, and

tree branches—it has been estimated that only 0.03 percent of the film contains images.[12] Brakhage describes *Passage Through* this way: "The film consists of mostly black leader with very brief shots of photographed objects that are usually unrecognizable. And I cut them to the music. So there are these long dark spaces of music with occasional flashes of imagery. It was one of the hardest films to edit since the challenge was to find the exact place where a particular image belonged. If I stretched some of those places ten seconds longer, it would become absurd."[13]

One¹¹. Dir. Henning Lohner. Germany, 1992.

As a young man, John Cage visited a village in Italy and planned on seeing a film that was scheduled to be projected in the local marketplace. Cage stared at the large screen that had been erected in the square and eagerly waited for the feature to begin. Little did he realize that the scheduled film had not arrived in town. As a result, the "film" that Cage ended up viewing was simply an empty screen accompanied by the ambient sounds of the environment: casual conversation, wind, forks and knives scraping against plates. This was Cage's kind of cinema: random, spontaneous, empty.

This formative experience helped to shape the extreme asceticism of *One¹¹*. (While the film was technically directed by the German American filmmaker Henning-Lohner, Cage is the film's auteur.)[14] The ninety-minute film visually consists of nothing more than the movement of light in an empty room. Everything about the light—its brightness, its location, its movements—is determined by chance procedures. Taking a cue from his favorite film—Nam June Paik's *Zen for Film* (1962–1964)—Cage

insisted that the 35-mm copies not be cleaned, so that dust particles could accumulate on the filmstrip and dance across the screen when the film was projected. *One¹¹* is generally accompanied by Cage's composition *103* (1991), an eerie abstract soundscape. Cage describes the film this way: "*One¹¹* is a film without a subject. There is light but no persons, no things, no ideas about repetition and variation. It is meaningless activity which is nonetheless communicative, like light itself, escaping our attention as communication because it has no content."[15] Cage sees the film's lack of content as liberatory: "One is freed of the problems of politics and economics. Even perhaps free of oneself."[16]

Blue. Dir. Derek Jarman. United Kingdom, 1993.

After being diagnosed with AIDS in 1986, the British filmmaker Derek Jarman began taking medication that turned everything he saw blue. Over time the medication caused him to lose his vision entirely. *Blue* explores the deterioration of Jarman's vision by pairing a monochromatic blue screen with ethereal music, ambient sounds, and poetic language:

Dead good looking
In beauty's summer
His blue jeans around his ankles
Bliss in my ghostly eye
Kiss me on the lips
On the eyes
Our name will be forgotten
In time.

Unseen Film Substitution. Dir. Michael Betancourt. United States, 1998.

Unseen Film Substitution exists only in the mind: it is nothing more than a set of instructions encouraging spectators to remember a film that they enjoyed in the past. There is no pre-determined running length for this conceptual film, but Betancourt's "screenings" have generally been quite brief, and as a result, many have "missed" the film altogether. As Betancourt notes, "Being imaginary, [*Unseen Film Substitution*] is easy to miss in a film screening since there's nothing to see on screen during the show. You'd have to notice it in the program book to realize it 'happened.'"[17] My experience with this work involved an attempt to mentally reconstruct my favorite film: Stanley Kubrick's *2001: A Space Odyssey* (1968). I quickly realized the difficulty of this task. Even though I have seen *2001* more than a dozen times, I found it impossible to imagine more than just a few seconds of the film at a time; my mind could only reproduce ephemeral fragments of Kubrick's magnum opus. Can the memory of a film itself be a film? And what would happen if Betancourt released a "sequel" in which spectators were asked to remember *Unseen Film Substitution*? Can one remember remembering?

Black. Dir. Anouk De Clercq. Belgium, 2015.

The Belgian multimedia artist Anouk De Clercq pairs a black screen with self-reflexive language for five minutes. An excerpt from *Black's* sound track: "The room is darkened so that a beam of light can travel across it, haunt it, unfold an entirely new world

on a two-dimensional white plane. That is why, for me, black does not have anything to do with unpleasant gloom. On the contrary, it is related to a concentrated form of living. With essence and substance. Immense, like the night. Intimate, like the pupil of an eye."

Am I Pretty? Dir. Jennifer Proctor.
United States, 2018.

Jennifer Proctor appropriates audio from a series of YouTube videos in which young girls ask spectators to leave comments on their physical attractiveness:

People say I'm ugly. So tell me. Am I?
Am I pretty or ugly?
If I wasn't pretty, I wouldn't have a boyfriend named Grayson, okay?

But Proctor's "visually silent film" replaces the visuals of the original videos with an imageless monochromatic screen, thus removing any basis for judgment.[18] (The color of the screen gradually shifts between various shades of pink and purple, and the color even seems to change depending on where in the auditorium one happens to be when viewing the film.) In one particularly revealing sequence, a voice insists, unconvincingly, "I don't care what anyone thinks of me . . . I really don't care what anyone thinks of me." *Am I Pretty?* is a poignant exploration of insecurity, vulnerability, and the damaging effects of society's obsession with beauty.

FILMS WITHOUT SOUND

Symphonie Diagonale (*Diagonal Symphony*). Dir. Viking Eggeling. Germany, 1924.

Symphonie Diagonale is a landmark of abstract cinema, one in which angular and curvilinear forms gradually expand, contract, and disappear. While the film is often projected with musical accompaniment, this runs counter to Eggeling's artistic vision. In the words of Paul O'Reilly, "Eggeling insisted that the film be screened without any form of musical accompaniment, instead using his intricately-patterned visual motifs to produce a syn-aesthetic evocation of absent sound."[19]

Portrait of a Young Man. Dir. Henwar Rodakiewicz. United States, 1925–1931.

Though the title evokes James Joyce's *A Portrait of the Artist as a Young Man* (1916), this film is not an adaptation of Joyce's novel. It is, however, Joycean in its ambitious stream-of-consciousness aesthetic. Throughout its fifty-three-minute duration, *Portrait of a Young Man* displays a number of visually arresting objects that seem to have little relation to each other: waves, leaves, smoke, clouds, machines. The film's abstract play of light on water reminds one of Ralph Steiner's *H2O* (1929) and its contemplative aesthetic prefigures the cinema of James Benning (such as the magisterial *California Trilogy* [1999–2001]). Rodakiewicz thought about adding music to the images in *Portrait of a Young Man*, but he ultimately decided that the film should be projected in silence since any musical accompaniment "would only be saying the same thing twice."[20]

Radio Dynamics. Dir. Oskar Fischinger. United States, 1942.

This abstract film begins with Fischinger's adamant instructions: "Please! <u>No music</u>. Experiment in Color-Rhythm." But even if *Radio Dynamics* features no music (or any other sounds, for that matter), it remains profoundly musical. (A later title card describes the film as "A COLOR-MUSIC COMPOSITION.") Fischinger generously lathers the screen with vibrant blues, reds, yellows, and blacks, among other hues. At times the film resembles a Kandinsky painting that has come to life. At other times it engenders the sensation of being sucked into a chromatic vortex. (Imagine if the Star Gate sequence from *2001: A Space Odyssey* had been animated by Chuck Jones.) In spite of its auditory "void," the film is lacking precisely nothing. As Jonathan Rosenbaum notes, *Radio Dynamics* presents "a visual music so generous, plentiful, joyful, and alive it finally makes musical accompaniment superfluous."[21]

Meshes of the Afternoon. Dir. Maya Deren and Alexander Hammid. United States, 1943.

Deren and Hammid's canonical masterpiece is replete with haunting and cryptic images: a flower, a key, a corpse, and a mysterious hooded figure with a mirror for a face. In spite of the film's unrelenting silence, spectators invariably "hear" the sounds that are suggested by the film's images: footsteps, a knife shattering glass, waves on a beach. Those who insist on experiencing Deren's imagery with musical accompaniment should skip the 1959 version of *Meshes* (with a score by Teiji Ito) in favor of Wendy Morgan's 2010 music video for Janelle Monae's

"Tightrope," which blends reconstructed imagery from *Meshes* with infectious funk and hip-hop.

The Potted Psalm. Dir. Sidney Peterson and James Broughton. United States, 1946.

This mysterious and disjointed experiment is filled with "noisy" images that make no noise: a man playing an accordion, a hand rummaging through a box filled with keys, an old woman chewing on a large leaf. Francean Campbell composed a score for *The Potted Psalm*, but Peterson and Broughton ultimately decided to project the film in silence. Instead, they would allow the images to speak for themselves. But what are these bizarre images saying? Never mind. To ask what *The Potted Psalm* "means" is to miss the point. As Broughton puts it, "Travelling in the Far East . . . it is fruitless to go about looking at images of the Buddha, asking what they mean. It is better to permit them to look at you. Then you will have an experience. Then the image will ask: What do *you* mean?"[22]

Angel. Dir. Joseph Cornell. United States, 1957.

Brakhage claimed that the first time he was "consciously against adding sound" to a film was *The Wonder Ring* (1955), a work commissioned by the artist Joseph Cornell, who shared Brakhage's commitment to silence.[23] Like Brakhage, Cornell added no sound or music of any kind to most of his films. Perhaps the apotheosis of Cornellian silence is *Angel*, a "masterpiece of tonal nuance" in which shots of a serene sculpture of a female angel are intercut with shots of a nearby pool reflecting the placid blue

sky above it.[24] The film's silence infuses it with a gentle tranquility. *Angel* is as transcendent and ethereal as its title suggests.

Window Water Baby Moving. Dir. Stan Brakhage. United States, 1959.

By the late 1950s Brakhage came to see cinematic sound as a barrier to his growth as a film artist. He recalled, "Gradually it became more and more apparent to me that my abilities as a composer of sound were not keeping up with my abilities as a visionary; sound was tearing the films apart."[25] While Brakhage would forgo the use of sound in literally hundreds of films, *Window Water Baby Moving* represents one of his most poignant uses of silence. Spectators witness the birth of Stan and Jane's first child, Myrrena, but hear nothing except the gasps and shrieks of the film's stunned spectators.

Blow Job. Dir. Andy Warhol. United States, 1963.

A significant number of Warhol's early films are silent, including *Sleep* (1963), *Kiss* (1963), *Empire* (1964), and the *Screen Tests* (1964–1966). I would argue, however, that *Blow Job* provides one of Warhol's most evocative silences. In this film, spectators see nothing more than a man's face for thirty-five minutes. Presumably, the actor is being fellated off-screen, although as Roy Grundmann notes, *Blow Job* "depicts neither sucking nor sucker."[26] I would add that the film also depicts neither the sounds of the sucker (slurping, swallowing) nor the sounds of the suckee (heavy breathing, moaning). Grundmann argues

that the silence of *Blow Job* "tends to produce a nervous self-consciousness among viewers in classrooms and movie houses."[27] I agree, although I doubt that spectators would be any less nervous or self-conscious if they could hear the sounds of fellatio. That said, spectators may well have been less uncomfortable if the film had included the traditional accoutrements of pornography, such as suggestive dialogue and erotically charged music. By stripping his film of these generic conventions, Warhol prompts spectators to confront sexuality directly (even if this is paradoxically achieved by not showing the sex act at all).

Go! Go! Go! Dir. Marie Menken.
United States, 1962–1964.

Go! Go! Go! is a twelve-minute experiment in time-lapse photography that captures the frenetic rhythms of New York City, as boats, cars, and people zig and zag with dizzying speed. One can imagine a number of sound tracks that Menken might have used to accompany her fleeting images: the cacophonous sounds of the city, perhaps, or the breathless bebop of Charlie Parker's "Anthropology" (1945). Instead, Menken's images are accompanied by a contemplative silence, one that allows the spectator to better apprehend the rhythms of the city itself. Given Menken's interest in visual rhythms, it should come as no surprise that Stan Brakhage declared *Go! Go! Go!* to be an "epic masterpiece."[28]

Film. Dir. Alan Schneider.
United States, 1965.

Samuel Beckett once mused, "I realised that Joyce had gone as far as one could in the direction of knowing more, [being] in

control of one's material. He was always *adding* to it; you only have to look at his proofs to see that. I realised that my own way was in impoverishment, in lack of knowledge and in taking away, in subtracting rather than in adding."[29] This aesthetic clearly undergirds Beckett's only screenplay, *Film*. (Although Alan Schneider is credited as the work's director, he is quick to acknowledge that Beckett was "its real author.")[30] In the film, O (played by Buster Keaton) attempts to escape from being the object of anyone's (or anything's) vision. The work is completely silent, with the exception of a single sound: "Sssh!" Thus *Film* breaks its silence by demanding the immediate return of that silence. With this single phoneme, Beckett evokes what he elsewhere called "the expression that there is nothing to express, nothing with which to express, nothing from which to express, no power to express, no desire to express, together with the obligation to express."[31]

10/65: Self-Mutilation (Selbstverstümmelung). Dir. Kurt Kren. Austria, 1965.

Self-Mutilation focuses on the disturbing actions of the Austrian performance artist Günter Brus. For the entirety of the film's five-minute duration, Brus, who is covered in a gooey white substance, masochistically attacks himself with scissors, razors, thumbtacks, and other sharp instruments. The film borrows heavily from *Un Chien Andalou* (1929). For example, like Luis Buñuel and Salvador Dalí's Surrealist masterpiece, *Self-Mutilation* features a random disembodied hand. Additionally, near the end of the film, Brus appears to attack his own eye with a pair of scissors, mirroring the infamous eye-slicing sequence

at the beginning of *Un Chien Andalou*. (In a perverse joke, the shot of the masochistic performer cutting up his right eye is followed by a shot of him smoking a postcoital cigarette.) At several points in *Self-Mutilation*, Brus appears to be screaming, although given the film's silence, it is impossible to know if he is actually screaming or simply pretending to scream by opening his mouth in a facsimile of terror. Only eight of Kren's fifty-three films feature sound, and Kren's argument for cinematic silence is quite Brakhagean: "There's a danger image and sound will start to compete against each other. I've always been more interested in visual rhythm; it allows the viewer to grasp an inner music."[32]

Fuses. Dir. Carolee Schneemann.
United States, 1964–1967.

Fuses is a wild and uninhibited exploration of sexuality. Schneemann films a number of erotic encounters between herself and her lover James Tenney, including vaginal penetration, fellatio, and cunnilingus. But *Fuses* is not only about the skin of the lovers—it is also about the skin of the filmstrip, which Schneemann has painted, baked, and dipped in acid to produce a series of phantasmagoric effects. Like Brakhage's *Window Water Baby Moving*, *Fuses* is an implicit assault on the censors who sought to ban "obscene" films in mid-twentieth-century America. As Schneemann recalled, "There were no aspects of lovemaking which I would avoid; as a painter I had never accepted the visual and tactile taboos concerning specific parts of the body."[33] Additionally, both *Window Water Baby Moving* and *Fuses* offer a glimpse into private corporeal experiences, ones that are seen but not heard.

Lemon. Dir. Hollis Frampton.
United States, 1969.

Lemon is a gorgeous cinematic still life that examines the effects of light and shadow on the titular fruit. Lemons at rest do not make sound, and neither does Frampton's film. In an interview with Robert Gardner, Frampton mused, "I now . . . have been making silent films as I felt they needed silence for ten years. But if the image seemed to require no sound, if the sound was merely decorative or just explanatory, then there was a certain pleasure simply of seeing, especially on a large screen. A 40-foot lemon is magnificent."[34]

24 Hour Psycho. Dir. Douglas Gordon.
United Kingdom, 1993.

Descriptions of the art installation *24 Hour Psycho* tend to focus on Douglas Gordon's daring decision to radically decelerate Alfred Hitchcock's *Psycho* (1960) so that the work takes a full twenty-four hours to see in its entirety. This is perfectly reasonable; after all, the work's unorthodox use of found footage and extreme Warholian duration are certainly striking. What often goes unmentioned, however, is the work's utter silence. Spectators no longer hear the sounds of *Psycho*: Bernard Herrmann's unnerving score, Norman Bates's awkward dialogue ("A boy's best friend is his mother"), the sound of a knife penetrating flesh. Hitchcock's rich sound track is replaced by an eerie quietude. The result, according to Klaus Biesenbach, is "an atmosphere of hypersensitivity in which viewers, alone with the silent movie, become aware of the rhythmic pace of their own breathing."[35]

CINEMATIC ERASURES

Boxing Fight (Combate de boxe). Authored by Marcel Duchamp. France, c. 1920s.

One of Duchamp's unrealized cinematic ideas: "(slow motion) Boxing fight—take a film of a real boxing fight—done with white gloves and blacken all the rest of the pictures so that one only sees the white gloves boxing."[36] What would the effect of such a cinematic erasure be? A bit of playful Mélièsian trickery? Or perhaps uncanny horror? In any case, Duchamp's idea anticipates Paul Pfeiffer's digital erasures of boxers. It also anticipates Martin Arnold's appropriations of cartoons in *Tooth Eruption* (2013) and *Elsewhere* (2016), both of which feature disembodied hands in white gloves on a black screen.

Note Five. Authored by Jonas Mekas. United States, 1963.

Though these instructions never resulted in an actual film, the idea is tantalizing: "1. Take a print of the film *Gone With the Wind*. 2. Cut out every second foot. 3. Splice the remainder. 4. Run it through a tank of black ink. 5. Dry it. 6. Open the windows (preferably on both sides of the auditorium, to create enough draft). 7. Project it (for music use Brandenburg Concertos 3 and 4)."[37] Notice that Mekas fantasizes about three distinct forms of cinematic erasure: the removal of the film's sound track (which is replaced by Bach); the removal of much of the film's footage; and the use of black ink to cover the remaining images. Would any images be visible through the black ink? If not, would the audience even know that they were "watching" *Gone with the Wind*?

Monochrome for Yves Klein, Fluxversion I.
Authored by Ben Vautier. France, 1963.

Fluxus artist Ben Vautier's event score reads, "Performer paints a movie screen with nonreflective black paint while a favorite movie is being shown."[38] This work displays a number of the hallmarks of Fluxus art, including participation, intermediality, and iconoclasm. If Yves Klein advocated the "dematerialization" of painting, Vautier makes a case for the dematerialization of cinema.[39]

Film No. 3 (Ask audience to cut . . .). Authored
by Yoko Ono. United States, 1964.

Ono's unrealized film script for *Film No. 3* reads as follows: "Ask audience to cut the part of the image on the screen that they don't like. Supply scissors."[40] Of course, cutting up a film screen hardly erases the image. If anything, it underscores the *persistence* of imagery, as the image will still be seen projected on the wall behind the screen. And this is not to mention the fact that filmic imagery tends to be ephemeral anyway, so that audience members might begin cutting out one image, only to find themselves cutting out an entirely different image. But this may well be part of the work's charm: as the film continues, spectators wonder what imagery will appear on (what is left of) the screen, and what imagery will fall into the void.

Metamorphosis. Dir. Divna Jovanović.
Yugoslavia, 1972.

Jovanović obtains preexisting footage and scrapes at the images on the filmstrip to create surreal displacements and dislocations.

Faces are almost entirely erased, leaving behind only disembodied lips. Two lovers in an embrace are obliterated except for hair, hands, and an amorous smile. These uncanny images enter the realm of the numinous when they are paired with the sound of a guitarist playing Charles Gounod's *Ave Maria* (1853).

removed. Dir. Naomi Uman. Mexico/United States, 1999.

Uman erases the women from an old pornographic film using nail polish and bleach, and the result is a provocative and playful deconstruction of cinema's representational codes. Uman invites viewers to do whatever they want with these "holes." One can attempt to "peek" at the women who are being erased (since they occasionally become visible, in whole or in part, for a split second). One can enjoy the absences *as* absences, taking pleasure in the shimmering voids that haunt the film's mise-en-scènes. Or one can fill in the blanks with one's own desiderata. In the words of Claire Stewart, "The hole in the film becomes an erotic zone, a blank on which a fantasy body is projected."[41]

The Long Count (I Shook Up the World). Dir. Paul Pfeiffer. United States, 2000.

The Long Count (Rumble in the Jungle). Dir. Paul Pfeiffer. United States, 2001.

The Long Count (Thrilla in Manilla). Dir. Paul Pfeiffer. United States, 2001.

In this series of video installations, the artist Paul Pfeiffer digitally erases the boxers from three legendary fights in which

Muhammad Ali spars with Sonny Liston, George Foreman, and Joe Frazier, respectively. Unlike the erased figures in Martin Arnold's *Deanimated*, however, the figures here are not altogether invisible. Instead, they are replaced by barely visible shadowy forms (thus giving a new meaning to the term *shadowboxing*). Even if one has difficulty seeing these spectral manifestations, one can still perceive the effects they have on their environments, such as the ropes of the boxing ring, which bend and bounce for no apparent reason. Pfeiffer calls the work "a triptych put together by HBO."[42]

Pfeiffer employs similar strategies of erasure in other media, as well. For example, in *24 Landscapes* (2000/2008), the artist digitally erases Marilyn Monroe from a series of twenty-four photographs, leaving behind only the vacant landscapes she once inhabited. (Those who want more—or perhaps less—Monroe can also seek out an audio experiment by Language Removal Services in which Monroe's words are erased from a one-minute excerpt of speech, leaving behind sensual breaths and quasi-orgasmic moans.)[43]

Caryatid (Kirkland). Dir. Paul Pfeiffer. United States, 2016.

Caryatid (Duhaupas). Dir. Paul Pfeiffer. United States, 2016.

Caryatid (Cotto). Dir. Paul Pfeiffer. United States, 2016.

Like the *Long Count* series, this triptych traffics in erased boxers. The erasures here are much more seamless than those in *The*

Long Count triptych, however (no doubt an artifact of improved digital technology). Additionally, in these works only *one* of the boxers in each fight is erased, leaving the other boxer alone in the ring. Each solitary boxer is brutally beaten by his invisible opponent, and the works repeat endlessly, creating a sense of Sisyphean despair. These are the perfect videos for anyone who has ever wondered what it might look like for a man to get beaten senseless by a ghost.

Super Mario Clouds. Dir. Cory Arcangel. United States, 2002.

Totally Fucked. Dir. Cory Arcangel. United States, 2003.

Spectators of *Super Mario Clouds* watch bemusedly as blocky clouds slowly move across a giant screen on a gallery wall. (Cory Arcangel achieved the effect by manually removing part of the code from the classic Nintendo game *Super Mario Bros.*) The work exemplifies Arcangel's interest in "demonstrations of technology that in the end have no purpose—either misusing the technology or just employing it in a way that makes no sense."[44]

Arcangel modified *Super Mario Bros.* again the following year to create *Totally Fucked*, a perpetual loop of Mario stuck on top of a cube with nothing to do and nowhere to go. The panicked plumber looks left, then right, then left again, hoping for salvation, but instead finds himself alone and helpless in an indifferent universe. The work's minimalism, wit, and existential anguish evoke the writings of Samuel Beckett.

Forsaken. Dir. Martin Arnold. Austria, 2002.

Dissociated. Dir. Martin Arnold. Austria, 2002.

Deanimated. Dir. Martin Arnold. Austria, 2002.

In his trilogy of erasure, Martin Arnold digitally removes elements from classical Hollywood cinema to create works that embrace aesthetic emptiness. In *Forsaken*, Arnold erases characters from Fred Zinnemann's *High Noon* (1952), so that the installation's two screens often display little more than vacant streets and interiors. In *Dissociated*, Arnold erases the language from selected excerpts of Joseph L. Makiewicz's *All About Eve* (1950), resulting in close-ups of actresses Celeste Holm and Anne Baxter as they move their heads about and breathe without ever saying a word. And in *Deanimated*, Arnold gradually removes sounds and images from Joseph H. Lewis's *Invisible Ghost* until the film eventually becomes a silent black screen. In all these films, Arnold becomes a cinematic psychoanalyst, one who becomes intensely interested in each film's banal minutiae: a chair, a window, the sound of a woman swallowing. Arnold's aesthetic of absence is deeply indebted to Freud's concept of "free-floating attention": "What [Freud] meant is that the psychoanalyst should listen not only to what the patient tells but also to what he or she does not tell—to the blanks in the story. Furthermore the psychoanalyst should focus on small details that initially seem to be totally insignificant."[45]

Shadow Cuts. Dir. Martin Arnold. Austria, 2010.

Soft Palate. Dir. Martin Arnold. Austria, 2010.

Self Control. Dir. Martin Arnold. Austria, 2011.

Haunted House. Dir. Martin Arnold. Austria, 2011.

Tooth Eruption. Dir. Martin Arnold. Austria, 2013.

Whistle Stop. Dir. Martin Arnold. Austria, 2014.

Black Holes. Dir. Martin Arnold. Austria, 2015.

Elsewhere. Dir. Martin Arnold. Austria, 2016.

In these (de)animated works, Arnold deconstructs old Disney cartoons by digitally removing most of the elements in the frame and looping the elements that remain. In other words, these films combine the looping of Arnold's early trilogy of compulsive repetition with the digital elisions of his trilogy of erasure. Perhaps the most haunting of these films is *Black Holes*, in which an intermittently visible Goofy appears to shoot himself in the head repeatedly.

The films remind one of the cel animation techniques that were used to create many Disney cartoons, which involved drawing individual body parts (heads, arms, legs, etc.) on transparent sheets and then laying them on top of each other to complete the image. As Arnold puts it, "Metaphorically speaking, I'm deceling cel animation. Of course I do it digitally, but if the original sheets were still available and I could have gotten access to them, I could also have done it in an analog way."[46]

NOTES

INTRODUCTION

1. Arturo Schwarz, *The Complete Works of Marcel Duchamp* (New York: H. N. Abrams, 1969), 479. The first epigraph in this chapter is also from this volume (197).
2. Dalia Judovitz, *Drawing on Art: Duchamp and Company* (Minneapolis: University of Minnesota Press, 2010), 16.
3. In fact, Walter Arensberg did accidentally break the original ampoule in 1949, prompting Duchamp to write out these explicit instructions to his friend Henri-Pierre Roché: "Could you go to the pharmacy at the corner of Rue Blomet and Rue de Vaugirard (if it's still there—that's where I bought the first ampoule) and buy an ampoule like this: 125cc and the same measurements as the sketch [to scale, inserted]. Ask the pharmacist to empty it of its contents and seal the glass with a blow torch. Then wrap it up and send it to me here. If not Rue Blomet, somewhere else—but, as far as possible, the same shape and size. Thanks." Quoted in Robert Harvey, "Where's Duchamp? Out Queering the Field," *Yale French Studies* 109 (2006): 93.
4. Judovitz, *Drawing on Art*, 16.
5. Jerrold Seigel, "Selves Without Qualities? Duchamp, Musil, and the History of Selfhood," in *The Modernist Imagination: Intellectual History and Critical Theory*, ed. Warren Breckman et al. (New York: Berghahn, 2009), 30.

6. Ricky Gervais, "Does God Exist? Ricky Gervais Takes Your Questions," *Wall Street Journal*, December 22, 2010.

7. Jean-Paul Sartre, *Being and Nothingness: A Phenomenological Essay on Ontology*, trans. Hazel E. Barnes (New York: Washington Square, 1992), 38. Italics in original.

8. Ronald Green, *Nothing Matters: A Book About Nothing* (Ropley: Iff, 2011), 76.

9. Lawrence M. Krauss, *A Universe from Nothing: Why There Is Something Rather Than Nothing* (New York: Free Press, 2012), 153.

10. Branislav Jakovljevic, "Hinging on Nothing: Malevich's Total Art," in *Voids: A Retrospective*, ed. John Armleder et al. (Zurich: JRP|Ringier, 2009), 187–91, quote on 187.

11. Slavoj Žižek, *The Parallax View* (Cambridge, Mass.: MIT Press, 2006), 154, 85.

12. Jakovljevic, "Hinging on Nothing," 190.

13. Kasimir Malevich, "Non-Objective Art and Suprematism," in *Art in Theory, 1900–2000: An Anthology of Changing Ideas*, ed. Charles Harrison and Paul Wood (Malden, Mass.: Blackwell, 2003), 292–93.

14. I borrow this term from Ralph Rugoff, "A Brief History of Invisible Art," in *Voids: A Retrospective*, ed. John Armleder et al. (Zurich: JRP|Ringier, 2009), 373–79.

15. Yves Klein, "*The Specialization of Sensibility in the Raw Material State Into Stabilized Pictorial Sensibility*," in *Voids: A Retrospective*, ed. John Armleder et al. (Zurich: JRP|Ringier, 2009), 51–55, quote on 55.

16. Denys Riout, "Exaspérations 1958," in *Voids: A Retrospective*, ed. John Armleder et al. (Zurich: JRP|Ringier, 2009), 28. Of course, not everyone shared Camus's enthusiasm for *The Void*. One spectator rushed for the exit while screaming at the artist, "I'll come back when this emptiness is full!" Klein responded, "When it is full, you will no longer be able to enter." Klein, *The Specialization of Sensibility*, 55.

17. Klein, *The Specialization of Sensibility*, 55. One wonders how much was paid for these invisible paintings—and how much they are worth now. A caveat: anyone who is currently interested in purchasing these works should consult with an art historian to avoid being conned. After all, a forgery of nothing is worth less than nothing.

18. "Yves Klein," in *Voids: A Retrospective*, ed. John Armleder et al. (Zurich: JRP|Ringier, 2009), 36.

19. Benjamin D. Buchloh, "An Interview with Andy Warhol," in *I'll Be Your Mirror: The Selected Andy Warhol Interviews*, ed. Kenneth Goldsmith (New York: Carroll and Graf, 2004), 321–32, quote on 329.

20. Dörte Zbikowski, "Dematerialized: Emptiness and Cyclic Transformation," in *Iconoclash: Beyond the Image Wars in Science, Religion, and Art*, ed. Bruno Latour and Peter Weibel (Karlsruhe, Ger., and Cambridge, Mass.: ZKM, Center for Art and Media, and MIT Press, 2002), 429.

21. Viktor Bokris, *Warhol: The Biography*, 75th anniversary ed. (Boston: Da Capo, 1997), 154.

22. Andy Warhol, *The Philosophy of Andy Warhol: From A to B and Back Again* (New York: Harvest/HBJ, 1975), 7.

23. Warhol, *The Philosophy of Andy Warhol*, 7.

24. Warhol, *The Philosophy of Andy Warhol*, 144. Italics in original.

25. Delos Banning McKown, *The Mythmaker's Magic: Behind the Illusion of "Creation Science"* (Amherst, N.Y.: Prometheus, 1993), 39.

26. David Hopkins, "Sameness and Difference: Duchamp's Editioned Readymades and the Neo-Avant-Garde," in *Avant-Garde/Neo-Avant-Garde*, ed. Dietrich Scheunemann (Amsterdam: Rodopi, 2005), 101.

27. Thierry de Duve, "Yves Klein, or the Dead Dealer," trans. Rosalind Krauss, *October* 49 (Summer 1989): 79.

28. Roy Sorensen, "Hearing Silence: The Perception and Introspection of Absences," in *Sounds and Perception: New Philosophical Essays*, ed. Matthew Nudds and Casey O'Callaghan (Oxford: Oxford University Press, 2009), 131.

29. Slavoj Žižek, *Trouble in Paradise: From the End of History to the End of Capitalism* (Brooklyn: Melville House, 2014), 29. For a close analysis of this joke, see Alenka Zupančič, "Reversals of Nothing: The Case of the Sneezing Corpse," *Filozofski vestnik* 26, no. 2 (2005): 173–74.

30. Green, *Nothing Matters*, 58.

31. Sartre, *Being and Nothingness*, 42. Italics in original.

32. For more on absence in art, see John Armleder et al., eds., *Voids: A Retrospective* (Zurich: JRP|Ringier, 2009); Branden W. Joseph, "White on White," *Critical Inquiry* 27, no. 1 (Autumn 2000): 90–121; and Lucy R. Lippard, ed. and annot., *Six Years: The Dematerialization of the Art Object from 1966 to 1972: A Cross-Reference Book of Information on Some Esthetic Boundaries: Consisting of a Bibliography Into Which Are*

Inserted a Fragmented Text, Art Works, Documents, Interviews, and Symposia, Arranged Chronologically and Focused on So-Called Conceptual or Information or Idea Art with Mentions of Such Vaguely Designated Areas as Minimal, Anti-Form, Systems, Earth, or Process Art, Occurring Now in the Americas, Europe, England, Australia, and Asia (with Occasional Political Overtones) (Berkeley: University of California Press, 1997).

33. Steven Moore Whiting, *Satie the Bohemian: From Cabaret to Concert Hall* (Oxford: Oxford University Press, 2002), 81.

34. Daniel Albright, ed., *Modernism and Music: An Anthology of Sources* (Chicago: University of Chicago Press, 2004), 327.

35. The translation comes from Leo Carey, "Sh-h-h," *New Yorker*, May 24, 2004, 36.

36. John Cage, *Conversing with Cage*, ed. Richard Kostelanetz, 2nd ed. (New York: Routledge, 2003), 70.

37. John Cage, *Silence: 50th Anniversary Edition* (Middletown, Conn.: Wesleyan University Press, 2011), 12.

38. Craig Dworkin, *Nothing: A User's Manual* (N.p.: Information as Material, 2015), 5.

39. Peter Dickinson, ed., *CageTalk: Dialogues with and About John Cage* (Rochester, N.Y.: University of Rochester Press, 2006), 12. In this letter, Cage also implies that Allais and Duchamp were kindred spirits: "Marcel Duchamp, the evening he died, had been reading Allais and chuckling."

40. See, for example, Cage's lecture at Vassar College in 1948, where he discussed his idea for the "silent" composition that would eventually become *4′33″*. Cage admitted that while his plan to "compose a piece of uninterrupted silence" might seem "absurd," he was "serious." Quoted in Kyle Gann, *No Such Thing as Silence: John Cage's 4′33″* (New Haven, Conn.: Yale University Press, 2010), 126.

41. For further theorizations of silence, see Cage, *Silence*; Susan Sontag, "The Aesthetics of Silence," in *Styles of Radical Will* (New York: Picador, 1969), 1–34; Dieter Daniels, "Silence and Void: Aesthetics of Absence in Space and Time," in *The Oxford Handbook of Sound and Image in Western Art*, ed. Yael Kaduri (New York: Oxford University Press, 2016), 315–31; and Werner Wolf and Walter Bernhart, eds., *Silence and Absence in Literature and Music* (Boston: Brill Rodopi, 2016).

42. Samuel Beckett, *Waiting for Godot* (New York: Grove, 2011), 32.

43. Deirdre Bair, *Samuel Beckett: A Biography* (New York: Touchstone, 1993), 570.

44. "Scholars Discover 23 Blank Pages That May As Well Be Lost Samuel Beckett Play," *Onion*, April 26, 2006, https://entertainment.the onion.com/scholars-discover-23-blank-pages-that-may-as-well-be-lo -1819568421.

45. Mikhail Epstein, " ," *Common Knowledge* 16, no. 3 (2010): 390. For more on Vasilisk Gnedov's "Poem of the End," see chapter 4.

46. John E. Bowlt, "H2SO4: Dada in Russia," in *Dada/Dimensions*, ed. Stephen C. Foster (Ann Arbor, Mich.: UMI Research, 1985), 236.

47. For a reading of Man Ray's dumb poem as nonsensical Morse code, see Kenneth R. Allan, "Metamorphosis in *391*: A Cryptographic Collaboration Between Francis Picabia, Man Ray, and Erik Satie," *Art History* 34, no. 1 (February 2011): 102–25.

48. Luis Buñuel, "Notes on the Making of *Un Chien Andalou*," in *Art in Cinema: Documents Toward a History of the Film Society*, ed. Scott MacDonald (Philadelphia: Temple University Press, 2006), 102. Capitalization in original.

49. In keeping with the spirit of the novel, Gilbert Adair titles his English-language translation of Perec's text *A Void*, thus avoiding the unwelcome e's in the word *disappearance*. See Georges Perec, *A Void*, trans. Gilbert Adair (Boston: Verba Mundi, 2005).

50. Paul Fournel, *Suburbia*, Bibliothèque Oulipienne, 46, trans. Harry Matthews, in *OuLiPo Laboratory: Texts from the Bibliothèque oulipienne* (London: Atlas, 1995), i–viii, 1–16, quotes on i, 11, 2, 5, 7. Capitalization in original.

51. Beckett used this expression in a letter he wrote on July 9, 1937. Quoted in Leo Bersani and Ulysse Dutoit, *Arts of Impoverishment: Beckett, Rothko, Resnais* (Cambridge, Mass.: Harvard University Press, 1993), 22. For more on absence in literature, see Craig Dworkin, *No Medium* (Cambridge, Mass.: MIT Press, 2013); and Timothy Walsh, *The Dark Matter of Words: Absence, Unknowing, and Emptiness in Literature* (Carbondale: Southern Illinois University Press, 1998). For texts that focus on absence in the oeuvre of Samuel Beckett, see Ciaran Ross, *Beckett's Art of Absence: Rethinking the Void* (New York: Palgrave Macmillan,

2011); and Daniela Caselli, ed., *Beckett and Nothing: Trying to Understand Beckett* (Manchester: Manchester University Press, 2012).

52. André Bazin, "Theater and Cinema: Part Two," in *What Is Cinema?*, vol. 1, trans. Hugh Gray (Berkeley: University of California Press, 2005), 95–124, quote on 96–97.

53. *Limelight* is a film that meant a great deal to Bazin. See, for example, André Bazin, "*Limelight*, or the Death of Molière," in *What Is Cinema?*, vol. 2, trans. Hugh Gray (Berkeley: University of California Press, 2005), 124–27; and André Bazin, "The Grandeur of *Limelight*," in *What Is Cinema?*, vol. 2, trans. Hugh Gray (Berkeley: University of California Press, 2005), 128–39.

54. Bazin, "Theater and Cinema: Part Two," 96–97.

55. Walsh, *The Dark Matter of Words*, 108.

56. Nicole Brenez, *"We Support Everything Since the Dawn of Time That Has Struggled and Still Struggles": An Introduction to Lettrist Cinema*, trans. Clodagh Kinsella (Berlin: Sternberg, 2014), 10.

57. Kaira M. Cabañas, *Off-Screen Cinema: Isidore Isou and the Lettrist Avant-Garde* (Chicago: University of Chicago Press, 2014), 6.

58. Lola Hinojosa, *"Tambours du jugement premier"* (Drums of the first judgment), Museo Nacional Centro de Arte, 2011, http://www.museo reinasofia.es/en/collection/artwork/tambours-du-jugement-premier -drums-first-judgment.

59. Translations from the French are taken from Ken Knabb, ed. and trans., *Guy Debord: Complete Cinematic Works: Scripts, Stills, Documents* (Oakland, Calif.: AK, 2003).

60. See Guy Debord, *Society of the Spectacle*, trans. Fredy Perlman et al. (Detroit: Black and Red, 2010). It seems likely that Yves Klein's 1958 exhibition *The Void* was inspired, at least in part, by the filmic voids of the Lettrists, as Klein had attended screenings of Isou's *Treatise on Drool and Eternity*, Dufrêne's *Drums of the First Judgment*, and Debord's *Howls for Sade* in the early 1950s. One must tread carefully here, however. Debord has claimed that Klein's monochrome paintings were inspired by the twenty-four minutes of darkness at the end of *Howls for Sade*, but as Kaira M. Cabañas points out, Klein would not have actually seen the concluding darkness of *Howls for Sade*, since the screening he attended was terminated after twenty minutes. See Cabañas, *Off-Screen Cinema*, 124. To be fair, Debord did not take all the

credit for Klein's voids. He asserted, "When it comes to painting, it is not I who could possibly obscure the glory of Yves Klein. That is, rather, what Malévitch had done 40 years before." Quoted in Cabañas, *Off-Screen Cinema*, 124.

61. John Cage, *Musicage: Cage Muses on Words, Art, Music* (Hanover, N.H.: Wesleyan University Press, 1996), 135.

62. Dworkin, *No Medium*, 148.

63. Vivian Sobchack, *Carnal Thoughts: Embodiment and Moving Image Culture* (Berkeley: University of California Press, 2004), 6, 3.

64. Thelonious Monk, "You've Got to Dig It to Dig It, You Dig?" in *Lists of Note: An Eclectic Collection Deserving a Wider Audience*, ed. Shaun Usher (San Francisco: Chronicle, 2015), 151. Underlining in original.

1. WALTER RUTTMANN AND THE BLIND FILM

1. C. B. Morris, *This Loving Darkness: The Cinema and Spanish Writers, 1920–1936* (Oxford: Oxford University Press, 1980), 28; Steven Kovács, *From Enchantment to Rage: The Story of Surrealist Cinema* (London: Associated University Presses, 1980), 240.

2. Linda Williams, *Figures of Desire: A Theory and Analysis of Surrealist Film* (Berkeley: University of California Press, 1981), 107. For more on the *L'Age d'Or* riot, see Luis Buñuel, *My Last Sigh*, trans. Abigail Israel (Minneapolis: University of Minnesota Press, 1993), 117–18; and Salvador Dalí, *The Secret Life of Salvador Dalí*, trans. Haakon M. Chevalier (New York: Dover, 1993), 282–84.

3. Kovács, *From Enchantment to Rage*, 240.

4. For detailed discussions of *L'Age d'Or*'s sound track, see Rashna Wadia Richards, "Unsynched: The Contrapuntal Sounds of Luis Buñuel's *L'Age d'Or*," *Film Criticism* 33, no. 2 (Winter 2008): 23–43; and Torben Sangild, "Buñuel's Liebestod: Wagner's *Tristan* in Luis Buñuel's Early Films: *Un Chien Andalou* and *L'Age d'Or*," *JMM: The Journal of Music and Meaning* 13 (2014/2015): 20–59.

5. The Tri-Ergon sound-on-film system was patented in 1919. The system's name (Tri-Ergon, or "work of three") gives credit to the three German technicians who created it: Hans Vogt, Joseph Engl, and Joseph Massolle. For more on Tri-Ergon, see Douglas Gomery,

"Tri-Ergon, Tobis Klangfilm, and the Coming of Sound," *Cinema Journal* 16, no. 1 (Autumn 1976): 51–61.

6. *Weekend* is included on the DVD *Walther Ruttmann: Berlin, die Sinfonie der Großstadt & Melodie der Welt* (Edition Filmmuseum 39, 2014) and on the CD *Walter Ruttmann Weekend Remix* (Intermedium 003, 2000). (The CD pairs Ruttmann's original soundscape with remixes by artists like DJ Spooky That Subliminal Kid and Mick Harris.)

7. Nora M. Alter, "Screening Out Sound: Arnheim and Cinema's Silence," in *Arnheim for Film and Media Studies*, ed. Scott Higgins (New York: Routledge, 2011), 83; Walther Ruttmann, "Compilation of Excerpts from Interviews and Articles 1927–1937," DVD booklet for Walther Ruttmann, *Berlin, die Sinfonie der Großstadt & Melodie der Welt* (Edition Filmmuseum 39, 2014).

8. Justin Remes, "Colored Blindness: Derek Jarman's *Blue* and the Monochrome Film," in *Motion(less) Pictures: The Cinema of Stasis* (New York: Columbia University Press, 2015), 111–36, quote on 136.

9. Walter Ruttmann, quoted in Brían Hanrahan, "13 June 1930: *Weekend* Broadcast Tests Centrality of Image in Cinema," in *A New History of German Cinema*, ed. Jennifer M. Kapczynski and Michael D. Richardson (Rochester, N.Y.: Camden House: 2012), 211.

10. Walter Schobert argues that Ruttmann was "the first to complete an abstract film" and thus "the first film avant-gardist." See Walter Schobert, "The German Film Avant-Garde of the 1920s," in *The German Avant-Garde Film of the 1920's*, ed. Angelika Leitner and Uwe Nitschke, trans. Jeremy Roth, Susan Praeder, and Terry Swartzberg (München: Goethe-Institut, 1989), 10.

11. See Esther Leslie, *Hollywood Flatlands: Animation, Critical Theory, and the Avant-Garde* (London: Verso, 2002), 47.

12. For a more detailed examination of Ruttmann's diverse cinematic practices, see Michael Cowan, *Walter Ruttmann and the Cinema of Multiplicity* (Amsterdam: Amsterdam University Press, 2014).

13. See, for example, Jonas Mekas, "Spiritualization of the Image (June 25, 1964)," in *Movie Journal: The Rise of the New American Cinema, 1959–1971*, ed. Gregory Smulewicz-Zucker (New York: Columbia University Press, 2016), 151–53; Annette Michelson, "Gnosis and Iconoclasm: A Case Study in Cinephilia," in *On the Eve of the Future: Selected*

Writings on Film (Cambridge, Mass.: MIT Press, 2017), 55–75; and Herman Asselberghs, "Beyond the Appearance of Imagelessness: Preliminary Notes on *Zen for Film's* Enchanted Materialism," *Afterall: A Journal of Art, Context and Enquiry* 22 (Autumn/Winter 2009): 5–15. For discussions of imageless films that do begin with Ruttmann's *Weekend*, see the following essays by Gabriele Jutz: "Not Married: Image-Sound Relations in Avant-garde Film," in *See This Sound: Versprechungen von Bild und Ton / Promises in Sound and Vision*, ed. Cosima Rainer, Stella Rollig, Dieter Daniels, and Manuela Ammer (Cologne: Walther König, 2009), 76–83; and "Audiovisual Aesthetics in Contemporary Experimental Film," in *The Oxford Handbook of Sound and Image in Western Art*, ed. Yael Kaduri (Oxford: Oxford University Press, 2016), 397–425.

14. Asselberghs, "Beyond the Appearance of Imagelessness," 15.

15. Anton Kaes claims that *Weekend* was "presented in May 1930 as a radio play in a film theatre before a closed curtain," and this assertion is repeated by Michael P. Ryan. See Anton Kaes, *M* (London: British Film Institute, 2000), 19; and Michael P. Ryan, "Fritz Lang's Radio Aesthetic: M. Eine Stadt sucht einen Mörder," *German Studies Review* 36, no. 2 (May 2013): 261. This appears to be a misunderstanding, however. According to Jeanpaul Goergen, perhaps the world's leading expert on *Weekend*, the first performance of the work, which took place on May 15, 1930, was in a "radio hall, not a cinema room," and it appears that the work was not shown in an explicitly cinematic context until the 2nd International Congress of Independent Film in Brussels between November 27 and December 1, 1930. Jeanpaul Goergen, e-mail to author, February 25, 2017.

16. Michel Chion, *Sound: An Acoulogical Treatise*, trans. James A. Steintrager (Durham, N.C.: Duke University Press, 2016), 78; Ryan, "Fritz Lang's Radio Aesthetic," 261; and Paul Falkenberg, "Sound Montage—A Propos de Ruttmann," *Film Culture* 22–23 (Summer 1961): 61.

17. Hans Richter, "Köpfe und Hinterköpfe," in *The German Avant-Garde Film of the 1920's*, ed. Angelika Leitner and Uwe Nitschke, trans. Jeremy Roth, Susan Praeder, and Terry Swartzberg (München: Goethe-Institut, 1989), 92; and Hans Richter, "Experiments with Celluloid,"

in *The Penguin Film Review, 1946–1949*, vol. 2, ed. R. K. Neilson Baxter, Roger Manvell, and H. H. Wollenberg (Totowa, N.J.: Rowman and Littlefield, 1949), 114.

18. Walter Ruttmann, "Principles of the Sound Film," trans. Alex H. Bush, in *The Promise of Cinema: German Film Theory, 1907–1933*, ed. Anton Kaes, Nicholas Baer, and Michael Cowan (Oakland: University of California Press, 2016), 555–56.

19. S. M. Eisenstein, V. I. Pudovkin, and G. V. Alexandrov, "A Statement," trans. Jay Leyda, in *Film Sound: Theory and Practice*, ed. Elisabeth Weis and John Belton (New York: Columbia University Press, 1985), 84. Capitalization in original.

20. Walther Ruttmann, "Sound Films?-!," in *The German Avant-Garde Film of the 1920's*, ed. Angelika Leitner and Uwe Nitschke, trans. Jeremy Roth, Susan Praeder, and Terry Swartzberg (Munich: Goethe-Institut, 1989), 118.

21. Ruttmann, "Sound Films?-!," 118.

22. Eisenstein, Pudovkin, and Alexandrov, "A Statement," 84.

23. Cowan, *Walter Ruttmann*, 87.

24. Mary Ann Doane, "Ideology and the Practice of Sound Editing and Mixing," in *The Cinematic Apparatus*, ed. Teresa de Lauretis and Stephen Heath (New York: St. Martin's, 1980), 47.

25. Ruttmann, "Compilation of Excerpts."

26. In constructing this taxonomy, I have consulted Daniel Gilfillan, *Pieces of Sound: German Experimental Radio* (Minneapolis: University of Minnesota Press, 2009), 3–4; Peter Jelavich, *Berlin Alexanderplatz: Radio, Film, and the Death of Weimar Culture* (Berkeley: University of California Press, 2006), 81; Andy Birtwistle, "Photographic Sound Art and the Silent Modernity of Walter Ruttmann's *Weekend* (1930)," *New Soundtrack* 6, no. 2 (2016): 109–27, 113–14; and Patrícia Castello Branco, "*Weekend*," in *Directory of World Cinema: Germany 2*, ed. Michelle Langford (Chicago: Intellect, 2013), 287–88.

27. In both *Weekend* and *M*, there is a striking contrast between the cacophonous industrial sounds of the city and the euphonious sounds of whistling. In fact, the similarities between the sounds of *Weekend* and *M* are not merely coincidental. According to Anton Kaes, "Paul Falkenberg, Lang's sound editor and a close friend of Ruttmann's, drew inspiration from *Weekend* for *M*'s richly cadenced sound collages (for

example, noontime is evoked by the sounds of clocks, chimes, and bells); the use of crescendo (people's voices rising to a din); and the conscious employment of signature sounds (the obsessive whistle; the noisy honking of car horns; the insistent tapping of a nail)." See, Kaes, *M*, 19–20.

28. Birtwistle, "Photographic Sound Art," 121.
29. Luigi Russolo, "The Art of Noises: Futurist Manifesto," in *The Art of Noises*, trans. Barclay Brown (New York: Pendragon, 1986), 25. Italics in original.
30. Russolo, "The Art of Noises," 26.
31. Luigi Russolo, "The Orchestra of Noise Instruments," in *The Art of Noises*, trans. Barclay Brown (New York: Pendragon, 1986), 81.
32. Russolo, "The Art of Noises," 27–28. Italics in original.
33. Russolo, "The Art of Noises," 27.
34. Pierre Schaeffer, *In Search of a Concrete Music*, trans. Christine North and John Dack (Berkeley: University of California Press, 2012), 38.
35. Schaeffer, *In Search of a Concrete Music*, 66.
36. See Pierre Schaeffer, "Acousmatics," trans. Daniel W. Smith, in *Audio Culture: Readings in Modern Music*, ed. Christoph Cox and Daniel Warner, rev. ed. (New York: Bloomsbury, 2017), 95–101. This essay is an excerpt from Pierre Schaeffer, *Traité des objets musicaux* (*Treatise on Musical Objects*) (Paris: Éditions du Seuil, 1966). For more on the acousmatic, see Brian Kane, *Sound Unseen: Acousmatic Sound in Theory and Practice* (Oxford: Oxford University Press, 2014).
37. Schaeffer, "Acousmatics," 98.
38. Schaeffer, *In Search of a Concrete Music*, 169, 171, and 182.
39. Dieter Daniels, "Absolute Sounding Images: Abstract Film and Radio Drama of the 1920s as Complementary Forms of a Media-Specific Art," trans. Annie Buenker, in *The Music and Sound of Experimental Film*, ed. Holly Rogers and Jeremy Barham (Oxford: Oxford University Press, 2017), 38.
40. Falkenberg, "Sound Montage," 61.
41. Birtwistle, "Photographic Sound Art," 124.
42. Noël Burch, *Theory of Film Practice*, trans. Helen R. Lane (Princeton, N.J.: Princeton University Press, 1981), 90. Italics in original.
43. Dziga Vertov, *Kino-Eye: The Writings of Dziga Vertov*, trans. Kevin O'Brien (Berkeley: University of California Press, 1984), 15.

44. Hans Richter, "The Film as an Original Art Form," in *The Film Culture Reader*, ed. P. Adams Sitney (New York: Cooper Square, 2000), 18.

45. Siegfried Kracauer, *Theory of Film: The Redemption of Physical Reality* (Princeton, N.J.: Princeton University Press, 1997), 103.

46. Rudolf Arnheim, "A New Laocöon: Artistic Composites and the Talking Film," in *Film as Art* (Berkeley: University of California Press, 1957), 220; Stan Brakhage, *Screening Room*, presented by Robert Gardner, ABC TV Boston, 1973 (Cambridge, Mass.: Studio 7 Arts, 2008). DVD.

47. Rick Altman, "Introduction," *Yale French Studies* 60 (1980): 3.

48. Jonathan Walley, "The Material of Film and the Idea of Cinema: Contrasting Practices in Sixties and Seventies Avant-Garde Film," *October* 103 (2003): 30.

49. Michel Chion, *Audio-Vision: Sound on Screen*, ed. and trans. Claudia Gorbman (New York: Columbia University Press, 1994), 143.

50. Richard Misek, "The Black Screen," in *Indefinite Visions: Cinema and the Attractions of Uncertainty*, ed. Martine Beugnet, Allan Cameron, and Arild Fetveit (Edinburgh: Edinburgh University Press, 2017), 49.

51. This experimental film originally appeared as a video essay in the *Journal of Videographic Film & Moving Image Studies* 2, no. 2. *So's Nephew* is a response to my essay "Boundless Ontologies: Michael Snow, Wittgenstein, and the Textual Film," *Cinema Journal* 54, no. 3 (Spring 2015): 69–87, which was itself a response to Michael Snow's film *So Is This* (1982).

52. Jennifer Proctor, e-mail to author, November 22, 2016. Capitalization in original.

53. Ara Osterweil, *Flesh Cinema: The Corporeal Turn in American Avant-Garde Film* (Manchester: Manchester University Press, 2014), 239. See also Ara Osterweil, "Radio Daze: Why Ken Jacobs' *Blonde Cobra* Still Matters," *C Magazine* 130 (Summer 2016): 10–14.

54. Moira Roth and William Roth, "John Cage on Marcel Duchamp," *Art in America* 61 (November–December 1973): 78.

55. Michael Cornelius, "Süddeutsche Zeitung," in *The German Avant-Garde Film of the 1920's*, ed. Angelika Leitner and Uwe Nitschke, trans. Jeremy Roth, Susan Praeder, and Terry Swartzberg (München: Goethe-Institut, 1989), 90.

56. Robert Bresson, *Notes on the Cinematograph*, trans. Jonathan Griffin (New York: New York Review of Books, 2016), 49.

57. Julian Hanich, *Cinematic Emotion in Horror Films and Thrillers: The Aesthetic Paradox of Pleasurable Fear* (New York: Routledge, 2010), 111.

58. Julian Hanich, "When Viewers Drift Off: A Brief Phenomenology of Cinematic Daydreaming," in *The Structures of the Film Experience by Jean-Pierre Meunier: Historical Assessments and Phenomenological Expansions*, ed. Julian Hanich and Daniel Fairfax, trans. Daniel Fairfax (Amsterdam: Amsterdam University Press, 2019), 226.

59. Hanich, *Cinematic Emotion*, 113. Italics in original.

60. Fyodor Dostoevsky, *Winter Notes on Summer Impressions*, trans. David Patterson (Evanston, Ill.: Northwestern University Press, 1997), 49.

61. Hanich, *Cinematic Emotion*, 113. Italics in original.

62. This phrase comes from Wittgenstein's famous aphorism "*The limits of my language* mean the limits of my world." See Ludwig Wittgenstein, "Tractatus Logico-Philosophicus," trans. C. K. Ogden, in *Major Works* (New York: HarperCollins, 2009), 63. Italics in original.

63. Schaeffer, *Traité des objets musicaux*, 270.

64. Schaeffer, *In Search of a Concrete Music*, 4, 13.

65. Pauline Oliveros, "Auralizing the Sonosphere: A Vocabulary for Inner Sound and Sounding," in *Audio Culture: Readings in Modern Music*, ed. Christoph Cox and Daniel Warner, rev ed. (New York: Bloomsbury, 2017), 114.

66. Pauline Oliveros, *Deep Listening: A Composer's Sound Practice* (Lincoln, Neb.: iUniverse, 2005), xxiii.

67. Hanrahan, "13 June 1930," 211.

68. Quoted in Hanrahan, "13 June 1930," 211.

69. Richter, "Experiments with Celluloid," 114.

2. STAN BRAKHAGE AND THE BIRTH OF SILENCE

1. Translations from the French are taken from the Criterion DVD of *Band of Outsiders*, released in 2003.

2. Rick Altman, "The Silence of the Silents," *Musical Quarterly* 80, no. 4 (Winter 1996): 649.

3. Giannalberto Bendazzi, *Animation: A World History*, vol. 1: *Foundations—The Golden Age* (Boca Raton, Fla.: CRC, 2016), 58.

4. William Moritz, *Optical Poetry: The Life and Work of Oskar Fischinger* (Bloomington: Indiana University Press, 2004), 184.

5. Scott MacDonald, "Stan Brakhage," in *A Critical Cinema 4: Interviews with Independent Filmmakers* (Berkeley: University of California Press, 2005), 100. Interestingly, it is possible that Fischinger created a "truly silent" film even before *Radio Dynamics*. In 1931 he crafted a short, black-and-white abstract film that was later given the title *Liebesspiel* (*Love Games* or *Love Play*). According to William Moritz, this film "may have been intentionally silent," although it does not appear that the film was screened during Fischinger's life, which suggests that "perhaps audiences were not, after all, interested in seeing a silent film at that time." See Moritz, *Optical Poetry*, 38.

6. Deren and Hammid made the film not long after visiting Fischinger's house in Hollywood to study his art. See Moritz, *Optical Poetry*, 104.

7. Quoted in Elinor Pearson (Cleghorn), "Mute Movement: Score and Silence in the Work of Maya Deren," Moves Festival of Dance and Film, Manchester Metropolitan University, April 23, 2008.

8. Brakhage's admiration for Deren's cinema is especially salient in Stan Brakhage, "Maya Deren," in Stan Brakhage, *Film at Wit's End: Eight Avant-Garde Filmmakers* (Kingston, N.Y.: Documentext, 1989), 90–112.

9. I should add that P. Adams Sitney persuasively argues that contingent historical factors played a significant role in shaping the silent aesthetic of American experimental filmmakers like Deren and Brakhage: "It is true that live or recorded music usually accompanied the silent avant-garde films when they were shown in the 1920s. But the difference between the speed of projection at that time (between 16 and 18 frames per second) and the speed standardized in 1929 for sound (24 frames per second) made it next to impossible to put sound on those films even after the invention and popular use of optical soundtracks. The distribution of early silent films through the library of the Museum of Modern Art created a new aesthetic of *silence* within the American film experience." See P. Adams Sitney, *Visionary Film: The American Avant-Garde, 1943–2000* (Oxford: Oxford University Press, 2002), 62. Italics in original.

10. Stan Brakhage, "Interview with Richard Grossinger," in *Brakhage Scrapbook*, ed. Robert A. Haller (New Paltz, N.Y.: Documentext, 1989), 190–200, 195.

11. Motion Picture Producers and Distributors of America, "Code to Govern the Making of Talking, Synchronized, and Silent Motion Pictures (Motion Picture Production Code) (USA, 1930)," in *Film Manifestos and Global Cinema Cultures: A Critical Anthology*, ed. Scott MacKenzie (Berkeley: University of California Press, 2014), 407–8.

12. MacDonald, "Stan Brakhage," 63.

13. Quoted in Jonas Mekas, "Recollections of Stan Brakhage," in *Stan Brakhage: Filmmaker*, ed. David E. James (Philadelphia: Temple University Press, 2005), 112. As Brakhage puts it, Deren saw the film as a "blasphemy" since "it permitted men to see what they're not supposed to see." This quotation appears in one of the notes on *Window Water Baby Moving* in Criterion's Blu-ray set *By Brakhage: An Anthology, Volumes One and Two* (2010).

14. Stan Brakhage, *Screening Room*, presented by Robert Gardner, ABC TV Boston, 1973 (Cambridge, Mass.: Studio 7 Arts, 2008). DVD.

15. Stan Brakhage, "The Seen," in *Essential Brakhage: Selected Writings on Filmmaking*, ed. Bruce McPherson (New York: Documentext, 2001), 154–73. For more on Brakhage's sound films, see Eric Smigel, "Sights and Sounds of the Moving Mind: The Visionary Soundtracks of Stan Brakhage," in *The Music and Sound of Experimental Film*, ed. Holly Rogers and Jeremy Barham (Oxford: Oxford University, 2018), 109–28.

16. Brakhage, *Screening Room*.

17. Stan Brakhage, "Having Declared a Belief in God," in *Telling Time*, ed. Bruce McPherson (Kingston, N.Y.: Documentext, 2003), 135.

18. Stan Brakhage, "Bio-Logic," in *Telling Time*, ed. Bruce McPherson (Kingston, N.Y.: Documentext, 2003), 22. In an essay called "An Inner Argument" (1991), Brakhage follows Mandelstam's lead and leaves about a quarter of one of his pages blank "in homage of the fact that Film can *not* be written, or even adequately written about." See Stan Brakhage, "An Inner Argument," in *Telling Time*, 43. Italics in original. Furthermore, Brakhage has written a number of essays about the importance of the ineffable. See, for example, Stan Brakhage, "Geometric Versus Meat-Ineffable," in *Telling Time*, 70–74, and "An Exercise in Ineffability," in *Telling Time*, 75–77.

19. Stan Brakhage, *Metaphors on Vision*, ed. P. Adams Sitney (New York: Anthology Film Archives and Light Industry, 2017), 114.

20. Albert Einstein, *The World As I See It* (New York: Citadel, 2006), 7.

21. Brakhage, *Metaphors on Vision*, 119.

22. As Brakhage asserts, *Fire of Waters* includes a sequence in which a shot of a house is juxtaposed with "the speeded-up sound of Jane giving birth to Myrrena," although the manipulation of this sound has divested it of its original ambience; it now sounds like "a dog in somebody's backyard . . . yelping in pain." Quoted in Sitney, *Visionary Film*, 179.

23. Jane Brakhage, "The Birth Film," *Film Culture Reader*, ed. P. Adams Sitney (New York: Cooper Square, 2000), 232.

24. Stanley Brakhage, "The Silent Sound Sense," *Film Culture* 21 (Summer 1960): 65, 66.

25. Brakhage, "The Silent Sound Sense," 67. Stan Brakhage's "The Silent Sound Sense" has many affinities with the Soviet statement on sound (discussed in chapter 1), which is also critical of audiovisual complementarity. See S. M. Eisenstein, V. I. Pudovkin, and G. V. Alexandrov, "A Statement," trans. Jay Leyda, in *Film Sound: Theory and Practice*, ed. Elisabeth Weis and John Belton (New York: Columbia University Press, 1985), 83–85.

26. Brakhage, "The Silent Sound Sense," 67.

27. Roland Barthes, *S/Z: An Essay*, trans. Richard Miller (New York: Farrar, Straus and Giroux, 1974), 4. For more on silent cinema's ability to suggest sounds, see Melinda Szaloky, "Sounding Images in Silent Film: Visual Acoustics in Murnau's *Sunrise*," *Cinema Journal* 41, no. 2 (Winter 2002), 109–131; and Sarah Keller, " 'Optical Harmonies': Sight and Sound in Germaine Dulac's Integral Cinema," in *Not So Silent: Women in Cinema Before Sound*, ed. Sofia Bull and Astrid Söderbergh Widding (Stockholm: Stockholm University Press, 2010), 159–66.

28. Interestingly, Brakhage did release *Scenes from Under Childhood, Section One* (1967) with a sound track, only to remove it later when he decided that the work should be screened in silence. In this case, he allowed the sound version to remain in circulation, although this was only "for study purposes." See the note on *Scenes from Under Childhood, Section One* in Criterion's DVD set *By Brakhage: An Anthology, Volume Two* (2010). While Brakhage was quite willing to remove sound from

a film, to my knowledge he never added sound to a film that was orig-
inally screened in silence.

29. See Stan Brakhage, "Film and Music," in *Essential Brakhage: Selected
Writings on Filmmaking*, ed. Bruce McPherson (New York: Documen-
text, 2001), 78–84.

30. Brakhage, "Film and Music," 79.

31. Marilyn Brakhage, "'A Lifetime of Study, of Poetry, Music, Painting,
Film, and Vision Went Into Any and All of Stan's Work': Interview
with Marilyn Brakhage," Flicker Alley, Avant-Garde Essay Series,
December 18, 2015, www.flickeralley.com.

32. Brakhage, *Metaphors on Vision*, 114.

33. MacDonald, "Stan Brakhage," 63; Carolee Schneemann, "It Is Paint-
ing," in *Stan Brakhage: Filmmaker*, ed. David E. James (Philadelphia:
Temple University Press, 2005), 83.

34. Michel Chion, *Audio-Vision: Sound on Screen*, ed. and trans. Claudia
Gorbman (New York: Columbia University Press, 1994), 4.

35. Brakhage, *Screening Room*.

36. Maurice Merleau-Ponty, *Phenomenology of Perception*, trans. Donald A.
Landes (London: Routledge, 2012), 243.

37. Chion, *Audio-Vision*, 4.

38. Incidentally, this process of acclimation is a necessary step in the appre-
ciation of avant-garde fare, a fact that Brakhage well understood. For
example, in a discussion of Christopher MacLaine's *The End* (1952),
Brakhage supplied the following thought experiment: "Imagine some-
one who has eaten only Kraft American cheese and who is handed a
piece of limburger. He'll say, 'My god! What is this? A piece of shit? All
moldy and smelling and coming apart.' That is the analogy of anyone
who's been fed on Hollywood or TV pap and who sees *The End* or any
other MacLaine film for the first time. One must accept MacLaine's
'limburger' as a connoisseur would. You give any child who is used to
American processed cheese a piece of limburger or bleu cheese, or any
American who is used to TV movies a MacLaine film, and he's going
to make a face over it—at first, until his palate has been educated to
accept new tastes." See Stan Brakhage, *Film at Wit's End: Eight Avant-
Garde Filmmakers* (Kingston, N.Y.: Documentext, 1989), 118.

39. John Cage, *Conversing with Cage*, ed. Richard Kostelanetz, 2nd ed.
(New York: Routledge, 2003), 70.

40. According to William Moritz's tantalizing account, during this col-
laboration, Fischinger told Cage about "his Buddhist-inspired belief
that all things have a sound, even if we do not always listen or hear it,
just as a stone has an inherent movement even when it is still. Cage
credited Oskar with offering him the revelation that changed his whole
perception of music and sound." See Moritz, *Optical Poetry*, 78. For
more on the relationship between Oskar Fischinger and John
Cage, see Richard H. Brown, "The Spirit Inside Each Object: John
Cage, Oskar Fischinger, and 'The Future of Music,'" *Journal of the
Society for American Music* 6, no. 1 (2012): 83–113.

41. It is, perhaps, significant that *At Land* was released just a few years
before Cage came up with the idea for *4′33″* in the late 1940s. One can't
help but wonder if a young John Cage viewed *At Land* in the 1940s
and noticed the way that the film's silence allowed him to enjoy the
noises of the theatrical space itself: the film projector whirring, a
woman sniffling, a man scratching his head.

42. For an excellent analysis of Cage's influence on experimental cinema,
see Branden W. Joseph, *Beyond the Dream Syndicate: Tony Conrad and
the Arts After Cage* (New York: Zone, 2008).

43. Brakhage, "Film and Music," 78.

44. Quoted in James Pritchett et al., "Cage and the Computer: A Panel
Discussion," in *Writings Through John Cage's Music, Poetry, and Art*, ed.
David W. Bernstein and Christopher Hatch (Chicago: University of
Chicago Press, 2001), 201.

45. Quoted in Stan Brakhage, *Metaphors on Vision*, ed. P. Adams Sitney
(New York: Anthology Film Archives and Light Industry, 2017), 205.

46. MacDonald, "Stan Brakhage," 72.

47. Brakhage, *Metaphors on Vision*, 205. Capitalization in original.

48. Brakhage, *Metaphors on Vision*, 158.

49. Brakhage repeatedly calls Cagean chance operations "rigid." For exam-
ple, in addition to the *Screening Room* interview, see Brakhage, "Film
and Music," 80. Whether chance operations are, in fact, "rigid," is a
complex question. On the one hand, one could argue that an artist, by
opening up a work to chance, is fighting *against* rigidity, specifically
the rigidity of determinacy, convention, and personal taste. On the
other hand, the very act of giving up control of one's own work could
be seen as its own form of rigidity. The artist, one might argue, no

longer has the freedom to modify the work according to its organic needs but must slavishly relinquish the control of the work to the caprice of a coin toss.

50. P. Adams Sitney and Stan Brakhage, "Introduction to *Metaphors on Vision*," in Stan Brakhage, *Metaphors on Vision*, ed. P. Adams Sitney (New York: Anthology Film Archives and Light Industry, 2017), 112–13.

51. Brakhage, *Metaphors on Vision*, 167. Italics added. Cage compares art to "a net" in John Cage, *Silence: 50th Anniversary Edition* (Middletown, Conn.: Wesleyan University Press, 2011), 100.

52. See Fred Camper, "Sound and Silence in Narrative and Nonnarrative Cinema," in *Film Sound: Theory and Practice*, ed. Elisabeth Weis and John Belton (New York: Columbia University Press, 1985), 369.

53. Camper, "Sound and Silence," 369. See also chapter 2 of my book *Motion(less) Pictures: The Cinema of Stasis* (New York: Columbia University Press, 2015), entitled "Serious Immobilities: Andy Warhol, Erik Satie, and the Furniture Film," 31–58.

54. Annette Michelson, "Camera Lucida/Camera Obscura," in *Stan Brakhage: Filmmaker*, ed. David E. James (Philadelphia: Temple University Press, 2005), 38.

55. Kristine Stiles, ed., *Correspondence Course: An Epistolary History of Carolee Schneemann and Her Circle* (Durham, N.C.: Duke University Press, 2010), 288.

56. Schneemann, "It Is Painting," 83. Schneemann claimed that *Fuses* was also a response to Brakhage's film *Loving* (1957), which depicts a sexual encounter between Schneemann and Tenney. According to Schneemann, "*Loving* failed to capture our central eroticism, and I wanted to set that right." See Scott MacDonald, "Carolee Schneemann," in *A Critical Cinema: Interviews with Independent Filmmakers* (Berkeley: University of California Press, 1998), 142. For more on the respective aesthetics of Brakhage and Schneemann—including their shared interest in corporeality—see Ara Osterweil, *Flesh Cinema: The Corporeal Turn in American Avant-Garde Film* (Manchester: Manchester University Press, 2014), 93–176.

57. Carolee Schneemann, *Imaging Her Erotics: Essays, Interviews, Projects* (Cambridge, Mass.: MIT Press, 2003), 43.

58. Quoted in Marjorie Keller, "Montage of Voices," *Millennium Film Journal* 16–18 (Fall 1986–Winter 1987): 252.

59. This assertion is complicated by the fact that Jane Brakhage may have shot some of the material in *Window Water Baby Moving*—although this is a matter of considerable debate. See, for example, Osterweil, *Flesh Cinema*, 97, 130. For more on the issue of gender in *Window Water Baby Moving*, see Lynne Sachs, "Thoughts on Birth and Brakhage," *Camera Obscura* 64, no. 22, no. 64 (2007): 194–96.

60. Quoted in Keller, "Montage of Voices,"252.

61. Merleau-Ponty, *Phenomenology of Perception*, 244.

62. See Sitney, *Visionary Film*, 347–70. In spite of the numerous differences between Brakhage's films and those of structural filmmakers like Michael Snow and Hollis Frampton, it is striking just how frequently structural filmmakers follow Brakhage's lead by eliminating sound from their films. Examples include Michael Snow's *One Second in Montreal* (1969) and *So Is This* (1982), and Hollis Frampton's *Process Red* (1966), *Lemon* (1969), and *Poetic Justice* (1972).

63. For more on Benning's *Grand Opera*, see James Benning, "Sound and Stills from *Grand Opera*," *October* 12 (1980): 22–45.

64. Scott MacDonald, "James Benning," in *A Critical Cinema 2: Interviews with Independent Filmmakers* (Berkeley: University of California Press, 1992), 240.

65. As Benning succinctly puts it, "Stan is the man, but Snow and Frampton were my influences." James Benning, e-mail to author, April 10, 2016.

66. James Benning, e-mail to Ken Eisenstein, March 28, 2016.

67. James Benning, "AV Festival 12: James Benning: Nightfall Post Screening Q&A," YouTube video, www.youtube.com/watch?v=1Mq Gt7OuOxE.

68. Stan Brakhage (as told to Jennifer Dorn), "Brakhage Meets Tarkovsky," *Chicago Review* 47, no. 4 (Winter 2001): 46.

3. NAOMI UMAN AND THE PEEKABOO PRINCIPLE

1. Barbara Rose, *An Interview with Robert Rauschenberg* (New York: Vintage, 1987), 45.

2. John Cage, *Silence: 50th Anniversary Edition* (Middletown, Conn.: Wesleyan University Press, 2011), 102.

3. John Cage, quoted in Branden W. Joseph, "White on White," *Critical Inquiry* 27, no. 1 (Autumn 2000): 112. Italics in original.

4. "Robert Rauschenberg on 'Erased de Kooning,'" YouTube video, https://www.youtube.com/watch?v=nGRNQER16Do&list=PLY47u V3netxFTCbYXXx6UD3B QCM4jW2tN&index=72.

5. Rose, *An Interview with Robert Rauschenberg*, 51.

6. Craig Dworkin, *No Medium* (Cambridge, Mass.: MIT Press, 2013), 41.

7. Quoted in Nicole Brenez, *"We Support Everything Since the Dawn of Time That Has Struggled and Still Struggles": An Introduction to Lettrist Cinema*, trans. Clodagh Kinsella (Berlin: Sternberg, 2014), 32.

8. John Cage, "26 Statements Re Duchamp," in *A Year from Monday* (Middletown, Conn.: Wesleyan University Press, 1967), 71. For more on Duchamp's influence on Rauschenberg, see Rose, *An Interview with Robert Rauschenberg*, 63–64.

9. A number of philosophers have grappled with the ontology of holes. See, for example, David and Stephanie Lewis, "Holes," *Australasian Journal of Philosophy* 48, no. 2 (August 1970): 206–12; and Roberto Casati and Achille C. Varzi, *Holes and Other Superficialities* (Cambridge, Mass.: MIT Press, 1994).

10. See Laura Carton, *Stripped* (Portland, Ore.: Nazraeli, 2010). For more on the erasures of Cohen, Garrett, and Carton, see Kelly Dennis, *Art/ Porn: A History of Seeing and Touching* (Oxford: Berg, 2009), 143–47.

11. Dworkin, *No Medium*, 19.

12. Dworkin, *No Medium*, 21.

13. Laurence Sterne, *The Life and Opinions of Tristram Shandy, Gentleman* (New York: Penguin, 2003), 422.

14. Uman, e-mail to author, December 2, 2016. I should note that almost all the scholarship on *removed* mistakenly asserts that Uman used nail polish *remover* (rather than nail polish) on the filmstrip. See, for example, Ofer Eliaz, *Cinematic Cryptonymies: The Absent Body in Postwar Film* (Detroit, Mich.: Wayne State University Press, 2018), 141; Ofer Eliaz, "Acts of Erasure: The Limits of the Image in Naomi Uman's Early Films," *Discourse* 36, no. 2 (Spring 2014): 211; and Danni Zuvela, "A Little Light Teasing: Some Special Affects in Avant-Garde Cinema," *Continuum: Journal of Media & Cultural Studies* 26, no. 4 (August 2012): 594. Lest I be accused of throwing stones from within

the comfort of my glass house, I should confess that I also repeat this error in the introduction to my interview with Uman. See Justin Remes, "Animated Holes: An Interview with Naomi Uman," *Millennium Film Journal* 66 (2017): 70.

15. The sixth and allegedly final edition was published in 2016. See Tom Phillips, *A Humument: A Treated Victorian Novel*, final ed. (New York: Thames and Hudson, 2016).

16. Phillips, *A Humument*, 33, 366. The original Beckett aphorism is from *Worstward Ho*: "Ever tried. Ever failed. No matter. Try again. Fail again. Fail better." See Samuel Beckett, *Worstward Ho*, in *Nohow On: Company, Ill Seen Ill Said, and Worstward Ho* (New York: Grove, 1996), 77. The Joyce allusion is derived from the end of Molly Bloom's stream-of-consciousness soliloquy in *Ulysses*: "I put my arms around him yes and drew him down to me so he could feel my breasts all perfume yes and his heart was going like mad and yes I said yes I will Yes." See James Joyce, *Ulysses* (New York: Vintage, 1990), 783.

17. Phillips, *A Humument*, 1. Literary erasures have proliferated in the aftermath of *A Humument*. For example, in *Radi os* (Chicago: Flood Editions, 2005), Ronald Johnson deletes text from John Milton's *Paradise Lost*; in *Tree of Codes* (London: Visual Editions, 2010), Jonathan Safran Foer literally cuts out large swaths of text from Bruno Schulz's *The Street of Crocodiles*; and in *Darkness* (Los Angeles: Make Now, 2011), Yedda Morrison whites out most of Joseph Conrad's *Heart of Darkness*. This is not to imply, however, that *A Humument* is the first literary erasure. Thomas Jefferson, for example, anticipated this aesthetic trend when he used a razor and glue to reassemble and reimagine the New Testament gospels. His goal was to foreground Jesus's moral teachings (which he admired) while excising elements that he deemed superstitious, such as miracles and prophecies. See Thomas Jefferson, *The Jefferson Bible: The Life and Morals of Jesus of Nazareth Extracted Textually from the Gospels in Greek, Latin, French, & English*, Smithsonian ed. (Washington, D.C.: Smithsonian Institution, 2011).

18. Dworkin, *No Medium*, 9.

19. *Scopophilia* is a common translation of the Freudian term *Schaulust*. See Sigmund Freud, "Three Essays on the Theory of Sexuality," in *The Freud Reader*, ed. Peter Gay (New York: Norton, 1995), 251. For a

critique of *scopophilia* as a translation of *Schaulust*, see Bruno Bettelheim, *Freud and Man's Soul* (New York: Vintage, 1982), 90–91.

20. Laura Mulvey, "Visual Pleasure and Narrative Cinema," *Screen* 16, no. 3 (Autumn 1975): 9.

21. Mulvey, "Visual Pleasure and Narrative Cinema," 11.

22. Remes, "Animated Holes," 72.

23. Mulvey, "Visual Pleasure and Narrative Cinema," 11.

24. Uman, e-mail to author, November 23, 2016.

25. Remes, "Animated Holes," 71–72. The assumption that the nude women in pornography gratify only the "male gaze" is undermined by empirical research suggesting that women, like men, generally spend more time looking at nude women than nude men in heterosexual pornography. See Heather A. Rupp and Kim Wallen, "Sex Differences in Response to Visual Sexual Stimuli: A Review," *Archives of Sexual Behavior* 37 (2008): 209.

26. Quoted in Soledad Santiago, "Milking the Subject: Experiments in Film," *Santa Fe New Mexican*, January 27, 2006.

27. Remes, "Animated Holes," 72.

28. Quoted in Santiago, "Milking the Subject."

29. Ludwig Wittgenstein, *Philosophical Investigations*, rev. 4th ed., ed. P. M. S. Hacker and Joachim Schulte, trans. G. E. M. Anscombe, P. M. S. Hacker, and Joachim Schulte (Oxford: Wiley-Blackwell, 2009), 38. For more on the sorites paradox, see Sergi Oms and Elia Zardini, eds., *The Sorites Paradox* (Cambridge: Cambridge University Press, 2019).

30. Remes, "Animated Holes," 71. Italics added.

31. Rachel Shteir, *Striptease: The Untold History of the Girlie Show* (Oxford: Oxford University Press, 2004), 8. Italics added. For more on striptease, see Dahlia Schweitzer, "Striptease: The Art of Spectacle and Transgression," *Journal of Popular Culture* 34, no. 1 (Summer 2000): 65–75.

32. Linda Williams, *Hard Core: Power, Pleasure, and the "Frenzy of the Visible"* (Berkeley: University of California Press, 1999), 77. In making this argument, Williams builds on the insights of an unpublished essay by David E. James that argues that "the striptease consists of a continual oscillation between exposure and concealment—the satisfaction of seeing all and the frustration of having that sight cut off in a 'premature

climax.'" Along similar lines, in her book *Screening Sex*, Williams argues that "moving-image sex" is predicated on a "dialectic between revelation and concealment." See Linda Williams, *Screening Sex* (Durham, N.C.: Duke University Press, 2008), 7.

33. David Andrews, *Soft in the Middle: The Contemporary Softcore Feature in Its Contexts* (Columbus: Ohio State University Press, 2006), 17.

34. Zuvela, "A Little Light Teasing," 594–95.

35. Remes, "Animated Holes," 72. The impulse to obscure content to make spectators "look harder" is fairly common in visual art. Consider, for example, Jean-Michel Basquiat's explanation for his use of crossed-out words in many of his canvases: "I cross out words so you will see them more; the fact that they are obscured makes you want to read them." Quoted in Jeffrey Hoffeld, "Word Hunger: Basquiat and Leonardo," in *Jean-Michel Basquiat*, exhibition catalogue, ed. Rudy Chiappini (Milan: Skira, 2005), 87.

36. Quoted in Santiago, "Milking the Subject."

37. Mulvey, "Visual Pleasure and Narrative Cinema," 7.

38. Remes, "Animated Holes," 71.

39. Eliaz, *Cinematic Cryptonymies*, 205, 144. Italics added.

40. André Bazin, "Marginal Notes on *Eroticism in the Cinema*," in *What Is Cinema?* vol. 2, trans. Hugh Gray (Berkeley: University of California Press, 2005), 172.

41. Slavoj Žižek, *The Art of the Ridiculous Sublime: On David Lynch's* Lost Highway (Seattle: Walter Chapin Simpson Center for the Humanities, 2000), 7.

42. Remes, "Animated Holes," 72.

43. Eliaz, "Acts of Erasure," 211.

44. V. S. Ramachandran, *The Tell-Tale Brain: A Neuroscientist's Quest for What Makes Us Human* (New York: Norton, 2011), 227.

45. Pierre Louÿs, *The Woman and the Puppet*, trans. Jeremy Moore (Monroe, Ore.: Subterranean, 1999), 124.

46. Sigmund Freud, "The Sexual Aberrations," in *The Basic Writings of Sigmund Freud*, trans. and ed. A. A. Brill (New York: Random House, 1995), 536.

47. Roland Barthes, "Striptease," in Roland Barthes, *Mythologies*, trans. Richard Howard and Annette Lavers (New York: Hill and Wang, 2012), 165.

48. Bazin, "Marginal Notes on *Eroticism in the Cinema*," 172.

49. Motion Picture Producers and Distributors of America, "Code to Govern the Making of Talking, Synchronized, and Silent Motion Pictures," 416. Italics added.

50. Peter Bogdanovich, *Fritz Lang in America* (New York: Praeger, 1969), 86.

51. José de la Colina and Tomás Pérez Turrent, *Objects of Desire: Conversations with Luis Buñuel*, ed. and trans. Paul Lenti (New York: Marsilio, 1992), 69.

52. Quoted in Donald Spoto, *The Dark Side of Genius: The Life of Alfred Hitchcock* (New York: Da Capo, 1999), 398.

53. Ramachandran, *The Tell-Tale Brain*, 228.

54. Gotthold Ephraim Lessing, *Laocoön: An Essay on the Limits of Painting and Poetry*, trans. Edward Allen McCormick (Baltimore: Johns Hopkins University Press, 1984), 19.

55. V. S. Ramachandran, "The Science of Art: How the Brain Responds to Beauty," in *Understanding Wisdom: Sources, Science, & Society*, ed. Warren S. Brown (West Conshohocken, Pa.: Templeton, 2000), 277–305. Italics in original.

56. Ramachandran, *The Tell-Tale Brain*, 228, 229.

57. Remes, "Animated Holes," 72.

58. Many scholars in the humanities become nervous when appeals are made to fields like neuroscience and evolutionary biology. The concern, at least in part, seems to be that by positing a human nature, neuroscientists and biologists risk falling prey to biological determinism and essentialism. But as the evolutionary biologist Stephen Jay Gould was fond of pointing out, "Biology is not inevitable destiny." In other words, one's upbringing, culture, and education can all profoundly inflect one's genetic predispositions. So while Ramachandran is right to see the peekaboo principle as being a part of human nature, there is no reason to suspect that this tendency is *purely* biological, since biology interacts with social and historical factors in complex and multifaceted ways. See Stephen Jay Gould, *The Mismeasure of Man*, rev. and exp. ed. (New York: Norton, 1996), 389.

59. See, for example, Brenda Love, *Encyclopedia of Unusual Sex Practices* (New York: Barricade, 1992), 1–2, 93; and Mark Griffiths, "Aural Sex? A Brief Overview of Ecouteurism and Acousticophilia," *DrMarkGriffiths*

(blog), September 28, 2012, https://drmarkgriffiths.wordpress.com/2012/09/28/aural-sex-a-brief-overview-of-ecouteurism-and-acoustico philia/. While scholarship on the role of sound in human sexuality is scant, notable exceptions include F. M. M. Mai, "A New Psychosexual Syndrome—'Ecouteurism,'" *Australian and New Zealand Journal of Psychiatry* 2, no. 4 (1968): 261–63; and Roy J. Levin, "Vocalised Sounds and Human Sex," *Sexual and Relationship Therapy* 21, no. 1 (2006): 99–107.

60. Hilary Bergen and Sandra Huber, "Pornography, Ectoplasm, and the Secret Dancer: A Twin Reading of Naomi Uman's *Removed*," *Screening the Past* 43 (April 2018).

61. Colina and Turrent, *Objects of Desire*, 85.

62. Bruce Johnson, "Introduction," in *Earogenous Zones: Sound, Sexuality, and Cinema*, ed. Bruce Johnson (London: Equinox, 2010), 2, 1.

63. Williams, *Hard Core*, 91, 8, 94. Italics added.

64. John Corbett and Terri Kapsalis, "Aural Sex: The Female Orgasm in Popular Sound," *Drama Review* 40, no. 3 (Fall 1996): 103.

65. Corbett and Kapsalis, "Aural Sex," 104. Italics in original.

66. Williams, *Hard Core*, 123, 139.

67. Mulvey, "Visual Pleasure and Narrative Cinema," 8.

68. Juan Diaz, "*I Love Dick*: Jill Soloway and Kevin Bacon Explain What the New Amazon Comedy's Really About," *IndieWire*, April 18, 2017, https://www.indiewire.com/2017/04/i-love-dick-jill-soloway-kevin-bacon-behind-the-scenes-watch-1201806670/.

69. Robert Bresson, *Notes on the Cinematograph*, trans. Jonathan Griffin (New York: New York Review of Books, 2016), 59.

70. Quoted in Peter Wagner, "Minding the Gaps: Ellipses in William Hogarth's Narrative Art," in *The Ruin and the Sketch in the Eighteenth Century*, ed. Peter Wagner et al. (Trier: Wissenschaftlicher Verlag Trier, 2008), 121.

4. MARTIN ARNOLD'S
DISAPPEARING ACT

1. Robert Burgoyne, "Douglas Gordon and Cory Arcangel: Breaking the Toy," in *Embodied Encounters: New Approaches to Psychoanalysis and Cinema*, ed. Agnieszka Piotrowska (London: Routledge, 2015), 159.

2. Gertrude Stein, "An Elucidation," in *Gertrude Stein: Selections*, ed. Joan Retallack (Berkeley: University of California Press, 2008), 186.

3. Many scholarly analyses of *Alone. Life Wastes Andy Hardy* mistakenly claim that its content comes from the *Andy Hardy* series of the 1930s and 1940s, in which Mickey Rooney plays a clean-cut American teen-ager. See, for example, Michele Pierson, "Special Effects in Martin Arnold's and Peter Tscherkassky's Cinema of Mind," *Discourse* 28, no. 2/3 (Spring & Fall 2006): 40; and Steve Anker, "Reanimator, Stutterer, Eraser: Martin Arnold and the Ghosts of Cinema," in *Film Unframed: A History of Austrian Avant-Garde Cinema*, ed. Peter Tscher-kassky (Vienna: sixpackfilm, 2012), 249. While Arnold does borrow footage from George B. Seitz's *Andy Hardy Meets Debutante* (1940), all the remaining footage in *Alone. Life Wastes Andy Hardy* comes from two Mickey Rooney films in which the actor does *not* play Andy Hardy: *Babes in Arms* (1939) and *Strike Up the Band* (1940) (both directed by Busby Berkeley).

4. The appellation "trilogy of compulsive repetition" originally comes from Dirk Schaeffer, *"Alone. Life Wastes Andy Hardy," Program Notes, Views from the Avant-Garde*, curated by Mark McElhatten and Gavin Smith, New York Film Festival, 1998. For Freud's analysis of "the com-pulsion to repeat," see Sigmund Freud, "Remembering, Repeating, and Working Through," in *The Penguin Freud Reader*, trans. John Red-dick, ed. Adam Phillips (New York: Penguin, 2006), 391–401.

5. Steve Anker erroneously identifies the actress who appears opposite Anne Baxter in *Dissociated* as Bette Davis rather than Celeste Holm. See Anker, "Reanimator, Stutterer, Eraser," 250. While Davis plays a promi-nent role in *All About Eve*, she does not appear in Arnold's *Dissociated*.

6. See Mika Taanila, "Interview with Martin Arnold," Avanto/Helsinki Media Arts Festival 6, http://www.avantofestival.com/avanto2001 /2001_screenings/fv_arnold_interview.html.

7. The trilogy of erasure represents the first time that Arnold worked with a team to modify found footage. According to Arnold, "This is abso-lutely necessary—otherwise I would only be able to show [*Deanimated*] maybe two weeks before I die! It's so time-consuming that it takes for-ever. We'll have an output of something like five seconds per day per person. That's not very much for a 60 minute movie." Taanila, "Inter-view with Martin Arnold."

8. Anna Farennikova, "Seeing Absence," *Philosophical Studies: An International Journal for Philosophy in the Analytic Tradition* 166, no. 3 (December 2013): 430, 449. Italics added.

9. Sigmund Freud, *The Uncanny*, trans. David Mclintock (London: Penguin, 2003), 150.

10. Emmanuelle André, "Martin Arnold on Walt Disney: To Show *Per Via di Levare* (By Means of Subtraction)," trans. Martine Beugnet, *Screen* 58, no. 2 (Summer 2017): 210–17.

11. Scott MacDonald, "Sp . . . Sp . . . Spaces of Inscription: An Interview with Martin Arnold," *Film Quarterly* 48, no. 1 (Autumn 1994): 2.

12. Cahill, ". . . and Afterwards?: Martin Arnold's Phantom Cinema," *Spectator* 27 (2007): 25.

13. Taanila, "Interview with Martin Arnold."

14. Quoted in Akira Mizuta Lippit, *Ex-Cinema: From a Theory of Experimental Film and Video* (Berkeley: University of California Press, 2012), 132. Arnold is no doubt thinking here of James Whale's *The Invisible Man* (1933), in which the titular character can still be heard even when he cannot be seen.

15. Akira Mizuta Lippit, "----MA," in *Martin Arnold: Deanimated*, ed. Gerald Matt and Thomas Miessgang (Vienna: Springer, 2002), 31. The title of this essay by Lippit is remarkably rich. It mimics Arnold's use of erasure in *Deanimated* by eliminating the first four letters in the word *CINEMA*. The remaining syllable, *ma*, is the Japanese word for "gap" or "space," as well as an English word for the maternal figure (who plays such a dominant role in Freudian psychoanalysis). MA is also capitalized in Lippit's title, suggesting its status as an acronym: MA = Martin Arnold.

16. Jacques Derrida, *Specters of Marx: The State of the Debt, the Work of Mourning, and the New International*, trans. Peggy Kamuf (New York: Routledge, 2006), 124, 157.

17. Daniel C. Dennett, *Consciousness Explained* (Boston: Little, Brown, 1991), 35. Italics in original.

18. Tom Gunning, "To Scan a Ghost: The Ontology of Mediated Vision," *Grey Room* 26 (Winter 2007): 102.

19. Thomas Miessgang, "Beyond the Words: The Multiple Narratives of the Filmmaker Martin Arnold," in *Martin Arnold: Deanimated*,

ed. Gerald Matt and Thomas Miessgang (Vienna: Springer, 2002), 15–18, 16.

20. Taanila, "Interview with Martin Arnold."

21. Cahill, ". . . and Afterwards?," 20.

22. OED Online, s.v. "animate," accessed February 22, 2018, http://www .oed.com.proxy.lib.iastate.edu/view/ Entry/7778?rskey=QpDbiq&res ult=2#eid.

23. Crispin Brooks, The Futurism of Vasilisk Gnedov (Birmingham: University of Birmingham, 2000), 46.

24. Brooks, The Futurism of Vasilisk Gnedov, 48.

25. In fact, the sound track at the end of Deanimated is reminiscent of Ken Friedman's Zen for Record (1966), a phonograph record with no music on it that allows one to luxuriate in the aleatory pops and hisses produced by a needle on vinyl. As the title implies, Zen for Record was inspired by Nam June Paik's silent and imageless cinematic experiment Zen for Film (1962–1964).

26. Branden W. Joseph, Random Order: Robert Rauschenberg and the Neo-Avant-Garde (Cambridge, Mass.: MIT Press, 2003), 21; John Cage, Conversing with Cage, ed. Richard Kostelanetz, 2nd ed. (New York: Routledge, 2003), 70.

27. See "Melissus of Samos," in The First Philosophers: The Presocratics and Sophists, trans. Robin Waterfield (Oxford: Oxford University Press, 2000), 85.

28. Stephen Batchelor, Buddhism Without Beliefs (New York: Riverhead, 1997), 81.

29. Gay Watson, A Philosophy of Emptiness (London: Reaktion, 2014), 15.

30. Masao Abe, "Non-Being and Mu: The Metaphysical Nature of Negativity in the East and the West," Religious Studies 11, no. 2 (June 1975): 186.

31. OED Online, s.v. "emptiness," accessed May 24, 2018, http://www.oed .com.proxy.lib.iastate.edu/view/ Entry/61420?redirectedFrom=emptin ess#eid.

32. See Arthur Schopenhauer, "On the Vanity of Existence," in Arthur Schopenhauer, Essays and Aphorisms, trans. R. J. Hollingdale (New York: Penguin, 1970), 53; Søren Kierkegaard, Fear and Trembling, trans. Alastair Hannay (London: Penguin, 2003), 49.

33. The description of emptiness as "inclusive" comes from a biography of Bodhidharma written in 1004 by Dogen. Quoted in Paul Reps, "Foreword," in *Zen Flesh, Zen Bones: A Collection of Zen and Pre-Zen Writings*, comp. Paul Reps and Nyogen Senzaki, (Tokyo: Tuttle, 1985), 15. The word "sublime" is used in "Flower Shower," trans. Senzaki and Reps, in *Zen Flesh, Zen Bones*, 60.

34. "A Cup of Tea," trans. Nyogen Senzaki and Paul Reps, in *Zen Flesh, Zen Bones: A Collection of Zen and Pre-Zen Writings*, comp. Paul Reps and Nyogen Senzaki (Tokyo: Tuttle, 1985), 23.

35. See, for example, MacDonald, "Sp . . . Sp . . . Spaces of Inscription," 8, 11.

36. John Cage, *Silence: 50th Anniversary Edition* (Middletown, Conn.: Wesleyan University Press, 2011), 143, 154, 160, 187.

37. Cage, xxxi. For more on Zen Buddhism's influence on Cage, see Kay Larson, *Where the Heart Beats: John Cage, Zen Buddhism, and the Inner Life of Artists* (New York: Penguin, 2013).

38. Ruth Hirschman, "Pop Goes the Artist," in *I'll Be Your Mirror: The Selected Andy Warhol Interviews*, ed. Kenneth Goldsmith (New York: Carroll and Graf, 2004), 42; G. R. Swenson, "What Is Pop Art? Answers from 8 Painters, Part I," in *I'll Be Your Mirror*, 20.

39. Quoted in *The Autobiography and Sex Life of Andy Warhol*, ed. John Wilcock and Christopher Trela (New York: Trela, 2010), 116. For more on Cage's influence on Warhol, see Edward D. Powers, "Attention Must Be Paid: Andy Warhol, John Cage, and Gertrude Stein," *European Journal of American Culture* 33, no. 1 (2014): 5–31.

40. Andy Warhol and Pat Hackett, *POPism: The Warhol Sixties* (San Diego, Calif.: Harvest/HBJ, 1990), 64.

41. Andy Warhol, *The Philosophy of Andy Warhol: From A to B and Back Again* (New York: Harvest/HBJ, 1975), 9, 183, 199.

42. Quoted in Lippit, "—-MA," 32.

43. Anker, "Reanimator, Stutterer, Eraser," 253.

44. Heraclitus quoted in Thomas McEvilley, *The Shape of Ancient Thought: Comparative Studies in Greek and Indian Philosophies* (New York: Allworth, 2002), 431; Martin Heidegger, "Anaximander's Saying," in *Off the Beaten Track*, ed. and trans. Julian Young and Kenneth Haynes (Cambridge: Cambridge University Press, 2002), 261.

45. Tanya Shilina-Conte, "Black Screen, White Page: Ontology and Genealogy of Blank Space," *Word & Image* 31, no 4 (October–December 2015): 504. Shilina-Conte has written extensively about the black screen in cinema. See also her "How It Feels: Black Screen as Negative Event in Early Cinema and 9/11 Films," *Studia Phaenomenologica* 16 (2016): 409–38, and "Abbas Kiarostami's 'Lessons of Darkness:' Affect, Non-Representation, and Becoming-Imperceptible," *Iran Namag* 2, no. 4 (Winter 2018): 94–123. Also noteworthy is Shilina-Conte's as yet incomplete found footage film *This Video Does Not Exist*, a remix of imageless screens from dozens of different films across film history.

46. Guy Debord, *Society of the Spectacle*, trans. Fredy Perlman et al. (Detroit: Black and Red, 2010), 199.

47. Miessgang, "Beyond the Words," 18.

CONCLUSION

1. Hiroshi Sugimoto, "The Virtual Image," in *Theaters: Hiroshi Sugimoto* (New York: Sonnabend Sundell, 2000), 16.

2. Thomas Kellein, "Interview with Hiroshi Sugimoto," in Thomas Kellein, *Hiroshi Sugimoto: Time Exposed* (New York: Thames and Hudson, 1995), 91. Perhaps Sugimoto's *Theaters* photographs should become the holy relics of apophatic theology. To quote Meister Eckhart, "God is nothing . . . He is beingless being." See Meister Eckhart, "Sermon Sixty-Two," in *The Complete Mystical Works of Meister Eckhart*, trans. Maurice O'Connell Walshe (New York: Herder & Herder, 2009), 316–17.

3. Hiroshi Sugimoto, "My Inner Theater," trans. Giles Murray, in *Hiroshi Sugimoto: Theaters* (New York: Damiani and Matsumoto Editions, 2016), 3–7, 7.

4. Of course, in a sense, *all* photographs are silent, but not all photographs give the *impression* of silence. If *Teatro Comunale* had included a recognizable film still, such as Luke Skywalker battling Darth Vader in *The Empire Strikes Back* (Irvin Kershner, 1980), one would imagine the sounds of the film itself: perhaps John Williams's "Imperial March," or Darth Vader telling Luke, "I am your father." Along similar lines, if Sugimoto's photograph had included an audience inside the theatrical space, one might well imagine the sounds of those spectators:

whispering, fidgeting, eating popcorn. But by viewing a screen and a theater that are both *empty*, one instead imagines the intense silence of the depopulated theatrical space.

5. Sugimoto, "My Inner Theater," 4, 5.

6. See "An Evening with Tea Master Sen So'oku & Hiroshi Sugimoto: From Sen Rikyu to Marcel Duchamp," YouTube video, https://www.youtube.com/watch?v=uomP1qdwooI&t=1828s.

7. Kay Larson, *Where the Heart Beats: John Cage, Zen Buddhism, and the Inner Life of Artists* (New York: Penguin, 2013), 48.

8. Tosi Lee, "Fire Down Below and Watering, That's Life: A Buddhist Reader's Response to Marcel Duchamp," in *Buddha Mind in Contemporary Art*, ed. Jacquelynn Baas and Mary Jane Jacob (Berkeley: University of California Press, 2006), 126. For more on the connections between Duchamp and Eastern philosophy, see Jacquelynn Baas, "Before Zen: The Nothing of American Dada," in *East-West Interchanges in American Art: A Long and Tumultuous Relationship*, ed. Cynthia Mills, Lee Glazer, and Amelia A. Goerlitz (Washington, D.C.: Smithsonian, 2012), 52–65.

9. "An Evening with Tea Master Sen So'oku & Hiroshi Sugimoto."

10. "What Is Zen?," in *Zen Flesh, Zen Bones: A Collection of Zen and Pre-Zen Writings*, comp. Paul Reps and Nyogen Senzaki (Tokyo: Tuttle, 1985), 222–23, 223.

11. "What Is Zen?," 223.

12. Quoted in Margery Rex, "'Dada' Will Get You If You Don't Watch Out: It Is on the Way Here," in *New York Dada*, ed. Rudolf E. Kuenzli (New York: Willis Locker & Owens, 1986), 140.

13. Charles Thomas Samuels, "Robert Bresson," in *Encountering Directors* (New York: Putnam's, 1972), 59.

14. Quoted in Rex, "'Dada' Will Get You," 140.

FILMOGRAPHY

1. K. J. Donnelly, *Occult Aesthetics: Synchronization in Sound Film* (Oxford: Oxford University Press, 2014), 134.

2. Translations from the French are taken from Ken Knabb, ed. and trans., *Guy Debord: Complete Cinematic Works: Scripts, Stills, Documents* (Oakland, Calif.: AK, 2003).

3. Dieter Daniels, "Silence and Void: Aesthetics of Absence in Space and Time," in *The Oxford Handbook of Sound and Image in Western Art*, ed. Yael Kaduri (New York: Oxford University Press, 2016), 316.

4. Quoted in Stefan Grissemann, "Frame by Frame: Peter Kubelka," *Film Comment* 48, no. 5 (September/October 2012): 74.

5. The quotation appears as an epigraph to *The Flicker Film* on disc 1 of the DVD set *Norman McLaren: The Master's Edition*, National Film Board of Canada, 2006.

6. Saint Augustine, *Confessions*, trans. Henry Chadwick (Oxford: Oxford University Press, 2008), 230.

7. Hanna B. Hölling, *Revisions: Zen for Film* (New York: Bard Graduate Center, 2015), x.

8. See Scott MacDonald, "Tony Conrad: On the Sixties," in *A Critical Cinema* (Berkeley: University of California Press, 1988), 71–72.

9. Jonas Mekas, "An Interview with Tony Conrad: On the Flickering Cinema of Pure Light," in Jonas Mekas, *Movie Journal: The Rise of the New American Cinema, 1959–1971*, ed. Gregory Smulewicz-Zucker, 2nd ed. (New York: Columbia University Press, 2016), 236.

10. Yann Beauvais, "Lost and Found," trans. Miles McKane, in *Found Footage Film*, ed. Cecilia Hausheer and Christoph Settele (Lucerne: VIPER/zyklop, 1992), 15.

11. Thomas Beard, "Appeal to a Single Faculty," *Metrograph*, June 28, 2017, http://metrograph.com/edition/article/50/appeal-to-a-single -faculty.

12. John Powers, "Moving Through Stasis in Stan Brakhage's *Passage Through: A Ritual*," *Screen* 60, no. 3 (Autumn 2019): 414.

13. Suranjan Ganguly, "Stan Brakhage: The 60th Birthday Interview," in *Stan Brakhage: Interviews*, ed. Suranjan Ganguly (Jackson: University Press of Mississippi, 2017), 93.

14. See Henning Lohner's documentary *The Making of One11* (1992).

15. Quoted in Henning Lohner, "The Making of One11," in *Writings Through John Cage's Music, Poetry, and Art*, ed. David W. Bernstein and Christopher Hatch (Chicago: University of Chicago Press, 2001), 292.

16. Quoted in Lohner, *The Making of One11*.

17. Michael Betancourt, e-mail to author, February 24, 2019.

18. Jennifer Proctor, *Am I Pretty?*, http://cargo.jenniferproctor.com/Am-I -Pretty.

19. Paul O'Reilly, "*Diagonal Symphony*," in *Directory of World Cinema: Germany 2*, ed. Michelle Langford (Bristol: Intellect, 2013), 283.

20. Harry Dartford, quoted in Bruce Posner, "On Viewing *Portrait of a Young Man*" (2016), Flicker Alley, Critical Essays, http://www .flickeralley.com/mod/critical-essays/. In 2017 Flicker Alley released a Blu-ray of *Portrait of a Young Man* (along with the Japanese avant-garde film *A Page of Madness* [1926] by Tienosuke Kinugasa), which pairs the film's imagery with a piano score by Judith Rosenberg. I must admit that I admire Rosenberg's score, which features a series of evocative soundscapes in the style of Morton Feldman. Nevertheless, it is curious that Flicker Alley felt the need to include a sound track at all, given Rodakiewicz's assertion that the film should be screened in silence.

21. Jonathan Rosenbaum, "Music for the Eyes: Films by Oskar Fischinger," *Chicago Reader*, April 19, 2001.

22. James Broughton, "Film as a Way of Seeing," *Film Culture* 29 (Summer 1963): 19.

23. Stan Brakhage, *Screening Room*, presented by Robert Gardner, ABC TV Boston, 1973 (Cambridge, Mass.: Studio 7 Arts, 2008). DVD.

24. P. Adams Sitney, "The Cinematic Gaze of Joseph Cornell," in *Joseph Cornell*, ed. Kynaston McShine (New York: Museum of Modern Art, 1980), 108.

25. Scott MacDonald, "Stan Brakhage," in *A Critical Cinema 4: Interviews with Independent Filmmakers* (Berkeley: University of California Press, 2005), 65.

26. Roy Grundmann, *Andy Warhol's* Blow Job (Philadelphia: Temple University Press, 2003), 2.

27. Grundmann, *Andy Warhol's* Blow Job, 41.

28. Stan Brakhage, *Film at Wit's End: Eight Avant-Garde Filmmakers* (Kingston, N.Y.: Documentext, 1989), 40–41.

29. Samuel Beckett, *Beckett Remembering/Remembering Beckett*, ed. James and Elizabeth Knowlson (New York: Arcade, 2006), 47. Italics in original.

30. Alan Schneider, "On Directing *Film*," *Samuel Beckett Today* 4 (1995): 29.

31. Samuel Beckett and Georges Duthuit, "from *Three Dialogues*," in *Art in Theory, 1900–2000: An Anthology of Changing Ideas*, ed. Charles Harrison and Paul Wood (Malden, Mass.: Blackwell, 2003), 617.

32. Peter Tscherkassky, "Interview with Kurt Kren," in *Kurt Kren: Structural Films*, ed. Nicky Hamlyn, Simon Payne, and A. L. Rees (Chicago: University of Chicago Press, 2016), 252.

33. Carolee Schneemann, "Notes on *Fuses*," in Carolee Schneemann, *Imaging Her Erotics: Essays, Interviews, Projects* (Cambridge, Mass: MIT Press, 2002), 45.

34. Hollis Frampton, on *Screening Room*, presented by Robert Gardner, ABC TV Boston, 1977 (Cambridge, Mass.: Studio 7 Arts, 2005). DVD.

35. Klaus Biesenbach, *Douglas Gordon: Timeline* (New York: Museum of Modern Art, 2006), 15.

36. Marcel Duchamp, *Notes*, trans. Paul Matisse (Boston: Hall, 1983), 197.

37. Jonas Mekas, "Six Notes on How to Improve Commercial Cinema" (March 28, 1963), in *Movie Journal: The Rise of the New American Cinema, 1959–1971*, ed. Gregory Smulewicz-Zucker (New York: Columbia University Press, 2016), 87.

38. See Ken Friedman, Owen Smith, and Lauren Sawchyn, eds., *The Fluxus Performance Workbook* (Performance Research e-Publication, 2002), 104, www.thing.net/~grist/ld/ fluxusworkbook.pdf.

39. Yves Klein, *"The Specialization of Sensibility in Raw Material State Into Stabilized Pictorial Sensibility,"* in *Voids: A Retrospective*, ed. John Armleder et al. (Zurich: JRP|Ringier, 2009), 51.

40. Scott MacDonald and Yoko Ono, "Yoko Ono: Ideas on Films: Interview/Scripts," *Film Quarterly* 43, no. 1 (Autumn 1989): 17.

41. Claire Stewart, *"Removed,"* *Senses of Cinema* 16 (September 2001), http://www.sensesofcinema.com.

42. Paul Pfeiffer, "Go for Broke? A Conversation Between Paul Pfeiffer and Hal Foster," in *Paul Pfeiffer*, ed. Ingvild Goetz and Stephan Urbaschek (Ostfildern: Hatje Cantz, 2011), 129.

43. Bhob Rainey and Kenneth Goldsmith, curators, "Marilyn Monroe," *Music Overheard*, Institute of Contemporary Art, Boston, r7699244, 2006, compact disc.

44. Cory Arcangel and Dara Birnbaum, "Do It 2," *Artforum* (March 2009): 194.

45. Quoted in Emmanuelle André, "Martin Arnold: Animals, Tamers, and Clowns," *Mousse* 62 (February/March 2018), http://moussemagazine.it/martin-arnold-emmanuelle-andre-2018/.

46. Quoted in André, "Martin Arnold"

INDEX

Levinas and the Cinema of Redemption: Time, Ethics, and the Feminine
Sam B. Girgus

*Counter-Archive: Film, the Everyday, and Albert Kahn's Archives
de la Planète*
Paula Amad

Indie: An American Film Culture
Michael Z. Newman

Pretty: Film and the Decorative Image
Rosalind Galt

Film and Stereotype: A Challenge for Cinema and Theory
Jörg Schweinitz

Chinese Women's Cinema: Transnational Contexts
Edited by Lingzhen Wang

Hideous Progeny: Disability, Eugenics, and Classic Horror Cinema
Angela M. Smith

Hollywood's Copyright Wars: From Edison to the Internet
Peter Decherney

Electric Dreamland: Amusement Parks, Movies, and American Modernity
Lauren Rabinovitz

*Where Film Meets Philosophy: Godard, Resnais, and Experiments in
Cinematic Thinking*
Hunter Vaughan

*The Utopia of Film: Cinema and Its Futures in Godard, Kluge, and
Tahimik*
Christopher Pavsek

Hollywood and Hitler, 1933–1939
Thomas Doherty

Cinematic Appeals: The Experience of New Movie Technologies
Ariel Rogers

Continental Strangers: German Exile Cinema, 1933–1951
Gerd Gemünden

Deathwatch: American Film, Technology, and the End of Life
C. Scott Combs

*After the Silents: Hollywood Film Music in the Early Sound Era,
1926–1934*
Michael Slowik